transformed
anointed forgiven
beautiful adopted
victorious royal
righteous
chosen bold
daughter strong
holy free
secure
delivered
favored
accepted

THE IDENTITY EFFECT

A Collection of Stories by Women Who've
Discovered Their True Identity in Christ

Quantity order requests can be emailed to:
thefewwomen@gmail.com

The Identity Effect
Publishing Coordinator: Kimberly Joy Krueger

Volume 4 of the "Effect" Series from FEW International Publications

Contributing Authors: Amy Hauser, Becki Britz, Beth Zastrow, Brooke Kangas, Cheryl Matthews, Erika Villanueva, Heather Taylor, Jamie Dahl, Jasmin Almonte, Joni Jones, Julissa Moreno, Kayley Hill, Kimberly Krueger, Kristen Brzezinski, Luanne Nelson, Marlene Dawson, Sara Junio, Toni Campbell, and Victoria Reinke

Expert Contributor: Susan C. Brozek, M.S.W., L.C.S.W.

Contributing Editors: Amy Oaks and Kimberly Krueger
Associate Editor: Cumi Ikeda

Cover Artists: Maci Hahn and Lexi Niedfeldt
Cover Designer: Trace Chiodo; Chiodo Design, chiododesign.com

Interior Layout: Trace Chiodo; Chiodo Design, chiododesign.com

ISBN-10: 1-949494-07-1
ISBN-13: 978-1-949494-07-5

Categories:
Religion & Spirituality/Christian Books & Bibles/Literature & Fiction/Collections & Anthologies
Religion & Spirituality/Christian Books & Bibles/Biographies
Biographies & Memoirs/Reference & Collections

FEW International Publications

An Extraordinary Publishing Experience

FEW International Publications is a #1 Bestselling Publisher for women authors at all levels who are seeking more from telling their stories than just a printed project. We are privileged to watch FEW Authors connect, learn, grow, and heal through the creation of a written work that impacts others and glorifies God. Find FEW's books at thefewwomen.com and on amazon.com.

Extraordinary Women; Extraordinary Stories

thefewwomen.com

I have no greater joy than to hear that my children are walking in the truth.
—3 John 4

After working with women on their spiritual development for many years now, I knew these words penned by John, the Apostle, were the perfect introduction to this book.

I have seen firsthand, time and again, what happens when a Christian woman walks in the truth; it always brings pure joy! *I have also seen what happens when she doesn't.* I believe the importance of walking in the truth of who God is, and equally paramount, *who He says we are,* cannot be overstated. They are both crucial disciplines for women who want to experience the abundant life Jesus died to give us. The revelation and implementation of these will, in every case, make a woman unstoppable. Knowing our Father's heart for us and choosing to come into agreement with what He says about us will do nothing short of perfectly position us for our destinies!

And our enemy knows that.

It is my prayer for each woman who reads this book, that she remembers there is a battle for her identity—and her destiny is what is truly at stake. This battle is not against people, it is a spiritual battle won with the Sword of the Spirit, which is the Word of God. It is won by choosing time and again to believe,

What God says about me, is the truest thing about me.

Empowered by the Father's Love, may you choose to agree with and walk in your Identity in Christ!

In His Truth,

Kimberly Krueger
Founder of FEW International Organization, LLC

SUSAN BROZEK

Dear Reader,

God.
Heavenly Father.
Lord.
Father God.

What comes to your mind as you ponder who God is? You may think of His majesty, His greatness, His faithfulness … any of so many characteristics of His nature. Or, you may struggle with seeing Him as He truly is because of our human tendency to project the characteristics of our earthly father onto our Heavenly Father. Perhaps at times you may view God as distant, disinterested, or even uncaring. A distorted and inaccurate view of God is something I encounter frequently as I work with patients at my practice. This is why I am so compelled to help others understand the TRUE nature of the God we serve!

Within this book, you will find an invaluable resource: a list containing the Names of God which are stated in the Bible in the original Hebrew text of the Old Testament. As you study this list of the wonderful *attributes* of our God, keep in mind that in Biblical times, a person's name was also his or her 'fame.' For the most part, children during that era of time were named several days *after* they were born. For example, John the Baptist was named on the eighth day following his birth (and in case you were wondering, "John" means 'Jehovah is a Gracious Giver'). Delays such as this occurred because it allowed the child's parents to begin to get an idea of the personality of the child, and then they would pick a name that was suitable to whom they perceived that child to be. In other words, names had great meaning!

In contrast, when we approach God, we don't have to try to "figure out" what type of name to give Him, because God reveals Himself to us through a variety of Names in his Word, as the list demonstrates. We also know from God's Word that God IS love. Augustus Strong, a notable theologian, wrote

a very moving definition of love. He states: "By 'love,' we mean that attribute of the Divine Nature whereby God is eternally moved to self-communicate." Since God *is* love, His very nature continuously displays this fact! *And all of God's Names are expressions of His love toward us.* He strongly desires that we come to really know Him, as revealed both by His Names and also by our spending time in His awesome Presence as we worship Him, listen to Him, and continue to pursue a deeper relationship with Him. He wants us to know Him for who He is, not just for what He can do for us.

Will you allow the Maker of the Universe to reveal Himself to you today as you seek Him and as you read the beautiful examples of His intervention in the lives of the women in the book that you now hold in your hands? Doing so will be transformational in your life, because as you come to really know God, not only will your relationship with him grow and deepen, but you will be able to approach Him with trust and full assurance of His nature and character. You will not just know *about* Him, but *you will know Him for who He really is!*

Prayers and Blessings as you discover all He is,

Susan C. Brozek, M.S.W., L.C.S.W.
Director/Founder, HEALING WORD PSYCHOTHERAPY SERVICES, LLC
www.healing-word.com • 414-254-9862
#1 Bestselling Author
TV Broadcast Show Host at The NOW Network
International Radio Broadcast Host, "The Way of Healing", at Reaching Out Radio Int'l

Susan C. Brozek, M.S.W., L.C.S.W., is Director and Founder of Healing Word Psychotherapy Services, LLC (www.healing-word.com). She has a strong call and desire to help the hurting. She has been a Licensed Clinical Christian Psychotherapist for over 20 years and has spoken at many conferences and seminars. She hosts a monthly TV broadcast called 'The Way of Healing' on the The NOW TV Network (www.thenownetwork.org), and a bi-weekly International Radio Broadcast on Blog Talk Radio. She is a #1 Bestselling Author, and her books include: 'A FEW Words on Becoming Holy, Whole and Fit', 'A FEW Words of Comfort for the Grieving', and 'HEALING WORDS: 30 Devotional Word Studies for Emotional and Spiritual Healing'. Susan and her husband Jeff live in Mequon, WI, with the frequent trip to Door County, WI.

BECKI BRITZ

Becki Britz lives to tell the tale of transformation through her testimony of addiction, death, depression, hard work, and ultimately, triumph. With God's guidance, Becki has managed to go from "Junkie to Jesus" and overhaul her life one day at a time. When she isn't sharing her powerful story, Becki and her husband are chasing after their four young children in Menomonee Falls, WI. Connect with Becki through social media at fb.me/Beckibritz, instagram.com/beckibritz, or Beckibritz@gmail.com.

Chapter One

From Junkie to Jesus

by Becki Britz

In the world you will have tribulation,
but be of good cheer, I have overcome the world.

–JOHN 16:33 (NKJV)

Nothing. There was nothing. No bright lights, no Godly moment of a shadow figure telling me it wasn't my time and to go back. No running to the light. It was just black. Complete and utter nothingness.

"I didn't think you were going to make it, kid," the cop said when I came to.

So why did I, I thought. In the ambulance, the EMT asked me what happened.

"I think I did too much," I said.

"Too much of what?"

"Heroin."

I grew up in a Lutheran home, but we rarely went to church. Lutheran was what my dad identified with. My mom grew up Catholic, and my father was a recovering alcoholic who had found God when he got sober. I remember going to church only a handful of times in my childhood, and we rarely spoke of God in my house. There was one conversation I remember with my mother when I was maybe eleven or twelve years old. We were in our pool and she was looking

around. "I want you to look around, Becki. Look at the trees and the sky and everything else and tell me that there's no God," she said. I couldn't tell her if there was or wasn't, I had no clue what she was talking about. I wasn't taught about Him, and to this day I don't remember much of a Sunday School experience. We moved away from the church I remember going to and that was that.

You could say I had a normal childhood. We moved around a lot but settled into what I call my childhood home when I was about seven. We were a poor family living in a rich town, and I could tell I was different from my peers. I played by myself a lot; my brother and sister were older than me and did their own thing. I was an outsider. Although I had made a couple of friends, I never felt like I belonged where we were, and if I am being honest with myself, I never felt like I belonged anywhere. These feelings intensified, and by the time I was 13, I was cutting myself when things in my life got hard, or my depression got worse. I felt an enormous sense of relief after I did it—like everything might turn out ok. It was my first love, and my first addiction. It was my best friend. I did it when I was sad, stressed, angry, and worried. During all of this turmoil, it didn't dawn on me that God could help me. It continued until well into high school.

My parents separated after my mother had an affair with a man she met online. She and I moved into an apartment in a different city, and soon after that, she injured her back. She couldn't work anymore, and we lived off of disability. Her doctor prescribed her opiates for the pain, and after that, the pills became the center of everything. I felt like the walls were closing in on me; just getting out of bed was a struggle. My depression had intensified. My father had moved to a different state, and it was just my mom and me for a while. I was cutting constantly; my body covered with red stripes. I struggled with fear, depression, loneliness, and I felt despair. After an unsuccessful suicide attempt when I was 20, I decided to move in with my sister.

Things were looking better for me after that. I found a job, started college, and was going to therapy. I felt more freedom being away from that toxic environment—less worrying about my mom and her pills and more worrying about my own happiness. But the devil was still waiting to attack, and he did the day I decided to take one of my mom's opiates. I had a headache, and my mother thought it would help. My life changed that day. It was just like the cutting; I felt relief from my demons. I felt euphoric. I felt like I could conquer the world, and I had the clarity and energy to do so. It wasn't long until it was an everyday thing, and I would stop at nothing to get them.

I started stealing to support my habit. I stole from my jobs, my family, and my friends. I sold possessions and borrowed until I couldn't borrow anything else. I sold my body for money or drugs. I doctor-shopped, getting prescriptions at emergency rooms, urgent cares, office visits. I even seriously considered breaking my own hand just so I could get the pain meds for it. At this point, I was buying them off the street but still getting them from my mom every chance I got. She knew exactly what I was taking them for and didn't do anything about it. She saw me sick, sweating, and shaking when I didn't have any and said nothing. As long as I could find her some when she was out, she was fine. At this point, my relationship with my mother became centered around drugs. I was no longer able to stay at my sister's house, so I had no choice but to move back in with my mom. I used anything I could get my hands on, from the time I woke up to the time I passed out somewhere. It was only then that I started to think about God, but I was angry. I was angry at Him for letting me get this bad. I was angry at Him for giving me such a horrible life. I prayed for it to stop, for Him to just take me already. Why would he let me live such suffering? I didn't understand, but then again, I didn't understand anything about Him or the Bible. I knew I believed in Him, but I believed He had abandoned me. That was the worst feeling of all.

I had a breakdown in the summer of 2012. One afternoon, I decided I couldn't take it anymore. I couldn't take the physical withdrawals my body went through if I didn't take any drugs. I could no longer stand the emotional withdrawals either. I felt trapped in a cycle I didn't know how to break, and I had no help from anyone around me. I lived in a house with four other addicts. It was as toxic as toxic gets, and I was done. So I grabbed a bottle of Benadryl, a bottle of aspirin, and a bottle of E&J Brandy, and swallowed it all. I walked to a park near my house and called 911, only a moment before slitting my wrists. When the paramedics arrived, I knew they would have to take me somewhere and keep me for at least 72 hours. There, I would tell them that I was an addict and needed help. I did not think I would get help any other way. I felt like it was my only option. It is very difficult for people from a lower income bracket to find any kind of help beyond counseling for addiction in this country. Emergency rooms look at you like you're a degenerate. And while counseling and therapy are great, many, many addicts need inpatient care following a medically supervised detox. At the least, I thought I would find some more resources in a safe inpatient setting, and after three days on the behavioral health floor of my local hospital, I knew exactly what I needed to do.

I moved two hours away to a horse ranch owned by a friend of the family. I thought moving away from all the chaos at my mother's house was the ticket to my sobriety. Of course, I was wrong. I started drinking heavily because I didn't have my pills until, once again, I found some and set sail on that destructive ride. In late 2012, only months after my breakdown and my inpatient stay, I found out I was pregnant and thought, "This is it!! This is what will keep me clean! This child that I have made will be the answer to my problems." I gave birth to a healthy, beautiful baby girl in August of 2013. Two days later, my mom gave me another pill, and I accepted.

The next year or so is kind of a blur of using, going through withdrawals, and being a first-time mom, albeit probably a terrible one. I was living with my daughter's dad, my then-boyfriend, but of course, my drug use got in the way and we split up. Back to my mom's I went. This was around Christmas time, and by summer our pill use had turned to heroin. The first time I did it, my mom bought it for me, and we were in the living room. I remember staring at it, wondering what my life had come to. Where was God? Why was He allowing this to happen? Why didn't He love me? My mom and I snorted it until one day she decided she wanted to inject it. Following suit, I let my mom inject me with heroin until I learned how to do it myself, which wasn't long after. That was all I needed in life. I felt complete. It felt like warmth, and sunshine, and beauty. I finally felt alive, like I belonged somewhere. I chased that high until that fateful day in February of 2016, the day my life changed; the day I overdosed on heroin in front of my two-year-old daughter.

The paramedics worked on me for two and a half minutes. I was legally dead that entire time. I don't remember anything but darkness. Pools and pools of black paint. I was sinking deeper and deeper. They revived me with two shots of Narcan to the heart. I still have the scar. They put me on a stretcher, took me the hospital, and then hauled me to jail. They had found the needle I used, and there was enough left in there to charge me with felony possession of a controlled substance. I was facing 18 months in prison.

Three days later, I was released from jail on a signature bond and a promise to enter a court-ordered monitoring program while I awaited entry to a drug court program. If successful, my felony would go down to a misdemeanor and no jail time would be required. While I was in the hospital, before going to jail, the emergency room nurse told me I was pregnant. So here I was, in drug withdrawals, pregnant, with nowhere to go and no one to turn to. This. This is

what my life had come to. Scared, sick, sad; I had nowhere to go. This is when my life changed.

I got out of jail and knew I had to call my daughter's father, my ex. I had to come clean, especially since this all happened on the day I was supposed to drop my daughter off with him for the weekend. I called him, told him what happened, and we decided I would come stay with him instead of back at my mom's, which sounded like a great idea. And of course, child protective services paid me a visit considering there was a toddler at the scene of an overdose. The state took my daughter away and gave her to her dad while I cleaned myself up. My daughter's dad had been going to church and had been baptized. He played music for their worship team and said it was really life-changing for him. He stopped drinking, stopped smoking pot, and started living his life the way God wanted him to. I rejected it for a while and thought these Jesus freaks were brainwashing him. After all, God would NEVER forgive me for what I had done; what was the point? I remember going to a family Bible study at the same church and meeting his pastor, a woman I've grown to respect and love. I sat down at the table and introduced myself. They asked me how I was doing, and word vomit just poured out of my mouth. I told them everything. I told them about the overdose, the blackness, being pregnant, losing my daughter. Cindy, the pastor, looked overwhelmed, like she didn't know where to start with me. But then she started talking, and I felt relieved for the first time since this nightmare started. She told me that Jesus was my Savior and accepting Him into my heart would ensure that I would never see that darkness again. She asked me if sinking into that darkness scared me, and I wasn't sure if it did. I felt like I was going to Hell, and there wasn't much I could do about it. As reluctant as I was, I accepted Jesus into my heart that night. They gave me a Bible to take home, and Cindy's daughter, Jennifer, wrote one of my favorite scriptures inside the cover: Proverbs 3:5:

> *"Trust in the Lord with all your heart and
> lean not on your own understanding."*

I reread that over and over. It gave me hope because although I had almost zero understanding, I was willing to learn.

I would love to be able to end my story there and tell you all that everything was perfect, and God took away my addictions, and I was free. Unfortunately,

that wasn't the case. I struggle with it still, even with understanding all this stuff. I didn't understand praying, talking to something or someone who was not there. I made terrible choices without thought of God or Jesus. Nevertheless, in the spring of 2016, I was baptized at my church by Cindy and her husband, Donny. I leaned not on my own understanding but took comfort in the fact that God was watching over me, and He had my back. I prayed even when I didn't want to. I got up and went to Church when all I wanted to do was lie in bed and cry. I even brought my mom. I started to understand it more clearly and Cindy helped me tremendously. I was slowly turning into a real child of God, which is an amazing thing, especially since I was about to need Him more than ever.

Because I was still struggling with my addiction, and constantly relapsing and screwing up, the court program I was in decided a 90-day rehab would be in my best interest. I went, but unfortunately, after three weeks, I decided to leave. I missed my kids (I had my daughter and had since given birth to my son back at this point) and I wanted to be home with my family. I wasn't acting on carefully planned-out thoughts at the time, instead, it was pure emotion. The judge wasn't a fan of my actions and I was sent to jail for two weeks. I was facing dismissal from drug court, and there was a good chance I was going to be sent to prison for that initial 18-month sentence. This was when I needed God the most! At this point I didn't care if I understood it; I didn't care how silly I sounded to myself. I prayed, and I prayed HARD. I prayed every day, all day. I prayed when I woke up in my cell until they shut the lights out at night. Eventually, my prayers were answered. I got out of jail, and the courts decided to give me one more chance. So I took it. I went back to church, did what I was supposed to do, and followed the rules. Luckily for me, drug court required me to attend self-help groups during my sentence, so I chose a 12-step group. It was extremely faith-based, and it helped me with some of the things I struggled with. One of those things was how God saw me in his eyes. The Bible tells us that God loves us all, but I thought I was too far gone for a long time. How could He love little old me, especially with all the terrible things I've done? Acts 10:43 says, "All the prophets testify about Him, that everyone who believes in Him receives forgiveness of sins through His name." That was all I had to do to receive His forgiveness—believe! I had already done that! I slowly started to realize that I was a woman of God. I decided I wanted to live my life the way He wanted me to. My boyfriend at the time and father of my children (by this time I was pregnant with number three), who had stood by me through all of my

struggles, and I decided it was time to get married. We no longer wanted to live in sin. We wanted to bring glory to God in doing this, so in October of 2017, I married my best friend, a great man of God. I had started service work in my program and in the church. Cindy always tells me to keep my eyes on Jesus, and at that point, I can honestly say I was.

In March of 2018, my third and last (maybe?) child was born. By this time, I was settled firmly into my stay-at-home mom position, and even though I am prematurely grey and I'm not sure what this stain is on my shirt, I have never felt more suited for a position in my life. God absolutely put me on this earth to be a mother. Unfortunately, I don't have my mother to turn to as she lost her battle with her own addiction in July of 2018. It was extremely hard, but throughout her struggles, my mother was still a believer, and I take great comfort in knowing she is upstairs hanging out with Jesus, and that someday I will see her again. My mom had her demons, but she wasn't a bad person. She was actually my best friend for a while. We were so close, sometimes it was hard to see the harm we were doing to each other and how toxic our relationship had become. Being around my mother and hanging out with her was one of my greatest triggers. I so wish, as much as I hated my life in active addiction, that sometimes it could be like it used to be—hanging out with my mom, laughing, talking, and taking walks. Everyone was always trying to keep me from her, and it made me mad until I finally understood. However, I know the next time we see each other there will be no sadness, no pain, and I can't wait.

I have always considered myself a no-good junkie. I have never felt worthy of anything. I was raised in a family of addicts and alcoholics, and I always thought it would be my destiny to go down the same path. I honestly didn't even fight it in the early days, I just kind of let it happen. When I overdosed, I was genuinely upset when they revived me. I wasn't living, I was barely surviving, giving every last ounce of pretend happiness to my daughter. But when I accepted Jesus, something changed. Slowly, yes, but it did. I was finally somebody. I was a child of God. I was a Christian. I believe that when I die, I will go to Heaven to spend eternity. That is my gift for living for Him, and anyone who says yes to Him receives the same. How amazing is that?!

When I wake up now, the first thing I do is pray and thank God for giving me another 24 hours clean and sober. My life is so different now. I meditate-*ish*. (When I can stay awake! It's extremely hard for me not to fall asleep, because, well, kids.) I am present in my children's lives. I run a household now, where-

as before all I was running was my mouth. I attend my meetings, because if I don't, I become restless, irritable, and discontent and my husband starts giving me that look. Coupling my faith with my program is the real reason I am still clean today. Jesus put AA in my life for a reason, and I will never leave it. I call my sponsor or my pastor if I have a trigger or a problem, or if I just need to vent. I tell God what I am grateful for before I go to bed at night, thank Him for another day, and the next morning I do it all over again.

Today I get to be a wife, a mother, a sister, a best friend, a soulmate. I get to do those things because God gave me another chance at life. (Okay, and another and another, but who's counting?) Most of all, and this *is* the most important, I get to be a child of the MOST HIGH, and that is more sacred than anything!

Cheryl (Cherie) Matthews

Discovering "the formula" fueled Cherie Matthews' passion for helping women find hope in the Word of God. She is a wife, mother, grandmother, and owner of three businesses. As a John Maxwell Team Executive Director, she coaches and trains individuals and companies to reach their full potential. Her favorite topics are: Knowing Your DISC identity to Communicate Effectively, and Integrating Faith and Work Through Values-Based Leadership. Cherie provides schools with STEM and engineering equipment to encourage students to pursue technical careers. The Jersey Shore is home; hobbies include reading and puzzles on the porch, tennis, and playing with grandchildren. Learn more at www.cherylmatthews.com and www.tech-edsystems.com.

Chapter Two

Three Problems, Three People, Three Promises

by Cheryl Matthews

Have you ever asked, "When am I going to be enough?"

I have more times than I can count. I have learned the bad news is, 'I am not enough.' And, the good news is, 'I am not enough.' How can this be?

I had to work through this dilemma to fully understand and embrace my identity in Christ. As I reflected on my journey, God showed me that I had three problems:

> 1) a sin problem
>
> 2) a thought problem
>
> 3) a relationship problem

My mentor and friend, John C. Maxwell, says, "Every miracle in the Bible begins with a problem. So, if you have a problem, you are a candidate for a miracle. Small problems, small miracles. Big problems, big miracles."

God introduced me to three of His earthly saints to draw me deeper into His Word to discover the promises I have in Him: Terri, Dale, and a security

guard. When I finally understood that I am not enough alone, yet I am enough in Him, I discovered incredible freedom. Woven into my story is also the journey from head knowledge of who Jesus is to a heart of love for Him and His people because of what He did for all people.

I was invited to share my testimony at a women's conference at church. At first, I thought I didn't have a story because I didn't have a major life event or traumatic experience that jolted my growth. I would later find that many women have had a similar journey to Jesus. The conference theme was Rags to Riches: Real Life, Real Stories, Real God. The organizer encouraged the speakers to *get real*. Take off the mask we wear that everything is great, and share our deepest, innermost secrets. In this journey, God unraveled and revealed my story.

From the time I was a young child, I felt Jesus calling me to Him. Like some of you, I was blessed to grow up with parents and grandparents of faith in a wonderful church family. I went to Sunday School on Sundays, participated in the children's and handbell choirs, went to Youth Group during the week, and recited memorized prayers at mealtime and before bed. But other than that, there was very little mention of Jesus as we went about our daily lives. I knew the Bible stories and I knew about Jesus, but somehow this faith had to become my own.

I would describe my Christian journey as The Law of Gradual Growth. Once again, my friend John C. Maxwell describes a similar journey, The Law of Process, in his book *The 21 Irrefutable Laws of Leadership*. "Leadership develops daily, not in a day." This has been my experience in my walk with Jesus. My growth in becoming more like Jesus has been a gradual process—sometimes *very* gradual. Okay, sometimes even taking steps backward. Seeking to know and become like Jesus has been a focus of my adult life for the past 25 years, and I am humbled to share my journey with you.

My Sin Problem

I was volunteering at church and leading a group of parents raising children to know Jesus. But, as my faith grew, I became plagued with feelings of inadequacy and condemnation. I was consumed with thoughts I was too embarrassed to share because on the outside, I looked like I had it all together. The harsh reality that *my sins* put Christ on the cross to suffer a brutal death almost

crushed me. I was heartbroken and devastated and not enough.

I was not enough because of my past sins, and Satan wouldn't let me forget it. I grew up in a traditional Protestant denomination that didn't talk about Satan's influence in the world today, so these thoughts of condemnation felt like my own. Satan kept reminding me of past sins and shortcomings, even things going back to my early childhood. I had no human role model showing me how to "resist the devil" as James commands, so I allowed those thoughts to wear me down. How ridiculous is it that, as an adult, I would even entertain thoughts of guilt and shame over something I did when I was five years old?!

Because of my sin-focus and self-focus, I was missing the beauty of what Jesus did for me. Like a two-year-old, I was upset I couldn't earn my way to heaven "all by myself." Condemnation and pride kept me in bondage. If I could choose, I would be perfect. My prideful spirit was very, very sad that my behavior, works, and good deeds were not enough to save myself, and it kept me in the bondage of not enough.

So, I had a plan to make up for my not-so-perfect-past.

- I was going to read the Bible every day and pray without ceasing.
- I was going to follow all the commandments and "Christian rules."
- I made rules for our children to protect them from making the same mistakes I made (and to spare them from the sadness I felt).
- I gave up drinking because I partied too much in college.
- I became a faithful donor to Campus Crusade for Christ ministry on my college campus, so students might not sin like I did.
- I was going to attend church faithfully and volunteer for everything.
- I was going to be a perfect Christian.

Great plan, right? I am so glad that God had a better idea. His plan had

already been carried out, but to show me, He introduced me to one of His healing ministers.

Meet Terri, Earthly Saint #1

My sister-in-law's friend, Terri, a woman of deep faith, prepared a delicious dinner for us at her home. The after-dinner conversation moved to a deeper level, and Terri asked me about my faith journey. I told her the things I was doing to be the perfect Christian.

Her response was, "Wow! That sounds exhausting."

After a long pause, she said, "Ya know, you don't have to do any of those things."

"What do you mean?" I asked.

She explained, "When Jesus died on the cross, it was a free gift of His love and grace. No matter what you do or how perfect you are, you can't earn it. Jesus did it all. It is finished."

She further explained how it would be double jeopardy or double payment if God required us to pay again the price that Jesus already paid. This was new to me. Terri spoke about God's love and grace to my not-enough heart.

For by grace you have been saved through faith; and that not
of yourselves, it is the gift of God; not as a result of works,
so that no one may boast.
—EPHESIANS 2:8-9

His Promise – Your Sins Are Forgiven

This was good news. I could rest in Jesus instead of in my works. But I had to understand what the Father said about sin. I found my "Ah-ha!" moment in John 1:29.

"The next day [John the Baptist] saw Jesus coming
to him and said, 'Behold, the Lamb of God
who takes away the sin of the world!'

When someone *takes* something from me, I no longer have it. When I confess my sins, *He takes them*, He took them to the cross. They are not *my* sins anymore because He took them. He took them.

> When you were stuck in your old sin-dead life, you were inca-
> pable of responding to God. God brought you alive—right along
> with Christ! Think of it! All sins forgiven, the slate wiped clean,
> that old arrest warrant canceled and nailed to Christ's cross.

—COLOSSIANS 2:13-14

With the knowledge that He took my sins, I now had a strategy for those condemning thoughts. I don't entertain them even for a second. When guilt, shame, or condemnation come my way, I merely say, "He took my sins. I don't have them anymore."

Through continual confession reminding myself that He took my sins, I was able to break free from the bondage of sin. Jesus tells His bride, the church (you and me), in Song of Solomon 4:7...

You are all fair, My love, there is no spot in you.

Our Associate Pastor says that when God looks at us, He sees His Son. Likewise, we are to see the potential and the good in people. Previously, all I could see was my spots, but if this is how God sees me, then this is how I need to see myself: blameless and spotless. As I released my sins, I began to see others as free from their sins, too, and my heart softened.

My Thought Problem

I still had a thought problem. I have a wonderful husband, and God bless-ed us with two beautiful daughters. We were raising them in the same com-munity and same church where I grew up, surrounded by friends and family. However, while I was working in the corporate world, I felt like I wasn't good enough in any area of my life.

I was not enough as a mom because I worked outside the home and I wasn't there right after school to hear about their day or kiss every bump and bruise

and heartache. I didn't always remember to dress the girls in sneakers on gym day or put the right things in their backpacks.

I was not enough as a wife because many evenings I got home too late to prepare a good dinner like my mom and mother-in-law did, and many nights I fell asleep while putting the kids to bed instead of spending time with my husband.

I was not enough as an employee, like my male counterparts, who only worked while their wives took care of the rest. I was preoccupied with school assignments, playdates, laundry, and errands, sometimes trying to squeeze them in during the workday. I had schedule limitations due to caregiver's availability, sick children, family commitments, and school events.

I had a good reputation for getting things done in a timely fashion at work. My girls and my husband never complained. No one ever told me I had to do these things. The "not-enough thoughts" were all in my head, and they prevented me from living a joyful life and experiencing God's love for me.

I hid my feelings and was even in self-denial. Friends and family never knew because I wore the mask. I did it all. I was class mom, I organized playdates. I got dinner on the table (most nights). I was a Bible study leader at church, I was an elder, I belonged to a book club, I organized a Bunco Group with my friends. I organized countless church events.

Not-enough thoughts even drove me to make a major career change. I thought the new work-life balance would be the ticket to my happiness. Unfortunately, the feelings of not-enough came with me. I embraced a more relaxed schedule, but I struggled to learn new products and to meet new customers in an industry I didn't understand. I was still not-enough. This was more than fifteen years ago, but recently during the coaching process, I became aware that not-enough thoughts were still holding me back.

Meet the Security Guard, Earthly Saint #2

It was a typical day. I wanted to do one more thing before I left the house, so I didn't allow extra time for the inevitable traffic. I arrived a few minutes late for a meeting at Orange High School, and greeted the security guard who opened the door with the typical "Hi, how are you?" She responded, "I am

blessed and highly favored." I smiled and rushed ahead to my appointment. As her response registered, I wanted to run back and say, "Me too, me too!"

As those thoughts sunk into my spirit, I asked myself, "If this is true, why don't I think and carry myself as if I believe it?" It was a life-changing moment. It changed the way I think about myself and others.

I began speaking this blessing over our children, grandchildren, and co-workers. I say it out loud to myself before customer meetings. While I work, my computer background reminds me:

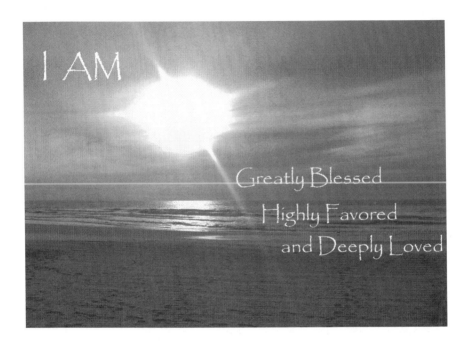

This is one of my favorite stories of God at work through ordinary people. I have told this story many times, including at the Rags to Riches Conference. Two weeks after the conference, I was having tea and discussing the next event with the organizer when the owner of the coffee shop spoke to us. As she described the impact the conference had on her, she shared how she tells her teen children every day that they are "greatly blessed and highly favored." Hearing this made my heart sing. God blessed me by showing me the impact of these

words. I long to see the security guard again to share how God is spreading her simple greeting. I believe God is at work, and He will connect our paths someday.

God's Promise – Thoughts and Words have Creative Power

As the security guard's words took life in my heart, so did other powerful thoughts—especially the power of the words of God. I purchased some books about praying the scriptures and started following ministers who teach about the power of words and thoughts. The power of God's promises is throughout the Bible, and they are available to all believers. I began to confess them out loud and claim them as promises for me. There are promises in the Bible linked to our thoughts and the words we speak.

Matthew 4 shows us how Jesus responded to Satan's temptations. Three times Jesus responded: "On the other hand, it is written…" and he quoted a Scripture, citing God's truth. If this is how Jesus responded to attacks from Satan, then it must be a model for how I am to respond. In Philippians 4, Paul instructs us on how to think:

> *Dwell on whatever is true, honorable, right, pure, lovely,*
> *of good repute, excellent and anything worthy of praise.*

My not-enough thoughts weren't any of these.

In the Values-Based Leadership curriculum that I use with my sales team at our weekly Round Tables, we say, "Thoughts become Actions, Actions become Habits, Habits form our Character, and our Character determines our Destiny."

I began to understand how my thoughts and the words I speak are intimately connected. I need to think correctly and choose my spoken words carefully. Another "Ah-ha!" moment came when I was listening to a teaching about how God created the earth.

God created the heavens and the earth with His spoken word. In Genesis 1, it is written nine times: "Then God said …" God's words have creative power. Since we are made in the image of God, our words have the power to create or destroy. To change our lives and circumstances, we need to change our thoughts and words. The more we think about our problems, the more

problems we have. When we think about the promises of God, we see those promises fulfilled in our lives.

> *Words satisfy the mind as much as fruit does the stomach;*
> *good talk is as gratifying as a good harvest.*
> *Words kill, words give life;*
> *they're either poison or fruit—you choose.*
>
> —Proverbs 18:20-21, The Message

How do I want to use my words? Ephesians 4:29 tells us to build others up. I want to be an encourager. And that includes encouraging myself with positive thoughts and words.

My Problem Relationship

I am an engineer and I love formulas. I would love to have a formula for every area of my life. I long for someone to show or tell me, "If you do XYZ, then_____." (Fill in the blank with *you'll be happy*, *have a great marriage*, *raise great kids*, *have financial abundance*, *be successful at work*).

If there was a formula for success in all areas of life, I would follow it perfectly. Or would I? I think about how well the Israelites followed the Ten Commandments and wonder if I would do any better following a precise formula. My longing for this formula was distancing me from God rather than drawing me closer.

During a time when I felt unmotivated at work, I found myself playing solitaire, hearts, and mahjong on the computer. I told myself I was just taking a "short break" and hours later find myself still playing. One day while playing computer games, God spoke this question to my heart, *What is My will for you?* I thought about it and knew it was to love God and love others. When God wants to get my attention, He puts a verse in my path in various ways three times. He had done that the past week with Matthew 22:37-39.

> *And Jesus said to him, 'You shall love the Lord your God with*
> *all your heart, and with all your soul, and with all your mind.'*
> *This is the great and foremost commandment. The second is like*
> *it, 'You shall love your neighbor as yourself.'*

Was playing computer games fulfilling either of these commandments? I knew the answer was a resounding, "No!"

I prayed that He would take away my desire to play computer games, and miraculously He did. I deleted all electronic games from my computer and phone. When the occasional temptation arose, I either turned to scripture or called a loved one to break the grip it had on me. This was a good first step, but it didn't fully take me to the relationship that I needed.

Meet Dale, Earthly Saint #3

We experienced a family crisis, and my daughter and I were introduced to Dale, a pastor, and Christian counselor. During our session, he said, "You have to know who you are in Christ, so when challenges and negative thoughts come, you will know who you are not."

I am a geek at heart, and I love studying and learning. "Oh, good," I thought, "an assignment." Even though books have been written on this topic, the exercise of discovering who I am in Christ was meant especially for me because of how God created me. It was part of the transforming journey God planned to move me from head knowledge of Him to a heart of love. My mission became to know who I am in Christ. I came home and spent hours and hours with my Bible searching for answers and asking God, "Who are You?" and "Who do you say I am?"

I came up with nineteen pages of words and scriptures to support who I am in Christ. My head was full of knowledge, but it had not yet sunk into my heart. The not-enough thoughts were still ruling my mind.

His Promises – Right Relationship!

The first promise I embraced was "I am the righteousness of Christ." It was easy to say, but what does it mean? Does it mean that I always do the right things? No, that would be self-righteousness. Jesus's righteousness was a free gift given to me at the cross to bring me into right relationship with the Father.

I have spent my life looking for the "God Formula" to success. In this ever-changing world, God didn't give us a formula. He gave us a person. He gave us Jesus Christ who says, "Follow Me. Abide in Me. Walk with Me. Think like Me. Pray like Me. Love like Me. Become like Me." When we abide in Christ, He

gives us the formula we need on our journey to be like Him. The formula is a day-by-day, minute-by-minute relationship with the Most High God given to us by the blood of Jesus.

I dug even deeper into scripture and the power of God's Word. My growth accelerated when I began to daily apply Matthew 6:31-33.

> *Seek first the kingdom of God and all these*
> *things shall be added to you.*

The key to a relationship with God is to be the *seeker*. I am fully convinced He only gives us one step of the journey at a time, so we continually seek Him.

God's Word has become the first place I go to find the truth. I replaced my limited and unworthy thoughts with the Word of God. I wish I could tell you this settled it, and that I was forever victorious in this area, but that's not how a relationship works. Our bodies need to be continually nourished with food, water, and rest, and our spirits need to be continually refreshed with the word of God. We have what the word of God says we have, we can do what the word of God says we can do, and we are who the word of God says we are. The word of God is living, which means that it can speak new revelations depending on our needs and circumstances when we read it. I can see in my journal that from the same verse I have different insights depending on my needs that day.

As women, as humans for that matter, we all have insecurities. I have grown to realize these insecurities are not meant to defeat me; they are to draw me closer to Christ.

The Great Exchange – I Am Enough in Him

Those not-enough thoughts returned from time to time and kept me up at night. This time *Jesus* had enough.

God spoke into my spirit and said,

Every time you believe that you are not enough, you discount what I did on the cross for you. You are not enough, but I am enough for you.

I scrambled to find a pen and paper to write down, "You are not enough, but I am enough for you." **This is the good news about being not-enough.**

I put this together with all the things He has been speaking to me and let the riches of this moment sink into my heart. By not receiving his forgiveness and act of love, I was not truly receiving Him. I was still trying to do it "by myself."

The cross is the place of the Great Exchange.

Jesus took my sins.	I don't have them anymore.
Jesus doesn't remember my sins.	Neither should I.
Jesus paid the price.	I don't have to strive to earn His love and grace.
Jesus did for me what I could not do for myself.	He took my sins and freely gave me His righteousness and God's riches.
It is a story of love, not condemnation and shame.	I am eternally grateful, deeply loved, and secure in Christ.

Thousands of years before He created me in my mother's womb, He perfected me on the cross. He made me in His image. He made me good enough to come to Earth to show me how to live, and He made me enough to die for. He made me enough to be forgiven, to be healed, to be provided for, to do the works that he prepared for me here on Earth, to have my prayers answered, to be with Him in Eternity, and to be loved! He gave me His righteousness so that I am enough to be in a relationship with the Father, every minute of every day. I believe it. I receive it, Lord! I receive all of it. Thank you, Lord, for making me enough!

In this journey to my identity, I needed to move away from self and toward Jesus. The answer was finding peace in being not-enough, and letting Jesus be enough for me. I had to let go of my pride, perfectionism, self-condemnation, self-sufficiency, and receive and embrace what Jesus did for me. When I finally did, I became free and love was able to bloom and grow in my heart. Not only love for my family members, but love for all of God's people, even those who are still hurting, and those who have not yet come to know the risen Savior.

When am I going to be Enough?

When I realize that I am not-enough,

 But that Jesus is enough for me.

 Because Jesus is enough, only He can make me enough.

 And because He makes me enough,

 He also makes each person that I meet enough.

 Enough for my personal attention,
 for my grace, for my time,

 for my kindness, for my help,
 for my sharing of what

 Jesus has done for me.

Thank you for coming on this journey with me. The question for you is, "Will you allow Jesus to be enough for you?"

AUTHOR BIO
VICTORIA REINKE

Vicki Reinke is a firm believer in the life-changing power of Christ. She shepherds others to Jesus for a better life in Him! Vicki loves the outdoors and her animals. She is a Washington County Master Gardener and a lifelong learner of Natural Health, especially through Essential Oils and nutrition. Vicki is a mother of nine with three grand babies and more on the way. She and her husband Todd own both auto body and auto repair shops in Richfield, WI. After more than 30 years in business, she can diagnose your car almost as well as Todd can! Connect with her at vickireinke11@yahoo.com.

Finding Me

by Victoria Reinke

"Are you afraid of anything?" he asked me.

"Uh… NO!" I said with a little more emphasis on the "no" than needed, as I climbed up onto the load of straw we were taking to our former church for the gardens there. I was rather taken aback by that comment because I didn't really know him. He was the husband of a friend of mine, but I hadn't really interacted with him until now.

Later on, I reflected upon that statement. I remember being afraid of the dark. I still am a little bit, but not like I was then. Darkness tormented me. I had to talk myself through dark places or turn on lights. I was afraid of being alone. I was afraid of offending people. I was afraid people would see me: the *real* me.

I was afraid of being the good kid.
I was afraid of being the *bad* kid.
I was afraid of being a good mom.
I was afraid of being a *bad* mom.
I was afraid of being a good wife.
I was afraid of being a *bad* wife.
I was afraid of being successful.
I was afraid of *not* being successful.

What exactly WAS I supposed to be? What exactly AM I supposed to be?

I was so confused. I wanted to be loved but was afraid to love. I wanted

to be pretty but feared I was ugly. I wanted to be one thing but was another. I wanted to be a boy but was a girl.

I became quite a conundrum.

I still battle fear and confusion sometimes. I am a woman who appears strong on the surface, but who, underneath, struggles in so many ways. I'm fearful of lots of things. Fearful of being found out, always. How does one operate in all these fears and realities and yet, become who God has called her to be?

One doesn't.

The enemy caused so much confusion in my mind that I simply could not. I wanted one thing but lived another. I wanted to be strong, but I felt so very weak. I doubted everything. My mind became a battleground. What I believed is not how I behaved. Double mindedness ruled my life and every thought became a battle for right and wrong. Shame and fear are awful companions. They mess up your thinking in so many ways. They keep you in a place full of doubt and sabotage, stealing your best life away from you. They destroy your confidence and ability to succeed in any area of your life. Sure, you might win little victories that encourage you to keep going, but then other opportunities are stolen or sabotaged in some way. Some people cave to hopelessness and finally give up. Others give in to addictions and destructive behaviors.

I did neither of these. I turned to God and now know that I am His beloved child. That I cannot fail. But it wasn't always that way.

I was the firstborn child. My parents married when Mom was a few months pregnant with me. I screamed and cried for all of my first six months. My dad was the only one who could comfort me. I had curly, ringlet-type curls that my aunt would play with. I was the first grandchild on my dad's side. I spent my every waking moment waiting for my dad to come home from work so I could follow him around everywhere.

We spent a lot of time with my aunts and uncles on their farms, and I tagged along with my older boy cousins trying to do what they did. I didn't like the big cows they fed and milked. But I did like playing in the oat bins or climbing in the hay mows.

When my next cousin came along, and then my sister, we three became inseparable. When all of us cousins were together, we were one big pack of kids who ran around and did everything together, from catching tadpoles to playing

baseball. We all have great memories of our adventures. We were fearless, to be honest. It seemed that as long as we were all together, we could do anything.

Over the years, I began to identify with my boy cousins and my dad more than the girls in my life. I loved to play sports—baseball especially. I loved to follow my dad around, work on the yard, and fix broken things. I didn't like messing around with my hair and make-up or trying on clothes and wearing dresses. I thought it was dumb. I mean, I played around with it sometimes, but I would much rather be outside playing baseball or doing whatever my dad was doing. I wore boyish clothing and kept my hair cut short, partially because my hair was so curly and it was a pain to keep it neat and not completely tangled. It was just easier.

I began to want to be a boy, identifying more with the boys than girls most of the time. I played kickball at recess and was pretty mad when we got older and the boys were allowed to go play in the dirt lot across the street from our school at recess. Girls had to stay on the concrete playground. During those years, we also moved and switched schools several times. I was awkward. I couldn't find a place to fit in because I wanted to hang with the boys, but they didn't want me. I also wasn't afraid to fight them, which they didn't appreciate. I think the boys were relieved when I had to stay on the concrete playground with the other sixth grade girls at that school! I did learn to do cheer moves, though. I tried out for cheerleading, but of course, didn't make the team. I ran track and that was fun. I liked running and throwing stuff, so it was perfect!

But also, somewhere along the line, there were some incidents with bigger boys that scared me quite a bit. One time, when I was about seven or so, some big boys grabbed me, held me down, and were going to do something to me. I wet my pants because I was so scared. They let me go then. Another time, one of the same big boys tried to hide in my hiding place with me while we were playing a game. I screamed and ran away to my parents. I am not sure if they knew why I went running to them.

Shame had been my identity for a very long time. Shame caused me to believe that I was not good enough, that I was not beautiful or even a little pretty. Shame incited more fear that people would only see the ugly me. Unfortunately, that caused the ugly me to be shown very clearly. I made people see me as ugly then, like a self-fulfilling prophecy. I swore more than anyone else. I hid behind socially awkward behaviors. I would not speak in front of a group. Ever. (At least not in positive ways.)

I might tell a dirty joke or tell a story that demeaned another. I purposely made sure I was the worst child in the group. I purposely did things that showed just how ugly I could be. Even as an adult, I remained nervous in most social situations. What if they saw me for who I really was? I couldn't let that happen, so eventually fear completely took over, and that fear and shame together caused a lot of confusion.

Once I hit my teen years and moved to a new school, I recognized it was fear that caused me to make bad choices in order to keep the friends I had made. The reality is that I didn't have to make those choices. I could have kept my friends, but I felt I had to be the most rebellious in order for them to like me.

I certainly didn't want to be a wife and never thought I would marry. I loved kids and wanted to be a mother, but I was too busy playing boy games to play at being a wife and mother. I wanted to be like my grandmother and have lots of kids but also dreamed of being a race car driver or a truck driver like my Dad. More confusion!

My mom and dad loved me, though. They let me do what I wanted because they both knew that I was a girl. I knew I was a girl. Physically, I am a girl. There is no questioning that. But I think that if I had been told I could choose which sex I wanted to be, based on what I wanted at that moment, I likely would have seriously considered being a boy. I wanted to be unafraid. I wanted to be strong. I wanted to be bold.

Funny thing is, that I can be either a boy or a girl and still have those feelings and deal with those things.

Never mind that my mom was most definitely not a fearful woman. Somewhere along the line, I got that mixed up. What I believed was proven wrong over and over again, and yet, I was stuck in a cycle that destroyed my identity. I am a woman from a long line of strong women!

All this confusion caused me to make decisions based on wrong thinking. I was not confident in who I was in order to be who I needed to be. I was a girl who wanted to be someone she simply was not. I was trapped in an unhealthy pattern of behavior, paralyzed in a pattern of continually making poor decisions.

The Father's love is so beautiful. He loves us even when we have done nothing to deserve it. He has a plan and a purpose for each one of us. He has created us perfectly in His image.

I lived my life in such a way that caused me pain, and the people around me even more pain. I didn't care if I lived or died. In fact, at least once, I should have died. Several times I drove my car so recklessly that I should have been in a bad accident. I made many choices that put me directly in harm's way.

I was so confused, and I didn't want to deal with it anymore. I didn't want to be a boy *or* a girl. I just wanted to be left alone, but I also wanted to be liked. I guess you could say I was looking for love, as so many people do. I didn't have an identity, so I tried to fit in using whatever identity worked for that situation or time. I could be a hard ass. I could swear and bully and be just plain mean. I rocked that role for a long time. I could play the fool and be funny. I could take a dare no matter what it was or how stupid it might be. I could drink more than anyone else, too. I could take whatever drugs were offered to me. (I never bought my own.) I could tear people down.

But then ... the consequences of my actions caused me to rethink some things. I became pregnant, and that little boy changed my life for the better. His name, Samuel, means "God has heard." God has heard my cries and the prayers of my mother who was, I am sure, quite done with my behaviors. Her long nights praying for her daughter to come home safely took a toll.

I then took on the identity of a mother. But it still wasn't my true identity: my *own* identity. I played the role of a mother for a long time. Not very well, at times, but I played the role.

Then I met this guy. He had gorgeous blue eyes. He had a good job. He was nice and liked spending time with my son and me. We moved in together. Soon I found out he had an anger problem. I was scared because his anger was worse than my own. I wanted to leave. What if he got mad about me leaving? Then I would be alone again. I was afraid to be alone. I was afraid to stay and afraid to leave. I was afraid to be the single mom. I was afraid I wouldn't be able to support my child. I was defiant of my parents. I would show them I could handle life.

Lots of things happened during this time. My parents—my support system—moved four hours away. My grandmother passed away. I had an infant to care for. I made a lot of bad decisions during this stressful time in my life. A LOT. And I was bold enough to continue to think that I could do it myself. Instead of listening to my support people, I made snap decisions just to make a decision. It was not a good season for me.

I upset a lot of people around me.
I lost my family.
I lost my friends.

I still didn't know who I really was. I struggled with self-image and still believed I was ugly and not worth anything. I was "damaged goods." I felt stupid and like I couldn't do anything on my own. I had to keep up an act or people wouldn't like me. Turns out, all that acting was actually what caused them to not like me. All the stress of this time period and keeping up a front came crashing down. I focused my "front" on the man I was going to marry. I thought things would be better if I married him.

They weren't.

For the most part, things went pretty well. We each had our anger and control issues, but as long as we both walked on eggshells, life was good! There were times when anger got the best of us, but we managed. We fell into a routine. He worked. I took care of the kids. We had four more children during those years. I began to homeschool. He worked hard to support us. But I couldn't take it anymore. I was tired of being stuck in a marriage that was hard. I was tired of being the good wife. I was tired of the eggshells.

I began to read a devotional called *Simple Abundance*. It focused on finding your "inner divine." I called out to God through that book. I knew my inner divine came from God, not me alone, so I focused on that. I was brought up with God and learned about Him through time in Catholic church and school. My grandparents were very good Catholics, and I had spent plenty of time going to church and praying the rosary with them. I had also been going to a Lutheran church and was in charge of the Sunday School program there. I truly believed there was a God. I just didn't know that He could meet me where I was, or that there was more to Him than I had learned about. Boy, was I in for a shock!

I was pregnant again with my sixth child and finally had enough. I wasn't going to live like that any longer. I was tired of being stuck. I felt alone and beaten down. I didn't feel loved. I felt like a slave woman. I was no more than the mistress to my husband's career. I was a bother. He tried to be a good husband, in his own way. But he had other things on his mind.

Then I met God.

I thought I knew God. I knew that the Bible was true. I knew a lot about Him. But then, I MET Him. Don't get me wrong, it took a long time for me to

find out who I was to Him, but once I met Him for myself, I realized that I really didn't know much after all. I still struggle sometimes. Who doesn't, I guess?

I picked up a book at a rummage sale—a teen Christian novel. I didn't know it at the time, but that book, along with some conversations with a friend, would be life-changing. I finished reading the book, knelt by my bed, and prayed a prayer from the book, something like this:

"God, I can't do this anymore. I'm tired. I am choosing to trust you with my life. I believe you died and rose again for me. I am crying out to you. Either heal my marriage or I am out of here."

Later that month, I again prayed the "official prayer" with my friend at the time. Fast forward…we are still married, and we still struggle in our marriage sometimes. But God has healed me. He led me to a church that became my healing place. I met some amazing people. They loved me and prayed me into healing. They taught me about Jesus' healing power and guided me, with Him and the Holy Spirit, into wholeness.

Through that journey, God showed me that I am His child. I am a princess in His Kingdom. I am His beloved daughter. Once I was able to grasp that, even just a little bit, it began to heal me. It began to restore me. The confusion began to dissipate, and I was able to think clearly. I began to see myself as God saw me.

At the beginning of my walk with God, I saw myself as a woman in a cave. This was a vision in my head that God showed me. In the middle of this cave sat a boulder that I walked around. I was skinny and weak. I had stringy hair and huge glasses. I knew that I was trapped in this place in my mind. I realized that I walked around and around this boulder creating a rut and getting nowhere. My patterns of thinking kept me walking in circles. I was literally stuck in a rut.

Later on, as God worked in me, He began to show me how I looked to Him. I wore a beautiful blue, Medieval style dress made of velvet. I had long, beautiful hair and no glasses. I had a sword and stood strong and fearless. I stood at the top of a hill with the wind blowing through my hair. No cave and no huge boulder.

During this time, God sent some amazing women into my life. All of them are beautiful and I began to learn from them. It opened my eyes to the other amazing women in my life who had been there all along, but I hadn't seen them for who they were. I couldn't see them for who they were when I was stuck in

that rut. These women had been through a lot, but it didn't take them down. They were courageous and strong, beautiful and loving.

Several had large families. They led their families with a strong hand and yet accomplished so many other things. One had an addicted husband. Another had a husband who also worked long hours like mine did. Some of them had kids who were struggling. All of them had their own battles and triumphs, as I did.

One friend did amazing remodeling work. Another worked alongside her husband through a home addition project. Several others were gifted at leading and encouraging other women in the ways of God. So many of these women spent time and energy pouring their love into me to help me heal and find the person God created me to be. All of them taught me that I could be that person. I could be more than a mother. They showed me that marriage is a partnership. A husband and wife should work with each other, not against each other. Wives aren't under husbands.

Even the woman whose husband was an addict was strong and courageous throughout her battle. She did not conform to what others told her she needed to do because of their own misdirected thought patterns. She listened to what God told her and she forged her own path with Him. I shudder to think of where she would be if she had followed their advice.

Then I began to look at strong women in my own family: those women I had looked up to my whole life. I saw the truth in their eyes. I saw just how strong, beautiful, and amazing they really were. My mom wrote a book about her life during this time. I was shocked at how much happened to her that I had no idea about. She never let on to any of it. She is truly the strongest, most amazing woman I know. I began to realize that being a woman is a good thing. I slowly began to realize that God created me to be ME.

And I am beautiful.

Being a woman IS being strong and courageous—as the Lord had been trying to tell me for years. God pointed me to Joshua 1 several times, highlighting how many times He told Joshua, "Be strong and courageous." I knew those words were there for me, even though in the book He was speaking to Joshua. That is the beauty of the Word of God.

Being a woman includes embracing how God created me to be!

As God began to heal my heart and show me who I really was, I found it was okay to be all those things. I don't have to play a role. I don't have to be this type or that type.

I can be the God type ... The type of woman God called me to be:
One who likes to dig in the dirt.
One who likes to dig in the garden.
One who likes yard work—especially if I get to drive my tractor!
One who likes to get all the laundry done in one day.
One who likes to have at least one job completely finished!
One who likes a clean kitchen.
One who likes to feed her family healthy meals.
One who likes to raise the food we eat.
One who likes to make BIG fires in the fire pit.
One who likes to race cars.
One who likes to drive cool cars, including my 15-passenger van.
One who likes to do donuts in her 15-passenger van.
One who notices powerful, beautiful cars and motorcycles.
One who would totally climb trees if her body would let her.
One who is not afraid to be who God called her to be.
One who embraces her identity.

It took many years, but I finally feel like I am not afraid or confused about who I am. Sure, there are lots of things I am still afraid of—like writing this chapter! But I am no longer afraid to be the strong woman God has called me to be. It is ok to be who God has called and created *you* to be.

I cannot say it was this or that one thing. For me, it has not been just one amazing event. It has been several years of learning slowly and reprogramming my brain to understand the truth about who I am. Slowly taking back the ground and getting out of that cave as I move into my own "Promised Land." I am still learning to be the woman He has created me to be. I am most definitely a woman. I have nine children and five grandchildren. One of them passed away before I was able to meet her. Only a woman can deliver nine children and breastfeed them. Only a woman can create life within her body and bring it into the world. That all requires bravery.

Today, I know Whose I am. Sure, I still battle fear sometimes. I still battle with insecurity. We all do at different times if we are honest. But I am confident in who I am. I battle to keep my mind focused on Him and what he says about me:

I am His child.
I am strong and mighty.
I am a warrior in His army.
I am a woman.
I am a beautiful woman.
I am courageous.
I am loved.
I am the apple of His eye.
I am victorious.
I am a child of the Most High God.
I am strong and courageous.
I am lovely.

I found me.

TONI CAMPBELL

From HR to Radio to her current position as Benevolence Ministry Leader at Princeton Alliance Church, Toni Campbell's journey has never been ordinary. She currently oversees a food pantry, cars ministry, financial requests, and several large-scale events. Toni loves chocolate, singing, painting rocks (yes, it's a thing!), hitting the beach with a good book, sharing her passion of church outreach, and writing her lakeside lessons blog featured on tonicampbell.org. Mom to Ken, Jackie, and son-in-law Jay, her favorite title is Grandma to Emma. Toni resides in picturesque Crosswicks, New Jersey. Connect with her by searching for "Toni Campbell" on Facebook, Twitter, Instagram and Pinterest.

Chapter Four

Life from Loss

by Toni Campbell

Whoever finds their life will lose it,
and whoever loses their life for my sake will find it.

—Matthew 10:39

Loss isn't something we strive for. No one wakes up thinking, "Lord, I'd like to experience loss today through death, divorce, illness, or maybe just some unemployment." You'd be called crazy if you did. Self-preservation says avoid loss at all costs. It hurts to lose!

Dictionary.com defines loss as "Detriment, disadvantage, or deprivation from failure to keep, have, or get." Yeah, sign me up for some of that … or not. Definitely not. Yet, I've discovered that while I don't long for loss, God brings life out of it. He does it in incomprehensible ways. Ways I couldn't see when I was in the midst of pain. Ways that somehow add rather than subtract. Multiply rather than divide.

I've experienced quite a bit of loss. My parents divorced when I was 17. I had an abortion at 18. My mom died when I was 25. The company I worked for most of my adult life closed, leaving me unemployed at 41. I was divorced at 49 and forced to sell my home of 28 years when I was 53. I had one type of cancer at 56 … and another type at 57.

Despite all that loss, this is not a story of detriment, disadvantage, or deprivation. It is a story of determination, discovery, and even delight. It is what hap-

pens when one's identity goes from being lost in the midst of life to being found in the Giver of life. It is the story of a special kind of math where adding the One to the life of one willing person equals not two, but *infinite* possibilities.

In June 2002, my career at a small pharmaceutical company was coming to an end. As jobs went, I had it pretty good: great coworkers, good pay, excellent benefits. But the company was family-owned and the man at the top felt he was ready for a change. So, the company was split in two and sold off, leaving me with nothing to do but weigh my options. Many of my coworkers took the safe route and went on to work with one of the purchasing companies. But working in Human Resources wasn't a career I had chosen and pursued. It was just a job I was good at that evolved over time until the golden handcuffs of a pension and a month's vacation made it hard to imagine leaving. I'd spent the past 20 years counseling employees on benefits, and it had all but sucked the life out of me. Like the owner of the pharmaceutical company, I was ready for a change.

For me, that meant becoming a full-time college student at the age of 41. You'd think after working in HR for so long, I'd pursue accreditation in that discipline or perhaps a general business degree. But my life's path wasn't a neat, straight line. It looked more like an Etch-A-Sketch creation—looping, zigzagging, doubling back on itself until things were so obscured by the scribble, I wasn't exactly sure where I was headed. I signed up for communications and fell in love with radio.

Radio may seem like a strange choice after a corporate career, but it actually makes sense when you look at my past. As a 17-year-old with the whole world in front of me, I wanted to be a performer—a singer, to be exact. I'd been accepted as a voice major at a small Christian college in New York, but there were last-minute financial issues for my parents. Just weeks before classes began, I encountered the Dean of Admissions from Rider College at a mall kiosk. He made several scholarships available to me, so I gratefully enrolled, completing my first year on the Dean's List and as a Freshman Honor Society inductee.

While my life looked full of promise on the outside, inside I was a mess, making horrible life choices. My home life was in a state of upheaval. My parents were divorcing, my mom was diagnosed with breast cancer, and I just wanted to run and hide from it all.

My mom and I fought about my boyfriend quite a bit. She was not a fan. The night before the spring semester finals, things reached the breaking point.

"I've packed you a bag, Toni. You either need to stop seeing him or leave home."

I was a good girl. I was a firstborn people-pleaser who didn't break the rules—at least not until that fateful night. Then I broke them all. I picked up the suitcase, shot my mother a look of disdain, and marched out the door. Pride would not allow me to apologize and stay. Once inside my car, the tears flowed. I loved my mother, but no one was treating me like an adult. I was in college for Pete's sake! I peeled out of the driveway and headed to my boyfriend's apartment.

That was the beginning of a short, fast, downward spiral. My boyfriend and I had dated since we were 13 and 14 years old. As the years passed, he put more and more pressure on me to go further. I'd resisted his advances, but once I moved in, all attempts to wait on sex until marriage hit the skids. It took no time at all to become pregnant. I was devastated and totally lost. My mom had always been there for me, and if I'd given her the chance, I know she would have supported me. But I was too frightened, embarrassed, and ashamed to go back home and admit my mistake. Everyone had had so much faith in me and in what I could accomplish—how could I let them down? Besides, with her cancer, she didn't need another piece of bad news.

In my desperation, I made matters worse. I couldn't imagine dropping out of college and putting my dreams aside to care for a child. I was still a child myself! So, I hid one shame with a bigger one and had an abortion. I became so terribly depressed over how far I'd fallen. I began smoking pot to numb the pain and face myself in the mirror each day. I had never really understood my identity in Christ as a daughter of the King. The image in the mirror was a lost and scared little girl who was a failure and a liar, hiding a horrible secret. It was one of the lowest points of my life.

A Christian since age 14, I'd never really grown in my faith, although I certainly knew right from wrong. I knew every choice I'd made since leaving home had been out of God's will. But rather than take a lesson from the Prodigal Son and return home with a contrite heart, I tried to make things right on my own.

"If you want me to continue to live here, you're going to have to marry me" was the ultimatum I gave my boyfriend.

"Okay."

That was the extent of the proposal. No romance. No excitement. I chose

to ignore good counsel from friends and family as well as my own gut feelings and reservations, and in 1979, at the ripe old age of eighteen-and-a-half, I became a married woman. Foolishly, I thought the fact that he didn't share my beliefs didn't matter all that much. Besides, I'd messed up so badly, who was I to question anyone's walk with God? Unfortunately, the marriage was a perfect example of 'two wrongs don't make a right.'

After the wedding, life took over. The lie I'd told myself about having the abortion so I wouldn't jeopardize college was exactly that … a lie. Now married with bills to pay, I quit school to find work, falling into my first HR job after about a year. Over the next decade, I gave birth to my daughter, bought a house, and had my son, all while working two and three jobs at a time to keep us out of the financial straits brought on by my husband's constant bouts of unemployment.

Three months after my daughter was born in 1986, my precious mother passed away. Over a period of seven years, her breast cancer had spread to her lungs, and finally, to her brain. We had long since reconciled over that fateful night when she packed my bags, and before she died, she said something that would impact my future decisions.

"You know how I feel about your husband, Toni. He's never been my choice for you. But you two have a child now. You have to do your best to make things work for her sake."

For a long time, I'd watched the grace with which my mom faced her trials. She clung to God and drew strength from the promises in His Word. I didn't understand why God didn't heal her, but I knew I needed her level of faith. She had peace in her pain, and a joy I barely remembered possessing when I first became a Christian.

Two years after my daughter's birth, I began looking for a church. I hadn't attended regularly in ages, so when I found a place I liked, I joined the choir. I figured if I couldn't trust myself to get to church on a regular basis, I'd commit myself to something to force my hand. This might not have been the most spiritual reason to join the choir, but it worked. Hearing God's Word preached week in and week out was water in the desert of my thirsty soul. I no longer needed to force myself to attend, and I eventually recommitted my life to God. My faith became far deeper than it ever had been as a teen.

While I found strength in my renewed faith, my marriage suffered all the

classic symptoms of being unequally yoked. We didn't see eye to eye on raising the kids, on spending money, or on the time I spent in church.

Because we were always at odds over one thing or another, my announcement in 2002 that I was taking a year off to finish my degree was not well received. My husband inundated me with questions.

"How can you be so irresponsible?"

"Who'll provide benefits for the family?"

"Aren't you a bit old to pursue your dreams?"

No, there was no support for my decision. Normally, I would have backed down in the face of such resistance, but I believe God was weaving things together for what was to come. He gave me resolve I didn't know I had to fight for my convictions. I'd sacrificed for my family for over two decades. There had to be more to life than avoiding verbal sparring matches with the one who was supposed to be my partner. It was time to see where my God-given dreams would take me.

So, I found myself at 41 years old back in community college taking radio classes. In my announcing class, I discovered I could use my voice not by singing, but by creating theater of the mind. I wasn't writing the Great American Novel, but I could create 30-second vignettes through commercial writing. My creative side had finally found an outlet after years of being stifled. My professors praised my flair for copywriting and encouraged me to consider pursuing a career in that vein. Best of all, the positive feedback I received that year did amazing things for my self-esteem which had shrunk to nothing after years of being called "stupid, fat, and lazy" at home.

An internship was required to complete my degree, so in 2003, I became the world's oldest intern. I worried about finding work as a copywriter since most radio stations don't employ people for that specific purpose. Like many industries, radio employees wear many hats and it's not uncommon for salespeople to write commercials for their clients. I also knew most interns plugged away in the Promotions Department representing the station at concerts and events, but that wasn't what I wanted to do.

I expressed my concerns to my adviser, and through contacts at a local station, he got me into the Creative Department. For three months I learned audio software, production techniques, and wrote—even voiced— commercials.

When one of the staff writers unexpectedly resigned, I was offered the position and eagerly accepted it, even though it was far less than my HR job had been paying me a year earlier. My unemployment compensation had just run out and the timing was perfect. What I didn't know was that the subtraction of that writer would become a multiplication of blessings for me, both short- and long-term.

I had hoped working full-time again would silence the grief I'd received at home over being in school and not earning an income. After all, I'd beaten the odds. I'd switched careers after 40, found a position doing exactly what I wanted to do 15 minutes from my home in an industry where my new job was an anomaly, and at a station where most were much younger than me. I knew God was in it, pulling all the circumstances together. Unfortunately, my spouse looked at my small paycheck and mocked me for "playing radio."

Once again, while my life looked like it was falling into place on the surface, my home life was in upheaval. I suspected my husband was having an affair. He vehemently denied it, but circumstances suggested otherwise. Even his parents hinted they weren't pleased with his actions. I felt like a fool. It seemed everyone knew and pitied me, but no one wanted to clue me in. Each day I died a little inside even as I cried out to God in anger, confusion, and desperation.

Afraid of being alone with two kids and little money, I took no action. Then in the fall of 2006, I escaped a little by pursuing a passion I'd put on hold since high school … community theater. I was cast in a production of *It's a Wonderful Life*. It was pretty ironic because, at this point, my life was even less wonderful than usual. Added to increased tensions at home were strong rumors of layoffs at work. Even the new church I'd attended the past eight years provided no solace. With almost 1,500 members, it was difficult to connect with people. I was part of the worship ministry, but ongoing changes left me feeling unwanted and unneeded. No, life wasn't very wonderful at all.

Suddenly, things became exponentially worse. On a Thursday evening in December, my boss told me the layoff rumors were true. He said the department was being reduced from three to one–him. He was doing his best to keep one of our positions, but it didn't look good. Subtraction seemed like a great way to solve my unknown when it had been in my favor a few years earlier, but now being on the other side of the negative sign, things looked bleak.

I asked when it would happen.

"Tuesday."

Even after months of rumors, it was still devastating to think I'd be unemployed in five days. I packed up my desk that weekend so I wouldn't be a teary mess when it happened. As far as I knew, I had the only job of its kind in the area. NOW, what would I do? Going to school full-time had coincided with my husband starting his own business. The combination wreaked havoc on our finances. We were just getting back on our feet and now I'd be out of work again. I spent A LOT of time in prayer that weekend.

Tuesday morning, my boss was called out of the office by the HR rep. My co-worker and I exchanged glances, certain he was getting instructions on how to handle our terminations.

"You may be luckier than you think," my boss said upon his return.

"You were able to keep one of us?" I asked with a glimmer of hope.

"No," came the unbelievable reply, "they're letting me go instead."

My boss and co-worker were both fired! With that, the HR rep returned and led my co-worker from the room. I was stunned. What had just happened? I felt horrible for them both, but especially my boss. He had prepared me, but now he was blindsided. A few minutes later another manager pulled me aside.

"Your job is safe," he assured me. "We'll talk more when the dust settles."

I suppose that should have made me feel better, but as my co-worker and boss walked out of the office to grab a drink and commiserate over their job losses, I was suddenly faced with a shocking reality. I was about to run the department where I had been a novice intern less than three years before, and I had to do it alone. I wasn't ready.

Becoming Creative Services Director sounded a whole lot better than it was. There was no joy in receiving the promotion, no pay raise, and my hours doubled. It wasn't uncommon to be sitting in front of my computer at 10:00 PM. Work time away from my family, coupled with rehearsals for the show three times a week, created more flack than usual at home. Although my kids were 16 and 20, my spouse accused me of being a bad mother who had her priorities all messed up.

I'd been so certain God had handpicked this job for me. Now I was full of doubts. My body was weary, my heart was heavy, and my mind was too tired to pray. Even if I'd been able to form the words, I don't know what I'd have said to God. In the end, I cried a lot, and I wondered if anything I was doing had any value at all.

I had been spared the loss of another bout of unemployment, but loss was still in the offing. Approximately one month later, my husband walked out, leaving a voicemail that he'd be staying at his mother's and didn't know when, or if, he would return.

For the past 28 years (my entire adult life up to that point), my identity had taken a beating. Nothing I did was right. I was led to believe I had failed as a parent and a spouse. I wasn't smart, I wasn't attractive, I wasn't successful. My husband had warned me repeatedly that if he chose to leave me, I would find myself unloved, undesired, and alone. Sadly, when you hear a lie often enough, you begin to believe it. I knew God well at that point. I had rededicated my life to Him years before and had made strides in my spiritual growth, but the condemning voice I lived with spoke so loudly it was hard to hear anything else.

Two weeks later, I found myself standing in the parking lot of a local drug store, talking to my husband who was asking to come back home. From somewhere deep inside, I finally heard the voice of God speaking to my soul.

You have worth. You have value. I love you. I am your Provider. Do not fear being alone.

"No," I calmly said to my husband.

He was visibly taken aback by my response.

"I need to see a heart change in you. Go to church. Pray. Work on your relationship with God. I can't say yes until I see a change."

I was shocked by the boldness of my own words, but so grateful I stood my ground and spoke from my heart. If I acquiesced, I knew it would be just a matter of time before the verbal assaults and mental manipulations would start again.

At this point, I was attending a small church plant of just 40 people. There, I was introduced to the concept of community outreach. While serving soup to the homeless one evening, I finally understood what is meant by the question "Does your heart break for the things that break the heart of God?" It felt good to be doing for others, so I didn't have to dwell on what was going on in my life. Even more, it felt like a calling. Sadly, after eight months, the congregation dwindled in number so I began looking for a place where I could both serve *and* grow.

I was now involved in a new community theater show. Two of my cast-

mates from the previous production, who were also Christians, were in this show as well. One evening, talk turned to a search for a new home church, and I was invited to try theirs.

I attended for the first time the week before Christmas and knew immediately I had found a new church home. A few months later, the pastor asked for volunteers to drive a van to the local homeless shelter to pick up women who had been participating in a Bible study there, and who wanted to come and attend services with us.

For almost two years, I headed up a group of van drivers while also becoming involved in other ministries in the church. I was invited to a leadership conference where the book *The Externally Focused Church* was given to attendees. That gift would change the trajectory of my life and my career. I read, "If you (the local church) picked up and left, how would the city feel? Would your city weep? Would anybody even notice? Would anybody care?" and my heart was pierced. I knew that this church was a loving, giving place, but I didn't know if our community was aware of that truth.

I made an appointment with the senior pastor and poured out my heart. Thankfully, he agreed and we began planning the first outreach—a food drive. While that was a huge success, I went back to him saying, "We never left the building. No one was stretched inside the walls, and no one was encountered outside the walls."

That conversation began a four-year journey, which resulted in the congregants of that church embodying a culture of service. I'm thrilled to say the ministry we created, Community Connections, continues today even though I moved on to a staff position in another church almost five years ago.

There's so much more to my story, and example after example of God's miraculous provisions: ways in which He made Himself known to me in times of uncertainty and doubt. The important thing to take away is that God uses the difficult things in this life to teach us about His love, mercy, and consistency. Then we can use God's faithfulness to us to teach others about Him. One of the coolest things to come out of my time in radio is that the owner of the station began to get involved in our outreaches. Over the course of four years, he donated thousands of dollars. When he finally decided to sell the station, he called me into his office to thank me for being the kind of person who does for others without looking for anything in return. I asked if he was familiar with the story of Esther. He wasn't, so I gave him a quick summation and ended with "I don't

mean to compare myself with a woman who saved an entire nation, but I often feel like my job at the station was preserved that day for such a time as this. Had I not been spared, you wouldn't have known about the outreach work and been a supporter of it. Your generosity made it possible for the lives of many to be touched." He remains a friend to this day.

I'm so glad God promised never to leave or forsake us. In the midst of the darkness, when I didn't know who I was and I doubted whose I was, He was there reminding me…

You have worth. You have value. I love you. I am your Provider. Do not fear being alone. Your identity is found in me.

KAYLEY HILL

Kayley Hill was born to sing. Since a very young age, she has been performing for all kinds of crowds. Upon graduation from The Boston Conservatory, she took her love for music to Nashville, TN, where she pursues her calling full-time. She was seen on Season 15 of NBC's *The Voice* and loves to partner dance with her husband when she gets the chance. When she needs a DIY fix, you'll find her playing with her miter saw. When she's excited, you'll most likely hear her holler, "Honey Yesss!" You can follow Kayley on social media by searching @kayleyhillofficial, email her at Kayley@kayleyhill.com, and of course, find her music on iTunes and Spotify.

Chapter Five

From Fainthearted to Fearless

by Kayley Hill

Ever since I was a little girl, I've found myself drawn to two things: singing and Christ. Something in me felt set apart for these, as though I was being pulled towards something I couldn't put into words or even imagine. It also seemed more substantial than just the human conscience. There was something divine about what had a hold of my heart, and I remember feeling hyper-aware of my mistakes as a child. There was the time I disobeyed my mom around eight years old. I played hide and seek in an off-limits room, ultimately breaking a glass picture frame, then proceeded to make my brother the scapegoat, as if my mom wouldn't see through the lie. It makes me laugh thinking about my nature as a human, and my instinct not only to sin but then compound the sin with a lie. This was the first of many moments I recall where fear reared its ugly head and kept me from showing a little bravery in being honest, like accepting the consequences for the broken glass. It's moments like that from my childhood, when I saw my faults so vividly, that I felt more than just a simple pull towards the morally right thing to do. I felt a strong pull toward a place where my soul was at the center of it all.

And singing. I was *always* singing. Always being shown off by my proud parents who honestly had zero clues that it would become the calling on my life. Realistically, my poor parents had no idea what to do with me ... there I was, singing my lungs out through the different phases of my childhood. I belted out notes with wild abandon during my toddler days, and persisted

during ages seven through ten, only then much more shyly, pleading with my mom, "Whyyyyy? I need advance notice if I'm gonna sing for strangers in the grocery store." *Eye roll* (I was such a brat).

Then came the perfectionist phase at twelve years old, where I couldn't just sing and be bad at it. If I sang, I better sound darn good. This isn't to say that I've left the perfectionist behind me. She's still in there trying to keep my toes straight, but years of pursuing wisdom and peace have subdued her. (Praise God.) In addition, my bread and butter has always been words of affirmation. I needed to hear verbal compliments to feel worthy and less fearful the next time around. But my parents weren't ready for all the endless singing that would come forth from my mouth. Therefore, they also weren't prepared to know the first thing about how to cultivate it.

My mom really pioneered that task the best she could, giving me motherly guidance and the occasional overzealous signal instructing me to hold the microphone closer to my mouth, while Dad sat there grinning from ear to ear, proud as could be that his little girl could sing, and happy as a clam to tell everyone about it. Mom put me in piano lessons, and let me quit, although it might have been because I asked my teacher if she wore a wig. She had this insane, bouffant beehive, far too pigmented to be natural at her age, but as the old adage goes, "Kids say the darndest things."

Nonetheless, my mother signed me up for all the music camps, along with an audition for "Annie" at the local theatre. I never got cast, mind you, but I completely attribute that to not having found my gumption just yet. Who even was I? Just because I could belt out Simba's "I Just Can't Wait to Be King," in my living room, didn't mean my timid self was ready for downtown Bristol, Tennessee. Truth be told, my mother didn't know the right way to prepare me, but she was proud and committed and helped me chase opportunities as they came.

In high school, I began to take my budding artistry into my own hands. I dictated my schedule, became president of the Thespian Troupe, sang in the Show Choir, and practically lived in the chorus room. I naturally had a mind of my own and strong personal convictions about my faith. But I was still lost when it came to knowing what to do with my talent, where to go to sing, and how to pursue opportunities. It was essentially a fear factory in my mind. I couldn't see outside the box and certainly didn't know where to begin when it came to creating my own vocal frontier. I just followed what other people did

since that was within my reach. If my other talented friends went to a studio for lessons, then honey, I signed up, too. If they competed in those slightly bogus competitions that charge x, y, and z, I called Mom and Dad and said *please*. And then I applied to all the best musical theatre programs in the nation, which was no simple thing. We're talking the standard application process and fee, scheduling an audition through the theatre departments at each school, and THEN planning a trip to New York City so I could audition for all three of the programs at one time, while the other two schools required travel direct to campus for an audition. Thank goodness I only chose five and not thirteen like some of my crazy soon-to-be classmates. Still, my parents had no clue what to do with me. They trusted my research and believed me when I said I needed to go to NYC to apply for college, and then trusted me again when I wanted to commit to the Boston Conservatory, which was lightyears away from Fort Myers, FL, and not cheap by any definition.

My fainthearted self was afraid of so much during that time … the fear of rejection (God forbid I don't make it into a program), the fear of being in over my head and pursuing the wrong avenue, the fear of getting into a school and not being able to go because it was out of reach financially … the list goes on. I was forced to trust the few mentors I had, who helped me shape a couple of basic audition songs and monologues. I remember Proverbs 3:6 when I reflect on that time.

> *Remember the Lord in everything you do,*
> *and He will show you the right way.*

Honestly, looking back, I was lucky the Boston Conservatory saw my potential because I had no clue what I was doing. I didn't have the right clothes that all the other girls wore to the dance call. I didn't have the experience that many moms gloated to my mom about their children having. I wasn't getting the additional five-minute interview that others received. I was a fish out of water in a completely new territory where I had to sing, be judged, and ultimately have the fate of my college acceptance rest on two minutes of baring my soul to a few strangers who would really just be cherry-picking their students from the summer workshops I neither knew about nor could afford. Hello, fear.

And hello, Boston Conservatory who took me in and gave me an incredibly informative, yet expensive four years. They were the only program who

offered me a chance, which wounded my pride a little, but I forced myself to see it as though God were handpicking that school just for me. It felt right and it ended up being an amazing experience.

I feel slightly silly thinking about my trajectory from childhood through early adulthood, and the choices I made regarding my dreams and career. Realistically, I couldn't be luckier to have known what I wanted to do since elementary school. How many other people can be so decisive? Even today in the music industry in Nashville, I still meet artists who have no clue if they chose the right path. Some decide to go back to school, and others decide they find more value in a steady job versus the chaotic life of a musician. All roads lead to the same thing, in a way, right? Isn't it about the pursuit of our calling on our lives? And everyone's calling looks different ... mine just happens to be music.

I've been asked on different occasions, "If you could have any other job, what would it be?" I jokingly say "a contractor" because I like to build things, and occasionally say "linguist" because I like to communicate with people, but I will forever and always be sold out to performing on stage and sharing music. In interviews, I always say it was written in my DNA to perform. It can't be helped.

Some people can relate, but there's nothing scarier than having a dream and not knowing where to start. Many people just succumb to the pressure of the unknown and never make a move, but I knew I couldn't do that, no matter how afraid I was of stepping out in faith. I assumed my musical theatre degree would give me direction, and in ways, I know it has prepared me immensely. But there's something to be said about the safety net of college. I knew where I'd be day-to-day. I had assignments and deadlines and immense accountability. Cue graduation and the looming feeling that all of a sudden, I'd be on my own with no one giving me tasks to make me better. Suddenly, my dream was solely in my hands, and the only thing that seemed like a step in the right direction was to move to the country music capital of the world because that's what musicians did.

If I'm being completely transparent, I've now lived in Nashville for over five years and I still have no idea what I'm doing or how the music industry works. I've seen people find success based on chance or divine meetings. I've seen people get their careers ripped away from them over "It's business" and heard painstaking stories of the "ten-year town" as many people call it. I've

learned about failed record deals, great record deals, stories of how money made the artist, and stories of the underdog. *Truly what I've learned is that no journey looks the same.* There will always be luck, social-climbing tactics, an everyday name game—I can't tell you how many times I coveted the binder of faces that Anne Hathaway carried in *The Devil Wears Prada*—and chances of meeting someone who could shake your career at any moment. (Better pray you can form sentences.)

The variables are endless, and one 16-year-old girl from Idaho coming onto the scene and rising faster than you despite paying your dues is just gonna be a thing and there's nothing you can do about it. Life isn't fair no matter what my eight-year-old-self believed.

As I'm writing these words, I can't help but think I probably seem bitter. I would be lying if I said I haven't been jealous in this town or felt completely underprepared and worthless. I've put myself down both verbally and mentally over and over again. I've diminished myself from every angle; saying I wasn't skinny enough, or stylish enough, or that my guitar playing and songwriting were subpar, or even that my voice was annoying, and people didn't want to hear it. I've been mean and ugly to myself and played the comparison game to the point of being joyless and doubtful of my gifts.

I've been disrespectful to my Creator.

I'm 29 and technically old for this industry, right? Maybe. Maybe not. What I do know is that I've learned a lot about what confidence looks like and Who it comes from. What's crazy is that it took a non-believing friend to shake me out of my toxic negative self-talk.

She said simply, "Kayley, you need to look at yourself in the mirror and proclaim nice things about yourself." Then she pestered me until I finally stood in front of that mirror and tried to call myself beautiful, capable, and talented, all the while feeling completely foolish and awkward.

How sad.

My habit of negative self-talk was so profound that I couldn't say one nice thing to myself without feeling like an absolute idiot. It was right around this time that I realized words had more power than what I gave them credit for. I had coached myself down an ugly rabbit hole and needed to coach myself back out. Proverbs 15:4 says,

Kind words bring life, but cruel words crush your spirit.

It's no wonder I struggled with comparison and had trouble getting out of my own way. But, little by little, I started to see a difference in myself with each kind thought or spoken word. Any time I thought something negative about myself, I combated it with something positive and my confidence began to grow.

With my newfound courage, I decided to subscribe to the "fake it till ya make it" club. I swear I'm president of the darn thing. I knew I was capable in some ways, but I needed to be thrust into the deep end to really see how I could swim. My biggest struggle was playing a show for longer than an hour. I didn't think I had the chops nor the conditioning to get through anything longer by myself and always relied on other players to carry me. Ahh, such a fool I was. I remember my first two-hour set. I was so out of my element that the muscle below my thumb on my fret hand cramped up for two weeks while my fingertips swelled. These days, I play over four hours at a time and don't bat an eye. Amen to progress and opportunities to practice!

I figured out quickly that I worked better with accountability. If I booked a show, then I would be forced to learn songs and build practice into my schedule. It kept me playing regularly. I distinctly remember the first time I played a four-hour set down on the famous Broadway in Nashville. I was mistaken for someone else via text message and asked to play a last-minute show that evening. I felt like pooping my pants at the thought of saying yes but knew I couldn't say no.

I showed up that night, surprising the guy who called me who thought I was a different Kayley (I still laugh about that), and I'm sure he was sweating as I plugged in and began to play my first tune, but all was well. I made such a positive impression that we proceeded to play together regularly over the next few years. My biggest takeaway was that fear was a liar. I had more capabilities than I gave myself credit for but never would have known had I not taken that risk.

That show was the beginning of the end and I began to take Broadway by storm, finding gigs up and down the strip, eventually leading me to step down from my serving job and pursue music full-time. I have to pinch myself sometimes thinking about it. I told my husband, Matt, that my first goal when moving to Nashville was to make an income with music. Not only was I doing that, but I had worked up my momentum to the point of a full-time job.

I do also have to give credit to my poor, yet patient and amazing husband,

who took that initial risk with me right after we got married, saying, "Sure Kayley, you have no idea what you're doing but you feel led to Nashville, so I'm game." The plethora of pep talks he's given me is far beyond his pay grade. He celebrated with me when I got my first steady gig with a private event band, and he helped coach me out of it when it was time to move on. He never complains when I'm out late networking and lifts me up in conversation with everyone he meets. He challenges me to think outside the box about my artistry, and I would bet anything that he jumped and screamed the loudest of any contestant family member when I was on *The Voice*. Seriously, you can YouTube it. He tells me *I* inspire *him*, but for sure, it's the other way around.

He really fulfills the role of helpmate like a champion and leaves me so thankful to have his steadiness in the midst of my moving pieces. When I look at Matt, I see God's strategy in my life. I don't think He ever intended for me to pursue music as a single woman, and in fact, my marriage has protected me from a lot of collaborations that could've been based on ulterior motives. People see the ring on my finger and (most of the time) show respect.

But let's get back to the club I'm president of…one of the most incredible things that came from faking my way through the industry is that I ended up growing my abilities and morale. I'd constantly quiet that pesky little voice inside begging me to sit still, and I'd go pound the pavement. I quickly learned that "no" was going to be tossed my way more than I'd want, but I no longer took it personally. I kept seeing Christ in the closed doors.

I would always say "Thank you, God. Now I know that circumstance isn't for me."

Then I'd move on until I found a yes. In addition, I've always known that the respect I show for people could be crucial to my success, even for the Broadway stages in Nashville. I tried to cultivate positive relationships by being communicative with bookers. I never called out last minute on a gig and found replacements if I had a conflict so the venues wouldn't have to. I refused to be the unreliable singer because I knew it would be a reflection of my character. I can't tell you how many times showing respect propelled me, and it still blows my mind when I think about the strength I've gained from taking risks. The growth is unreal.

I believe it was December 2017 when all my hard work started to take shape into a new opportunity. My time shedding on Broadway had strength-ened my guitar playing and conditioned my voice to the point of surprise. I'd

finish a song sometimes with bewilderment, thinking, "Wow, my voice has gotten stronger!" I knew more songs than I could count and became a pro at improvising when someone gave me an unfamiliar song request.

There are still days that I say, "Wait a second, let me go listen to the song for a minute and let's see if I can work it up."

I'm crazy. Normal people would just say no. I suppose it's the product of time spent making a fool of myself on stage. I no longer have shame and couldn't care less about messing up a note or a chord. I just try to make people feel welcome and put the focus on having fun.

I was playing a show in December of 2017, and a guy walked in from *The Voice*. He said, "Call me," and left his business card in my tip jar. Instinctively, I knew that God was planting a seed of possibility in that card, that it could be my next move, and voila, a few months later I was auditioning for NBC.

The Voice was wild. I can't indulge too much of my experience because of confidentiality agreements, but just know that the artists are treated so well, and it felt like summer camp. In the beginning stages, I remember asking "God is this you? Are you present in this opportunity?" Somehow, I acquired this kind of electric peace, which sounds oxymoronic, but nonetheless, it was an electric peace that grounded me. I knew without a doubt God's hand was moving during my audition process, and I slowly began to realize that I had His favor the entire time.

Matt called me while I was filming and said "God has anointed you, Kayley. I had a dream that he poured oil on your head and anointed you." I was shook.

I said, "Ok God, I'm going to steward these next few weeks as best as I can."

I believe the Lord gave me special discernment during that time. I felt called to build relationships with as many people as I could, knowing that the pinnacle of my time with *The Voice* wouldn't be in the moments I would be shown on national television, but in the bonds I formed with the talented souls I was locked in a hotel with. My roommate on the show would lovingly laugh at me because I knew everyone's name like three days in. I was on a mission to know every person, dadgummit!

Being on that stage at Universal Studios singing for the coaches was unreal. It felt out of body. I just remember focusing on the song, just sing the

song. Leading up to the audition, there was a lot of preparation, and I was able to apply those lessons I learned in college regarding heart rate and how to handle nerves. I was a champ at taking slow deep breaths, premeditation, and positive self-talk by the time the most thrilling and scary audition of my life rolled around. I also had hundreds of hours of experience on stage both playing solo and with a band, so I leaned on muscle memory and musicality. I smile thinking about it because it was all God's timing. He is no fool and there was no better time than then.

The Voice changed my life, and I'm still riding that wave of meeting people with stars in their eyes when they hear I was on the show. The friendships I made have helped shape my artistry, and we've become advocates for one another, which is a beautiful thing when your town is driven by competition. Competition can be ugly, and it can be healthy. When I was filming, I chose to celebrate the people I was surrounded by. I knew I was at the top of my game musically, and my fate on the show was bigger than the singer down the hall. God's plan had been predetermined, and my journey was no one else's. I was at peace whether I made it to the top four or whether I got sent home at round two. Better than that, I knew my value as an artist was not driven by what a TV show said, *but by who Christ says I am.*

I keep thinking of that analogy of a blacksmith molding metal with heat. Nothing is forged outside of the fire. My 2018 was an inferno that has blazed into today as I write these words. It makes me thankful for the heat. Though last year was one of the most exhilarating times of my life, I still shed tears, faced temptation, aligned myself with the wrong people, and experienced moments of desensitization in my faith. The biggest lesson of all is that God will not leave me. He gives me His Word to run to when I need counsel and has plucked me out of circumstances that didn't glorify Him.

Amen, a thousand times.

I'm beyond thankful for His perfecting fire and call on my life. It's humbling. In the moments when I get swept up in accolades, making my career or dream an idol, or when I lose myself in the idea of fame, he mercifully nudges me back in line. He shows me that I can't accomplish His work within my own human strength, that I must abide in Him to bear fruit. What a daily struggle that is … the simple call to abide. When I get caught up in my own abilities, I remember that sacrificing my pride and independence allows Him to shine. In turn, I gain hope and comfort, so I chide my tendency to rely on

myself when God beckons me to bring all burdens before Him. It's seasons like the one I'm in now when I see how much of a lamb I am. He lets me walk before Him and watches my steps so if I lose footing, He's there to guide me.

What comfort!

At the end of the day, my identity is constant, yet ever-changing. As I yield to the Lord and renew my mind in His Word, I slowly shift from a position of faintheartedness into a posture of deep confidence and fearlessness. I'm able to shed any doubt about my abilities and reflect on the weakest moments in my life with hope because God delivers, restores, and pursues you when you ask.

HEATHER TAYLOR

Heather Taylor's writing career started at just sixteen; today she is a two-time Amazon #1 Bestselling Author. Heather is FEW's *Lead Ambassador* giving her endless support to FEW's mission to empower women to live extraordinary lives and tell their stories. As a Keynote Speaker, she serves up her raw stories with Biblical strategies—and they always come with her in-your-face humor. As a FEW Certified Coach, she launches women in their relationships, businesses and destinies. Heather's first love is her family. She loves playing with her granddaughter, laughing with her three adult children, and her thirty years of morning coffee dates with her husband, Terry. For booking information please contact: **hjtenterprise@gmail.com**.

Chapter Six

I Am
Who He Says I Am

by Heather Taylor

In the Beginning

As a child I always dreamed of being in the front; the front of the line, the front seat on the bus, the front of the classroom, the front of the stage. I was always searching for a way to have all the attention focused on me. I was the fourth and last child to be born in my family and I was also the only girl, so maybe this is where the desire to have all eyes on me began. My mom and dad say they prayed for a girl. My brothers just wanted to know why I didn't have a proper "weenie" and where the batteries went. I pretty much got what I wanted from all of them anytime I wanted it. You could say I was a little spoiled—well, maybe a little more than a *little* spoiled!

I was constantly making my older brothers and parents watch me perform a new dance or listen to me sing the latest song I had written. They were willing to comply, and I took great advantage of that. I remember how easily my second oldest brother, Kevin, could be persuaded to watch me perform. He actually loved assisting me in my one-woman shows. Looking back now, I see why. He used to laugh as I acted out a totally improvised, on-the-spot monologue while pretending to be Wonder Woman, and he was the evil 007, wrapped up in my truth lasso. I think he truly enjoyed watching me come up with these crazy ongoing rants. It made him laugh, and I learned at an early age that I LOVE to make people laugh.

Losing My Innocence

As I got older and was exposed to the real world, I started to see that not all audiences were as biased as my family. In fact, a lot of people seemed to take quite a bit of pleasure in telling me what I didn't do well. Instead, they feasted on telling me not only what my performances lacked, but also what my face, body, hair, and mind lacked. I don't want to mislead anyone into thinking my head was so oversized from indulging in fake compliments from my family that I couldn't take criticism, because nothing is further from the truth. (I did mention I have three older brothers!) Trust me when I say they didn't mince words. They told me exactly what they thought and where I lacked. My mother was also known for being very specific about the areas I could improve upon, but there was a difference in what *they* thought and what the *world* thought.

I wanted to impress those people out in the world—especially those people who were the same age as I was. These were the people I *needed* to like me! Their approval was everything, so when they didn't give it to me, it made me feel less than, lacking, unworthy, and unwanted.

When you are a teenager, and you feel like you don't fit in, you do the only thing you know how...you change and find a way.

I quickly began to do less "Heather stuff" and more "cool stuff." I tried to hang with a more popular crowd, and I picked up on the "in" things to do. I still loved to make people laugh and seemed to be able to use this to my advantage, so of course, I became the class clown. I did almost anything and said absolutely everything if it meant I got a laugh. I did and said whatever I needed to, whether it was true or not so that I would fit in. I portrayed a different role for each group of friends, but none of those groups really knew me at all. I learned to put on a different mask for every occasion. Eventually, I got tired of trying to keep up with all the different roles and made the very bad decision to quit school. Luckily, I did get my GED and later continued my education, but not before I allowed the failure of not finishing high school to steal another big chunk of my self-esteem.

The real Heather very rarely came out, and when she did, she was usually extremely unhappy and desperate to feel loved. I would stay up all night writing what is now referred to in my family as "Death Poetry." Writing was the only time I felt like my real self. I would spend hours writing in the darkness of night, pouring my heart out onto the pages so that I didn't have to carry all the sadness and loneliness I was feeling with me. The relief I experienced

when I removed those feelings from my mind and placed them onto paper was therapeutic. I felt like I could take off my mask and be myself. After I was done writing, I would go back and read what I wrote. It gave me a great sense of accomplishment. It was the craziest feeling in the world. Here I was, reading all this pain I had just regurgitated out of my heart about how badly I hurt and how desperately I wanted to escape the world, and yet I felt accomplished! I didn't realize it then, but now I know that I was receiving joy from working in my calling. I spent so much of my life not being who I was called to be that I very rarely felt joy or happiness—instead, always feeling like I was lacking, unworthy, unloved, unwanted. Once I left school, I added another negative emotion to that list: stupid. I was at the bottom of my mountain looking up and feeling defeated before I ever took the first step!

I Needed To Be Loved

I was spending so much time trying to fit in and find a sense of belonging that I lost the true essence of myself. My need to be first never really left me, but began manifesting in a different way. Did you know that we are given gifts by God whether we are walking in the light or the darkness? We still own those gifts and we still use them. If you have a calling on your life like the one God put on mine, you aren't going to be able to just squash it! I mean, it's a calling from God Himself, and only He can remove it! What does happen, though, is you try to use His gifts in the wrong way, and that is exactly what I did.

My dream of being first, in front, on stage in the spotlight, changed from wanting to perform to needing to be the center of every guy's attention; especially if he *wasn't* interested. This became a very destructive and dangerous game that I played. I would see how long it would take to make someone who was interested in someone else become interested in me. I was becoming a master manipulator and knew exactly which mask to wear for each occasion. I wasn't interested in a relationship, just the thrill of feeling wanted. I would never stay with anyone very long, once I won their affection because then it became boring. As I mentioned earlier, this was a very dangerous game. I played with people's emotions to make myself feel better, and not everyone took it so well in the end.

One night at a beach in Clearwater, Florida, I was with a group of friends,

drinking and hanging out. There were several boys there and a few of them were new. I decided to attract the attention of this long-haired, drugged-up guitar player from one of the local bands that played there that night. At the time, he was interested in my girlfriend. I had been playing this game for a while at this point, so I am ashamed to say I knew how to get his mind off of her and onto me, and I did just that.

We quietly snuck away from the crowd and found a little nook to cozy up in where no one could find us. One thing led to another and things started to go too far. I didn't want to go any further, so I asked him to stop...but he didn't want to. I quickly began to pull myself up and apologized to him for misleading him...but he didn't want it to stop. He pulled me down and called me a few choice words—that I probably deserved.

I begged him not to do it. I was terrified. Panic ruled me and I was overcome with shame. Here I was in the middle of a very bad situation and I felt SHAME! The timing was crazy, but shame took over. In those few seconds, I saw a montage of similar choices I had made that led me to where I was. SHAME! I wasn't at the front of the stage or in the front of the line and all eyes were certainly not on me—just his eyes. This was not the attention I was desiring. This was not who I wanted to be. Our brains are so complex, and yet in this instant mine made everything so simple.

Heather, you can't keep chasing attention this way. You're gonna die! God made you for something better than this!

Crazy, I know, but correct. I was made for something better than this. I had to fight, and I was not going to lose. At this point, he was holding me down in the sand, my clothes were half on and half off, and my hair was being held—very tightly I might add—by this crazed maniac lying on top of me. I grabbed a fistful of sand and threw it in his face. It got him off me, but it got sand in my eyes, too! I scrambled (BLINDLY) to move and started to run. I wasn't able to see, and quickly realized I had run onto a bed of sharp, crushed seashells. He was quickly gaining on me, so I ignored the pain in the bottoms of my feet as the edges of the shells continued to slice into them every time I lunged to move away from him. I kept running and finally made it back to the others.

They could tell I was a wreck and tried to figure out what was wrong, but the questions quickly answered themselves as he charged up behind them, grabbed me by the throat, and continuously bashed my head into the closed window of a car until someone finally pulled him off of me.

To this day, I don't know who that boy at the beach was, or what he would have done to me if I hadn't escaped. I tried to block it all out of my memory once I got home. I wasn't successful though, because, for several weeks after the attack, every step I took was extremely painful due to the severe lacerations on the bottoms of my feet. The pain was a constant reminder of what I had gotten myself into, but it also reminded me of the promise I made to myself that night. Just like my feet, the memory of what had almost happened to me would heal and be replaced with determination to change! In the end, nobody there that night knew what had happened and I haven't told anyone—not even my husband—this story before. If I'm being truthful, I really had no idea that it was going to be in this book. As I began writing, I thought about the first time I saw a glimpse of my true identity, and this story came to mind. Now I realize that it was at that moment when he was going to take what I didn't want to give him, that I made a decision to stop being destructive and start figuring out what I was meant to do. I was 16 years old; it was gonna take another 30 years before I knew. My mountain was still in front of me, but I decided to take the first step.

And we know that in all things God works for the
good of those who love him, who have been called according
to his purpose.
—Romans 8:28 NIV

Claiming My Mountain (30 Years Later)

"There is NO way I am going to get up in front of these women and say that!" Those were the words I was saying to God as I began walking from the very back to the front of the classroom. The instructor of the leadership conference I was attending had asked us to "claim our mountain of influence" out loud in front of everyone. Up until now, I truly had no idea what I was doing there or that I even had a mountain I was supposed to claim and climb. I stumbled into this class under false pretenses! I thought I was here to help my friend, the instructor, organize the leadership conference; not actually participate in the class.

The "7 Mountains of Cultural Influence" are places of influence in society where God has called each of us to be a light for Him. There are seven of them:

Family, Religion (The Church), Government, Arts & Entertainment, Media, Education, and Business. During the conference, my friend instructed us to pray and ask God which mountain we were called to. All the other women not only knew their mountains but seemed (in my eyes) to have already reached their summit! I was sure that all of the ladies who attended this conference had their acts together.

They were all very well educated (I'm a high school dropout), knew their calling (the only thing I knew was that I didn't belong in this group of ladies), knew God really well (I couldn't recite one Bible verse without saying it backward), and they were all **much better than I was**! All these thoughts were rolling through my very insecure mind as I took what felt like a mile-long walk to the front of the classroom with my mountain clear in my mind.

God...please...this can't be the mountain I am called to. Look at me! I'm fat, uneducated, unattractive, and I don't have anything to offer people!

I continued pleading with Him all the way to the podium but in my heart of hearts, I knew He was right. *I had always known.* Once I began to pray, my mountain popped into my mind with complete clarity, leaving me no question. I just never claimed it before—especially out loud in a room full of perfect people! My very long journey to the front finally ended, and there I stood staring into the eyes of the perfect people. I took a deep breath and tried to control my heart, which was beating so ferociously I was sure it would pop out and jump onto the floor—or worse yet, hit the beautiful lady wearing white in the front row smack in her face!

I trembled as I spoke. "I truly cannot believe what I'm about to say, but I know with all my heart this is what God wants me to claim."

I took one last look at the eyes staring at me with what seemed like, to my surprise, anticipation, then turned to the dry erase board on the wall where all seven mountains were listed. I slowly raised my hand, which was shaking uncontrollably at this point, pointed to my mountain, and said, "I am called to Arts and Entertainment!"

I could feel something in me change the instant those words left my lips. To this day I cannot explain it or even begin to describe it, but all I can say is once I claimed my mountain out loud, God began to change me—and there was no going back. My mountain was steep, and the air was getting very thin, but I took the next step in faith.

Trust in the Lord completely, and do not rely on your own opinions. With all your heart rely on Him to guide you, and He will lead you in every decision you make.

—Proverbs 3:5 (TPT)

Climbing My Mountain

I would love to tell you that once I discovered my calling, everything came together and I never looked back, but that simply isn't true. Embracing my calling was only the beginning; the real work hadn't even begun yet. I still had a lot of self-doubts to confront and soul-healing to work on before I could see who I *really* was and not who I *thought* I was.

I had spent most of my life believing lies about myself. I repeatedly told myself that I wasn't worthy of being liked or loved or enjoying kindness and success. I knew I had nothing to offer anyone, and that I should be grateful I had the people in my life who put up with me even if some of them weren't very kind. I had lived with the lies for so many years that they were a part of me. That doesn't go away overnight, but with the REAL truth (God's truth), it does go away eventually. I had to believe that God's promises were also meant for me, not just for everyone else. It took a while for me to buy into the whole "Jesus loves me this I know" attitude, but God showed me how much He loved me over and over again.

Even if I made a bad choice or uttered a bad word, it became a little harder to reject each time. God continued to show me how much He cares for me. That, along with reading my Bible and learning what it says about who I really am, made me start to believe that I really am a daughter of the King. I soon knew I was put on this Earth for a purpose, and I was given gifts and talents that only I possess. I am as unique as a fingerprint because God created me in my mother's womb to be uniquely and unequivocally me! Only I can do what God has called me to do. I truly believe that there are certain people in this world that God designed me—and only me—to be able to connect with.

The way I look, the way I talk, the way I act is perfect for what God wants me to do and who God wants me to reach. He is a Master Artist and I, just like you, am His masterpiece. We are to be put on display so all the world can see His creations. He does that by giving each of us a unique calling with our spe-

cial gifts and talents. Sure, we aren't all going to be called to stand in the front, but that doesn't make us any less of a masterpiece. In order for God's plan to work, He needs us committed to Him in every area of our lives. Some will be called to the pulpit, but some will be called to the home, and some will be called to the school. Some will be called to the streets, or to pray, write, sing, or speak. We are all called to work with the gifts that God gave us to do the work of God together.

For we are God's masterpiece. He has created us anew
in Christ Jesus, so we can do the good things he planned
for us long ago.

—Ephesians 2:10 (NLT)

Living My True Purpose

People often ask me how I knew what my calling was. The answer is pretty simple: the thing that you love to do, the one thing that you keep going back to or you seem to have a natural instinct or ability to do with ease, is probably what your calling will be centered around. Do you feel totally alive when you get to serve people? Do you love to give advice and help people? Do you find that you can easily teach people how to do things? All of those are examples of different gifts God has equipped us with to help us in the areas we are called to. When I claimed my mountain of Arts and Entertainment, I had NO idea what that really meant. As I stated before, I knew something had happened at that moment, but I didn't really know how or where I was going to begin. The beauty of that is when you are willing to let God use you, He will lead you and open doors that only He can open. I stopped searching for an audience full of people and focused on an audience of One. In return, God provided me with the audience of His choosing. When I started working on, and believing in, my true identity, and not the one I had allowed myself to believe for so many years, God started me on a path that I still can't believe I get to be on.

I have wanted to be a writer my entire life. I have used writing as a tool to release anger, sadness, pain, frustration, joy, humor, and any other emotion worth mentioning. It has always been my release—my happy place. The idea of ever being a "real writer" was preposterous to me. Because of my decision to

quit high school, I believed I wasn't educated enough, smart enough, or interesting enough to even entertain the idea. I had nothing worth saying that anyone would ever want to take the time to read. That is what I believed, but God had other ideas. I am now a published co-author three times over, with two of those books going on to become #1 Bestsellers on Amazon! By the end of this year, that count will climb to five! More importantly, it is what these books are doing for people. I get messages all the time thanking me for sharing my story and telling me how my story is changing people's lives.

I am also the Producer and Co-host of a podcast called *Coffee With Kim* that encourages women to be extraordinary and tell their stories. This project is very near and dear to my heart because I get to meet the most amazing women and create real friendships with people from all over the country and the world that I would have never otherwise met. I also get to work with my best friend of 23 years.

Recently, God added a new opportunity to my journey and has opened doors that have allowed me to add Public Speaker to my resume. This is one of my favorite things to do because, as I mentioned before, I love to be in the spotlight and I love to make people laugh. I am privileged to do both, and the cherry on the sundae is when I can get them to laugh *and cry*!

All joking aside, I am living a life I never thought I would live. A life I never thought I deserved to live. I believed all the lies the devil told me and I self-promoted them, too. I told myself all the time how worthless I was, how ugly, undeserving, stupid, fat, unlovable, and undesirable I was. I truly believed that nobody could love me—especially God.

By accepting my true identity, the identity I was given by Christ, and saying "yes" to God and "no" to the lies I believed about myself, I have been given a new life! I love doing what I do and being who God made me to be. I spent so many years trying not to be Heather so that I could deserve someone's attention and love, but I never succeeded. Trying to be someone else is hard…too hard! Why not be who God made you to be? I promise it's a whole lot easier to be the real you than to try and remember who you are trying to be. God created you to be His own special treasure. You are unique, a one-of-a-kind masterpiece that only you can be. Sure, there are going to be people out there who won't like you, but so what? God didn't create you for them. He created you for Him!

I haven't reached the top of my mountain yet, but I am so much closer than I've ever been. The closer I get to the summit, the more difficult the climb will

get, but I know with God **ALL** things are possible (Matthew 19:26) **and He won't leave His masterpiece unfinished.**

Of all the people on Earth, the Lord your God has chosen you to be his own special treasure.

—Deuteronomy 7:6

JAMIE DAHL

Jamie Dahl has a diverse background and has enjoyed many life experiences. In addition to being an author and breast cancer survivor, Jamie danced professionally, worked in the fashion industry, taught elementary school, and worked as an account manager in marketing. Although these professions have taken her from New York City to Los Angeles and cities in between, her most rewarding job is as a wife and mother. She lives in Wisconsin with her husband and two daughters. Jamie enjoys being a Beautycounter consultant, advocating for healthier lifestyles, and sharing her faith in God through her powerful story. Her passion is helping women find hope during the trials of life. Follow Jamie on her blog: TheDahliaDiaries.com.

Chapter Seven

Seasons

by Jamie Dahl

They are absolutely one of my favorite things. I live in a part of the country where I enjoy the benefit of experiencing both the beauty and the extremes of the changing seasons, and I love it. Every year I struggle with which one gets the top spot on my "This Season Pretty Much Rocks" list because each has a little something that I find completely fills my bucket. Summer is one of my favorites for multiple reasons. I live in the Midwest, so we covet our warm evenings and nighttime firefly spectacles. Lazy days at the pool with my daughters and bike rides to the neighborhood ice cream shop after dinner make good arguments for why this season often gets top billing. Yet every year I always look forward to fall, and the crisp mornings spent on the front porch with a steaming cup of chamomile tea. The canopy of green leaves shading my backyard begins to show its brilliant colors so skillfully hidden away until time for their reveal, and everything pumpkin begins infiltrating my home. Winter always follows fall with fresh blankets of white snow and vibrant red cardinals that decorate the branches like ornaments on a Christmas tree. The annual family of snowmen takes up residence in my backyard, and my best winter hats and mittens adorn these frosty bodies thanks to my sneaky, yet creative, children. And finally, spring: a season of new life, new growth, and rebirth. All that seemed dead awakens, and our bleak and barren landscape teems with new life and soft pastel colors. Each time of the year is so different, but all are filled with a God-given beauty that only the Heavenly Creator can orchestrate.

Oftentimes these seasons mirror our own lives and make up the changing landscapes that we experience each and every day. As I look back over my life and the road I have traveled thus far, I see many seasons. Some have been

beautiful and full of life. Others have been dark, cold, and seemingly endless. It was during these seasons that I found myself striving to develop my identity. Sometimes I didn't even realize I was doing it, but because of what my world looked like at that moment, I found that it was shaping who I was … or who thought I was.

Birkenstocks to ballet shoes—that's how my mother used to describe me as a child. I was the girl who loved playing in the mud, making rushing rapid-filled rivers for my plastic Adventure People toys with a garden hose and climbing around my treehouse in the woods behind my home. Even though I enjoyed the rough-and-tumble activities a typical tomboy might gravitate toward, I was also quite a girly girl. Hair bows and fancy shoes were my thing and I may have been known to throw an earth-shattering tantrum—or two—over the desire to wear my frilly socks and Sunday church dresses to school. However, equally dispersed between frog-catching excursions were ballet lessons with other tutu-loving little girls. That was me. Rough-and-tumble, but soft around the edges. Ballet ticked off all of the boxes on my feminine side. I loved dancing and everything about it. I adored the music, tight buns, and soft leather ballet slippers that made me feel like a princess floating on air. I had found my thing, and I was beginning to realize I was good at it.

Dance became an expression that grew well past the hobby stage. As I advanced in my training, I found myself at the Boston Ballet Summer program, at the age of fourteen, surrounded by other fellow "bunheads" and a total sense of belonging. I had found my crew, my tribe. I was a ballerina. That was who I was, and I embraced every bit of that role. I bandaged my bloody toes, sewed ribbons on my new pointe shoes, and had that telltale ballet waddle as I walked down the street with a slight turnout. But, over time and as my developing body began to grow, I realized that I didn't have the ideal ballet physique. My hips were a little tight and didn't lend themselves to that great turned-out rotation that ballerinas need, and my feet didn't form that beautifully curved point quite as they should. I found myself drifting away from classical ballet and more toward a different style of dance in jazz. Jazz it was. I could be my unique self and put my own signature on my movements without the constraints of a strict ballet esthetic. It finally felt like I had settled into a comfortable shoe. I was no longer a ballet dancer. Now I was a jazz dancer, and I was home.

When it was time to go to college and pursue my advanced education, I landed at the University of Iowa. I initially thought that dance wasn't a logical

career choice and, consequently, studied Exercise Science with aspirations of pursuing graduate studies in the area of Physical Therapy. My dream was to become a physical therapist who specializes in working with ballet dancers. However, after graduating with my bachelor's degree, I felt the Lord's subtle nudging in my heart to return to my passion. Dance.

For years, I pursued my love of dance while living and working in New York City. I also toured with a contemporary Christian singer as a backup dancer combining the two things I loved most: Jesus and dance. I lived on a tour bus for months on end, traveling the country and performing for hundreds of thousands of people. I signed autographs, took pictures with concertgoers during the meet-and-greet sessions after shows, and lived the roadie lifestyle.

Dance became who I was; not only how I viewed myself, but how others viewed me as well. I was Jamie the dancer, and honestly, I was pretty proud of that. I had worked hard to get where I was, and I knew that God had placed me in this profession for a reason. He had given me gifts and talents that He was using to bring Him glory and I was soaking it all in. I was a dancer, and that identity felt comfortable and solid. I knew who I was … or at least I thought I did.

But then this season began to shift. I got older. My body started to fight me a bit when I tried to make it do the things I wanted it to do. I was a little stiffer getting out of bed in the mornings, and my muscles started rebelling like a whining child who doesn't get the cotton candy she wants at the fair. I was beginning to see the writing on the wall. I had to give myself that dreaded heart-to-heart talk: "Give it up sister, you're no spring chicken and it's time to hang up the dancing shoes." It was clear that this season was coming to an end, and it was time to move on to another profession. For the first time in my life, I couldn't identify myself as a dancer. Was it still a part of what made me who I was? Yes, of course. But, all of a sudden, the light of my identity I found in dance dimmed like a stage spotlight slowly fading to black. The curtain was closing on a season of my life, and I started feeling lost.

"If I'm not a dancer, then who am I?" I asked myself this question many times and struggled to fill that void. I felt that what I did as a dancer completely defined me, so I frantically searched for that next title to engrave on the imaginary name tag I believed I needed to wear. Around this time, I felt the Lord prompting me to pursue a career in teaching, so I went back to school to earn a post-baccalaureate degree in Elementary Education. I decided I was going to

be an elementary school teacher. I taught second-graders in Texas and surprisingly, I was able to combine my love of dance with my new position. Recess became a time to hold impromptu dance parties by the swing sets, and I was able to expose a group of my students, who may have never had the opportunity, to a professional ballet performance. I slowly saw my cup begin to fill again, and I could feel the shift from the season of being a "dancer" to the new season of being a "teacher" materialize. This was who I was now, a teacher. I poured myself into the profession, collecting cute notepads with apples on them, diving into children's literature, and morphing myself into what I thought an ideal teacher looked like. But as time went on, I felt a strong pull to leave Texas and move back to my hometown after being gone for almost 14 years. Because my Texas teaching certificate wasn't reciprocal with the state of Wisconsin, I would be required to go back to school for at least two more years to be able to continue my teaching career. I knew that wasn't something I was willing to do, so once again, I found myself starting over. As a teacher, I knew who I was … or at least I thought I did.

"If I'm not a teacher, then who am I?" That familiar void I felt when I ended my dance career began to creep in like black ink slowly spilling onto the floor. The darkness of not knowing who I was coupled with questions from family and friends in my hometown started infiltrating my heart, and it felt like I was drowning. Even more frustrating were the questions I kept asking myself. What am I going to do? Who am I to these people, let alone to myself? As much as I trusted that God was bringing me home for a reason, I was terrified. I was an aging, single woman with no specific career aspirations, moving to a small, Wisconsin town where the chances of finding my dream life partner were about as likely as the state running out of cheese curds. Thankfully, God had plans (as He always does). He was ready to finally introduce me to my match made in Heaven, my husband, Andrew. The next season of my life had officially started. Now I was a wife, and two years later, I became a mother.

This was it. I was living the life I had dreamt about for years. Thankfully, I had waited patiently for my husband to come into my world, and here he was. Over the next few years, I became the proud mom of two beautiful daughters, and life was incredibly fulfilling. I knew I was entrusted with a very important purpose, and as I had done in every previous season in my life, I dove in with both feet. In every attempt to live up to this unspoken standard that I felt accompanied the title of 'Mom,' I started ticking things off the "How to Seem Like a Fabulous Mom List." Baby swimming lessons for my six-month-old.

Check. Daily age-appropriate brain developing activities for toddlers. Check. Share cute kid pictures of the first day of school on my Facebook page. Got it. Sign up for volunteer opportunities in both of the girls' classrooms at school. I'm your gal, check. Healthy meals on the table. Check. (Well, semi-healthy.) Themed, Pinterest-inspired birthday parties with oodles of matching invites, decorations, and coordinating treats and snacks. Check, check, double-check. Truth break: the overachiever mom mode, regarding birthday parties, ended after about year seven. Now I'm lucky to get out a text message invitation and a store-bought birthday cake. Just keeping it real, moms.

Not for one second did I believe that I had this mom gig down pat, and I had my share of monumental mom fails, but I did feel pretty confident in this new role that I had. I was a mom. Plain and simple. My identity had once again shifted from the last season into this new one and I was feeling good. The days, months, and years flew by and I was very busy being busy but also feeling fully confident in who I thought I was. However, I was oblivious to the fact that a very scary freight train, disguised as a health crisis, was heading around the corner and aimed straight for me. It was the kind of freight train that starts with C and ends in, Oh crap.

On March 22, 2017, I was diagnosed with breast cancer. In my mind, I did not fit what I considered to be the stereotype of someone who faces this disease. I was a relatively young, healthy woman with no genetic marker or family history of breast cancer. Yet here I was, lying on a hospital table having a small lump biopsied and facing the scariest trial of my life. This was a turning point. Everything that I thought I knew or felt was a priority came crashing to a halt. Suddenly, the ever-growing to-do list and Target run didn't seem quite as urgent. My season of summer had just skipped the beautiful fall and headed straight for winter. It was cold, dark, and bleak, and I was living smack dab in the middle of it.

Cancer overtook our home, our emotions, and our lives. We went into full battle mode as I fought for my life. My treatment consisted of four cycles of chemotherapy and a double mastectomy with reconstruction. I often describe my chemo treatments as throwing a bomb into a barn to blow up the pesky mouse in the corner. The mouse gets taken out, but the barn is left in complete shambles. I struggled through the side effects that came with chemotherapy, and daily faced the physical assault my body was taking to rid itself of cancer. Bone pain, mouth sores, extreme fatigue, early menopause, and a few unwelcome nights in the hospital were just a handful of the "gifts" that came with my

treatments. The most devastating of all was the loss of my hair. As much as I tried to remain positive and imagine all of the creative ways I was going to tie pretty scarves around my head, I still found myself sobbing uncontrollably in the shower holding clumps of hair in my hands. I was losing two of the things that made me feel most feminine, and most like me: my hair and my breasts.

Now, my identity name tag had a new title: cancer patient. It was an identity I couldn't hide from or behind. My bald head and sunken eyes were a billboard to the world that I was fighting this disease, and there was nothing I could do at that moment to change it. During that time, I wasn't able to fulfill my duties as a mom like I had before the diagnosis, and I struggled with the guilt that this new, and very cruel, identity had just stolen my previous one. My husband and my daughters were all incredibly supportive, and they took on duties that I used to perform to simply keep our home functional. They made me toast and smoothies when I felt lightheaded or nauseous, buttoned my pajamas and put toothpaste on my toothbrush when I couldn't move my arms after surgery. They also helped my mother clean my wounds as I recovered from the procedure. We were so blessed with many other family members and friends that stepped in to help. Many days, all I wanted to do was take my daughters to the pool and run in the yard with them, but I couldn't. That nagging question came back to haunt me. Who was I now? If I wasn't performing and living up to the standard I had put on myself as a mother, then who was I? I was a breast cancer patient.

I was deep in this life season that felt like the coldest and harshest winter, but a soft constant remained steady throughout the storm. Jesus was there. From the day I experienced the first biopsy to the day I received the call that I was cancer-free, He walked me through this trial by filling my heart with peace. It began with a nurse asking to pray for me in the exam room when I received the news that my lump could be cancerous and needed to be biopsied. His faithfulness continued throughout my entire journey as He loved me through Scripture, words and prayers from friends, and gentle signs in nature. I believed with all of my heart that He would never leave my side as I walked through my valley of death. Psalm 23:4 became a living and breathing verse that spoke to me through my darkest days.

Even though I walk through the darkest valley, I will fear no evil,
for you are with me; your rod and your staff, they comfort me.

Thankfully, after every winter comes spring. This was true for me, too. I was a survivor. After finally receiving a clean bill of health, I began the long recovery process of rebuilding my strength. Days turned into weeks which turned into months, and slowly I saw progress and new life beginning within me. My hair started to grow back. I enjoyed all of the awkward hairstyle stages that one goes through when they find that they have now become a living, breathing Chia Pet. I was able to walk upstairs without feeling breathless, and the required naps became less and less frequent. I was so thankful to see the physical evidence that God was finally restoring me to some version of what I once was.

But, I was different now. I was no longer the woman I was before cancer. My priorities had changed, and I had been given a chance to push the reset button on my life. Experiencing the drastic loss of both my physical appearance and my internal stamina made me take a look deep inside and really examine what I saw. I couldn't rely on my appearance or my daily busyness to define who I was. My physical being was a shell, and all I was left with was my heart. I knew that God loved me for who I was—not what I did or how I looked. For the first time, I truly understood where my identity was found; it was in Christ. My identity name tag finally had its proper title ...

The Daughter of a King

THIS is who I am. I am not a dancer, a teacher, a mom, or a cancer survivor. I AM a child of God. Are all of those titles pieces that make up the story of my life? Absolutely. I am proud of every phase I have experienced and that God has walked me through. I believe each of these seasons has played a very specific and important role in developing me into the person I am today. Each has been an opportunity to gain wisdom and insight for the next season. I have seen how God uses the spring seasons in our lives to gently grow and mature the seeds He has planted within us. I have also seen how He uses the winter seasons to demonstrate His fierce and unwavering love for us and to teach us to trust in His goodness no matter what we are facing. He will never leave us through those storms because we are His.

I have a strong desire to instill this same identity in my daughters and equip them with the tools they need to face the identity crisis this world inflicts upon our youth. In searching for the best way to cement this concept into

their sweet little hearts, I turned to my always reliable and favorite theological resource, Hobby Lobby. Yes, believe it or not, I found what I was looking for at this craft store that I harbor a slightly unhealthy obsession for. One day around the holidays, I was perusing the aisles trying to decide what farmhouse chic item needed to come home with me and was stopped dead in my tracks by a pretty lettered sign propped on a shelf. It read,

> "I am the daughter of a King who is not moved by the world.
> My God is with me and goes before me.
> I do not fear because I am His."

I felt my arm reach out as if powered by something other than my own strength and watched my hand take this sign off the shelf. I put it in my cart and headed home. I wrapped it up and gave it to my oldest daughter for Christmas that year, and promptly hung it in her room where she would see it every night before she closed her eyes, and every morning when she woke up.

This saying has become what I call our family's "I am" statement. We recite this statement in the car going to school in the mornings and pull it out when my daughters are feeling inadequate in any area of their lives. We stress that they don't need to be moved by the world or by peer pressure and that their God is with them always. They do not need to fear the challenges to come because they belong to a God who hung the stars and set our world in motion. They are His now and forevermore. My hope and prayer are that these words will be rooted in their hearts, and will surface when they need them most. I want them to know their identities are in their Creator, and not their accomplishments. If this statement is a constant truth in their hearts, then it becomes a weapon they can use to fight the lies the enemy will whisper in their ears: "You are a failure. You are ugly. You aren't good enough." Truth trumps lies every time, and when it comes to our identities, it's no different.

So often my girls get asked the question, "What do you want to BE when you grow up?" They may answer, "I want to be an artist." Or "I want to be a doctor." I am guilty of asking them this question myself. However, I have learned that a better question to ask is, "What do you want to DO when you grow up?" God has given us all specific gifts and talents that He desires us to use for His purposes and His kingdom. But, defining our future by what we want to BE is deceiving because it insinuates that our identity is in what we do. I believe our

identities are who we are from the minute we put our faith in Jesus Christ, and that identity is a son or daughter of a King. We can aspire to work as a teacher, a lawyer, or a stay-at-home mom, but just as the seasons in nature change, so will these seasons in our lives. The only thing that remains the same throughout the ever-evolving life path we follow is our title as a joint heir with Christ.

Changing seasons are extremely unpredictable. In fact, as I sit at the table in my sunroom writing this, I'm gazing out at my snow-covered yard. You may think, "Oh that sounds lovely. All of that white, beautiful snow must compliment your Christmas decorations so well." It's April. Yep. Not just April, but the MIDDLE of April. Five days ago, my family and I were riding bikes and skateboarding in shorts. Today I'm looking at snow. It's the same in our lives. There will be days when everything in your world feels bright and sunny, and then in an instant, a violent storm blows through and everything you know and find comfort in is crashing down around you. The Bible says in John 16:33,

I have told you these things, so that in me you may have peace.
In this world you will have trouble. But take heart!
I have overcome the world.

We will experience hardship and trial. But through those storms is a constant and steady truth. You are a son or daughter of a King. You are loved and cared for by the King of all kings, and He is faithful to provide all you need.

When I excused myself from the rollercoaster of identity seasons and settled into the steady knowledge of who I truly am, I gained a peace that laid a foundation for me to build upon. This foundation is the rock-solid wall that I now decorate with the gifts and talents that God has given me. When one of those gifts or professions gets a little cockeyed on the wall, or flat-out falls off and crashes to the floor, I will still be grounded in who I truly am. I now have the confidence to proudly wear my identity name tag that will always and forever read:

Jamie Dahl
The Daughter of a King

LUANNE NELSON

Twenty years ago, Luanne Nelson's life changed the moment God told her, "You don't have to do that anymore." Her heart was branded forever; she belongs to Him. Today, Luanne is an ordained street minister and international motivational speaker; she is a witness, a warrior, and a wayfarer for Jesus Christ. She is a #1 Bestselling Author, sharing stories of her trials and victories through the healing grace of God. A former fashion model, chain-smoker, and flaming bon vivant, Luanne was named one of the most interesting people in the city by *Milwaukee Magazine*. She resides in Milwaukee with her husband. Please visit her website at www.LuanneNelson.com.

Chapter Eight

He Said

by Luanne Nelson

I always ask what I should write about when I am in the shower. I've heard His voice—out loud—only once. Answering me this time, He said to my heart, "Write about that." Alright. I will. I knew exactly what He meant.

～

There was an unusual amount of rain that summer. Small waves gently splashed against the shoreline. The pier was invisible, standing under about two inches of water. I sloshed a deck chair to the end of it and settled in. Lake water splashed over my bare feet. An iced bowl filled with cooked, peeled, and deveined shrimp sat on my lap. My cigarettes and lighter were partitioned off to one side in the white porcelain bowl, safely tucked in a plastic waterproof bag. A bottle of chardonnay sat on the pier next to my feet, the wine glass in my hand waited to be filled.

It would have been a strange sight to any casual observer. It looked like I was sitting in the middle of the lake directly on the water. I enjoyed a fleeting thought about Jesus walking on water and wondered if He ever had a picnic with his apostles on a lake without the benefit of a boat. You know, just sitting on the water passing around plates of fish, figs and unleavened bread while telling jokes. I dismissed this thought as sacrilegious and stopped thinking about it since I knew for a fact that Jesus was not a showoff.

I realized I'd forgotten to bring the perfectly rolled joint down to the lake. It was still sitting on the red checkered kitchen tablecloth up at the house. Oh

well. At least I remembered to bring an extra lighter in my pocket in case the one in the baggie fell into the water. I ate a shrimp and tossed the tail in the lake. I thought about my life. I was 36 years old. The children were spending part of summer break with their dad and his wife. This was my time off, my summer vacation. A few years earlier, I had married their dad's cousin. Things were messy.

I was glad in a strange way that my replacement husband drank more than I did. I convinced myself I was in a good spot as long as he drank more than me. He hid his bottles of gin in the sleeves of his sweaters—I didn't do that. This, of course, allowed me to consider myself to be the suffering spouse of a flaming alcoholic. I went to group meetings and whined about how everything would be perfect if only he would just stop drinking. I sipped some more chardonnay and appreciated the cool water splashing over my feet.

As long as I was doing nothing but daydreaming on the pier, I seized the moment to critique my former husband's wife. She wore press-on nails. I knew this because she apparently had popped one and I saw it sitting on the console of his Beemer. After giving him a wicked hard time about the tackiness of it, I continued laughing my derriere off and wondered exactly how and when I became so catty.

I tossed another shrimp tail in the water.

Deep down inside, I knew I was a dreadful mess. I imagined parts of me bobbing in the water next to the increasing number of shrimp tails and cigarette butts. An arm here, an ear there.

Another shrimp tail floated by. I lit a cigarette and inhaled deeply.

A piece of lakeweed drifted by. I imagined a few of my sad thoughts attached to it, never to be remembered again. I waved at it with my pinkie and wished it a good journey. *Bon voyage, little green slimy thing with awful thoughts all over it.*

How had I gotten into such a predicament, I wondered. What was I going to do? I poured some more chardonnay into my pretty crystal wrong-shaped-glass. I reminded myself of that very important tidbit of proper etiquette dictating the fact that flutes were reserved for champagne; chardonnay belonged in a totally different shaped crystal vessel. This fork here, fish fork there, that spoon next to the others to the right of the plate. This thought made me smile to myself, recalling the things that used to be so important that were still so stuck in

my head. The wine was working its magic. I felt delightfully fuzzy and warm.

There was a time in my life when I had taught charm school at a modeling agency. Saturday morning instructions and admonitions floated through my head: stand up straight, and what in the world are you thinking wearing blue eyeshadow? Tuck your hips under and keep your chin parallel to the floor.

I flicked another glowing butt into the air. A mini meteor of sorts.

He was a handsome guy, academic in nature, with a closely cropped beard and ocean-blue eyes that sparkled with mischief most of the time. He was a doctor, a self-described "MudFud," meaning he was an MD with a few PhDs after his name. He was a brilliant man who admitted to sedating his brain with alcohol. His gin was medicinal, he said. He blamed his sporadic neuropathy on being hogtied during a research convention down South. He had misbehaved, the police got involved and he landed on the floor of a jail cell tied up on the floor, face down. In the morning, the department chairman claimed him and bailed him out. Boys will be boys, the chair said. Later that week, before he headed back home, the mayor awarded him the keys to the city. I suppose the mayor felt it was a small, albeit adequate reparation, for bothering a conventioneer who happened to be a visiting physician from a large medical college. It worked; sparkle man had it framed and put it on his desk, bragging about it for years.

Little did we know, we were both already seriously destroyed when we re-met during that very hot summer years ago. While my children were visiting their dad and his tacky wife, I was out and about town visiting old friends, including blue eyes—my soon-to-be next husband. While I was visiting his grandmother, who was the sister of my first husband's grandmother, her eyes lit up and it was clear she was about to put a great new idea into motion.

She reached for the phone and called someone. "Guess who's in town?" she said. A few minutes later, handsome MudFud walked through the door. We saw each other at family gatherings over the years and had chatted occasionally. It was nice to see him again.

He was in his thirties, staying at his parents' house. His mom and his dad had died way too soon. Their clothing was draped on the cloth hangers in the master bedroom's closet. His mom's hats still sat on the top shelf of the en-

tranceway closet waiting to be worn and his dad's boots were on the floor waiting to be stepped in to. He explained to me that he just didn't have the time to go through everything and clean it all up even though his parents had both been gone for nearly a decade.

You never would have guessed looking at either one of us how wrecked we truly were; even we didn't know it. On the outside we looked just dandy. People said we made a stunning couple; he with his burled walnut pipe and me with my mane of messy blonde hair. He was book smart, I was street smart. We both were clueless.

A few years earlier, I had barely escaped a treacherous relationship after my divorce. I had landed in a shelter with my children 600 miles away out East, in my hometown. The monster was a wildly abusive guy who lied to me about pretty much everything. He was a smooth talker; I believed him. I learned a lot. Life can kill you if you're not careful. There are landmines everywhere.

So, the brokenhearted man who felt orphaned, and the brokenhearted woman who had just been damn near dragged and left for dead in Dante's inferno, fell in love and agreed to make a go of it. Give it a whirl of sorts, we said. After all, we figured we were both intelligent people who believed in God, had gone through some awful things, and came out on the other side of disaster alive. We decided to elope, sending postcards from Colorado to our family and friends to announce our wedding. A few years later, I found a box of old wedding announcements in the attic from his first marriage. I scratched out his first wife's name, wrote my name in the margin and mailed them out to a handful of friends. We made lemonade out of lemons, all the while stuffing our mouths with sugared cookies.

The children loved him and he adored them right back. Let's face it, their dad and new stepdad were related, so there was an instant bond. We truly had so much fun together. We all sat together at grade school basketball, football games, and Christmas pageants. We were quite the trio. Sometimes, I sat in the middle of the two of them. I suppose we looked strange from the outside for anyone who knew our story. We didn't mind. We would go out in the parking lot and smoke together during half-time or intermission.

We took the children to Disney World in the middle of the winter. The following summer, we vacationed in Colorado, foot skiing on the leftover snow in the mountains. One time, he made a makeshift Haitian flotilla-looking craft out of the pontoon boat after the canopy ripped. I nearly died laughing.

When my littlest one received her first Holy Communion, he was right there in church with us. He was not a religious man; rather, he was a scruffy guy with a loving spirit. His godmother was my children's great aunt. Sitting in the pew with his aviator glasses on, he reached into his pocket to grab his pipe. I whispered to him, "You can't do that in here!" He smiled that spectacular grin of his that did me in every time. He loved razzing me. He loved me and I loved him right back.

Three years into this marriage, the unthinkable happened. A life changing disaster of epic proportions struck. The phone call came early, before sunrise, one summer morning. The news was devastating. My first husband, the father of my three beautiful children, the cousin of my dear husband, had taken his own life at the lakefront. There are no words to describe the shock, the anguish, the raw pain.

Our children, who were nine, eleven and twelve years old, were hardly old enough to even understand death, much less death by one's own hand. Their beloved dad's life was gone, he was nowhere to be found, ever again. The suffering was palpable. They searched his closets and looked under the beds. He had to be there somewhere. It was gut-wrenching.

A few weeks later, I suffered a miscarriage. Then, I broke.

The next two years were miserable. I tried my best to balance a ship without a rudder. No sails. No wind. Sometimes, no air.

Hadn't I done everything you told me to do, God? I had gone to church (almost) every Sunday, I had been faithful in adversity, I had kept my chin up and made the best out of bad situations, I had my children baptized and drove them to Catholic school every morning, picking them up at the end of each day. I had prayed together with them. I was doing my best, God. I remembered, You had sent me an angel to let me know that there is life after this one. Where are you, God?

My world went dark. Very dark.

The doc prescribed Xanax. Chardonnay rounded some of the sharp edges of intense grief. The doc decided I'd had enough Xanax after a few months. My husband was drinking more and so was I. The more we drank, the more we fought. We had loved hard and fought with passion before this happened. It was different now. There was a heaviness in the air that was suffocating our marriage. We were mean to each other, and we got meaner to each other every

day. The children were suffering. We were all suffering.

Extended family needed someone to blame, and I became that person. After all, he would still be alive if I hadn't divorced him, right? Aren't we all that powerful? If I hadn't had the audacity to marry his cousin, everything would have been alright, right? I felt like running into the wilderness with everyone else's sins on my back and shaking all of them off. The scapegoat. Pour me another one. Please. It's all too heavy.

Although we did not realize it at the time, from the start we both had a hidden, deadly cache of landmines in our hearts. Over the next year, we routinely stepped on each other's mines enough that eventually we blew each other's hearts to smithereens. Later, we detonated whatever we had left during one of the cruelest divorces ever. Even our attorneys were appalled.

There was nothing civilized about it. He said he hoped I would end up living out of my car with the children and I told him I had the dogs killed even though I hadn't. We never stopped fighting long enough to realize what we were really doing was trying to kill the demons inside ourselves. Misplaced outrage. Heartsickness. Alcohol is not called "spirits" perchance. People—like us—unleash them with every sip. Amazingly, even through all of this, I still thought he was the one with the drinking problem, not me.

After five years of marriage, we parted ways, angrier than hornets, and didn't look back.

～～～

Well, there I was, lights out. Dark. Divorced again. Dead inside. Dank. Dreary. Destroyed.

I was sure I had used up all of my chances as far as my relationship with God was concerned. I had to sleep in the bed I had made for myself. It was an ugly bed. That is what I was taught, and I believed the lie.

Confidence in myself was shot. I began to look to everyone around me for approval. I knew I was no longer good enough. I knew it. I was wrecked. If I forgot this for even a moment, my family reminded me.

I want you to know, I can count on one hand the number of times I was actually inebriated. I just wanted that sweet buzz going so I didn't have to feel the pain. I drank my chardonnay at home. I didn't go to bars. This didn't make

me any better than the next sot, it just meant I drank in solitude. I didn't have to hide bottles in the sleeves of my sweaters. It didn't matter. I was angry all the time. I was furious at God. I wondered if He even saw me anymore or if He even cared enough to look at me, mess that I was. I figured even if He did catch a glimpse of me, He probably looked the other way, thoroughly disgusted.

One day, I was shocked to realize I could not stop drinking even though I wanted to. I, believe it or not, still considered myself to be a social drinker, one who was going through a rough time. The fact that I was drinking alone simply meant I didn't want to talk to anyone.

I figured I would want to be with people again sometime later, when I was in a better mood. I had alienated my friends, anyway. I had become a miserable, self-loathing, self-pitying pain in the neck.

Denial is a strange thing; while in it, I had refused to connect the dots until I got to the point I couldn't stop drinking. Good God Almighty in Heaven! I had a sudden realization that my life would not have been any better even if my husband had stopped drinking. It wasn't his fault. I realized he could not have stopped drinking even if he had wanted to. I realized I could not stop, and it had nothing to do with willpower. Nothing. I realized he didn't love his gin more than he loved me after all. He couldn't stop, either. Oh, dear God in Heaven, help me!

I tried to quit. Every day. For nearly a year. Every. Single. Day.

There was the day the alcohol stopped working. I would have a glass of wine and it made me sick, literally. I broke out in hives. I had a constant headache. I thought I had a brain tumor. It never dawned on me maybe I was hungover. I supposed being buzzed for a few years would do that, right? Please God, wherever You are—I need to sober up. I don't want to die like this.

I remembered there was a place, about an hour away from where I lived, called Holy Hill. I knew miracles happened there. Pilgrims from all over the world trekked to this designated holy place, leaving their crutches behind, hanging in rows on the Miracle Wall. I thought, I will go there and put my wine glass on one of the crutches. I had a plan. I felt hope for the first time in a very long time.

So, I started out early one day and drove up to Holy Hill. I kneeled at the altar and prayed my heart out. I confessed my sins. I apologized to Him for being such a mess. I begged, truly begged, Him to be there, to hear me, to heal me. Please please please, take my ugly bed, my mess, my old self, and make me new again.

I drove home and opened a bottle of merlot. No miracle for me. Of course not, I thought. Why would He bother with me after all I've done? Said? Thought?

Daily, I continued to do my morning supply inventory. I needed a 1.5-liter bottle of chardonnay daily, even though it made me sick. I was living in my own hell. I learned to say, "God help me." I said it a lot. I figured if I said it enough, He might feel sorry for me and in His pity for me He would help me. This went on for months.

"God help me."

I remember walking into my living room, standing in front of the fireplace right after I said this for at least the thousandth time, and then, I heard HIS VOICE—out loud—HIS VOICE said,

"You don't have to do that anymore."

I dropped to the floor. Not because I wanted to—rather, because I could not stand myself upright. I knew I was in the presence of the Most High God! At that moment, all of the pain, the tears, the heartache, the sorrow, the embarrassment, the rage, the misery, the grief, was pulled right out of me. Gone. This extremely crushingly heavy burden was—lifted! He healed me! He really and truly healed me! Just like that!!!

I was on the floor, a blank canvas. Lord God Almighty, write my new life on me however you want me to be ...

And this is the first thing He did: "Take away her thirst." And, just like that, my thirst cravings were gone.

～

It will be twenty years since God relieved me of my alcoholism. In the weeks following the Miracle, I prayed a lot and came to realize a few things:

I came to know that everything happens in His time—not mine, not ours.

He knows the map of our hearts. Every single one of us. We are His children. He knows every hair on our heads. He knit us together under our mothers' hearts. I know He loves me—and you.

And that prayer I prayed that day at Holy Hill? I now call it my "Brat Prayer." He knew very well my deeply rooted character defect of arrogance. Piecing it all together, I realized that had He lifted my sickness from me up there on the Hill that day, I would have taken some of the credit because "I" drove there and He heard "me." I would have missed the whole point.

I know now, He was not punishing me by delaying the Miracle for a later date, He knew I needed to learn to be humble, I needed to be prepared and ready to receive His generous Miracle. He wanted me to learn the difference between humility and humiliation.

I came to know—and it still takes my breath away to this day—that when I am at my weakest, I know the magnificent force of His strength and the loving touch of his tender mercy. God's grace is sufficient to see us through, no matter what.

As time passed, I have to admit I started to look for my former husband in crowds of people at museums, in stores, and at the mall. He was nowhere to be found. Last year, I sent a friend request to his new wife on Facebook. She spammed me. I figured he was either still pretty angry about everything or he had just decided to forget everything that happened. I wondered if he was still drinking. I wondered if he was alright.

I did hear from him last summer, during his season of death, in a very spiritual way. He let me know he needed my forgiveness in order to pass through the gates of readiness; to be able to love completely into that forever place we call Heaven. He let me know he knew he had hurt me. In all fairness, I knew I had hurt him, too. I completely, without hesitation, forgave him. I've asked him for his forgiveness, too. He tossed a glittering wrapped present of forgiveness to me from Heaven.

I truly hope he is having fun now playing with our loved child who was never born; the child we miscarried shortly after his cousin's suicide. I secretly named this little girl Annie Maroney. I think she was a little girl. It was his fa-

vorite name, the name he affectionately used to call me. If our baby was a little boy, I am certain he's named him after himself, just like we had agreed.

<center>~~~~~~</center>

Life goes on.

Who am I today? I am a forgiven woman, I am humbled, I am relieved, I am restored. I have been made new. I am renewed daily in Him, and I am strengthened by His Word. I am a Warrior. I am a Survivor completely and totally because of His Grace and Mercy.

I am a married woman, married to a good man who loves and protects me. I know I am strengthened by our prayers together. My husband is the head of this house, I am the heart of this home. I am a mom, I am a grandmother. I am thankful for what I have, for what I am today in Christ. God gives me exactly what I need today, saving the rest for later, in His time.

I am God's servant. He is my King, my Master, my Savior. I am no longer a slave to anything or anybody.

Today, I know I am enough.

I am His.

> *And we know that all things work together for good*
> *to those who love God, to those who are called*
> *according to His purpose.*
>
> —Romans 8:28 NKJV

KRISTEN BRZEZINSKI

Kristen has a passion for life and exuberates joy! She lives and breathes wellness, having worked in many different dimensions of the health and wellness field. She loves helping people understand wellness as attainable for everyone yet individually different, and loves being that connecting piece. She is currently pursuing her Master's Degree in Adult, Community, and Professional Education. With this knowledge, she hopes to continue her love of encouraging and educating others. Kristen is a Wisconsin native, loves camping, running, biking, fishing, enjoying a nice bonfire, and country music. Kristen feels complete spending time with her husband, family, friends, and her precious goldendoodle, Reggie.

Chapter Nine

From Worrier to Warrior

by Kristen Brzezinski

"Worrying is like a rocking chair. It keeps you busy but gets you nowhere." These words of wisdom from my Oma have stayed with me as long as I can remember. I always liked the way this quote sounded, especially since it was from my beloved Oma, but wasn't exactly sure how it pertained to me and my life quite yet. Years later, reflecting back and seeing how my life was driven by my fear and worry, I realized how greatly this quote impacted me. This, my friends, was the beginning of a wake-up call: the beginning of transformation.

Growing up I was always the odd one, a little different from all the other kids. I was a little chubby, a little weird, with no athletic skills whatsoever. I wanted so badly to be like the rest of my peers that I dove right in and did absolutely everything. You name it, I tried it. Being part of a team was so appealing to me. It made me a part of something great. I was in. I was accepted even if the talent wasn't all there. When I tried things and didn't quite measure up, I would remember every comment that wasn't encouraging. I remember being braver back when I was a kid—certainly bolder than I ever was in my teens and early twenties. When we are young nothing can stop us—no fear, no shame—but somehow, over time, when you put yourself out there and people make fun or say things, it sticks with you. Suddenly, trying everything and being brave and bold turned into, "Dang, I am not good at this at all! Am I good at anything?" I carried this strong desire to fit in and be accepted with me all throughout my adolescent years. Entering my high school years after another phase of growing up (thank goodness this was quick—Lord have mercy on those middle school years), I thought I would take matters into my own hands. I was a high schooler now. I had to be another level of cool.

What started off as something completely innocent quickly escalated and spiraled out of control. My motives shifted from, "I want to run more and cut some bad things out of my diet" to extremely restricting my food intake and using exercise as punishment. Before I could grasp what was happening, I was in this deep dark pit and didn't know where to turn or how it had become this bad. To be honest, I think I blocked out a large part of those two years, but I carried some distinct memories with me for a long time. Eating disorders don't just affect you, they affect your family and friends. I so desperately wanted to be normal, but skinny. As things grew worse, I isolated myself because I was ashamed by how far I let myself go. I didn't see what others saw. I believed that I was not enough, that something was now clearly wrong with me. I knew I was the topic of conversation around school. I would get looks—the sympathy looks—the "oh my goodness" looks. I hated being the center of attention: the center of people's gossip circles. Instead of Friday night football games and hanging out with friends, I spent my Fridays after school at countless specialists trying to figure out if they could help me. I was never satisfied with what I saw when I looked at myself. I saw only flaws, things that I needed to work on. I heard all the little digs that stuck with me from my childhood days. I saw disappointment.

My family wanted to do everything in their power to help me. My worried and loving mom forced me to go to a counselor, which in return, made me bitter and angry inside. She threatened that if I lost any more weight, I would not be able to go to pom camp because of the risk of me fainting and being too frail. This was not okay with me. Dance was my only outlet and the only thing that made me feel human during this process. I thought I could handle this myself. I didn't need or want others to get involved. When my family tried to help by sneaking Carnation Breakfast packs in my milk for dinner so I would get more protein, it only made me more frustrated. I wanted to be in control of my intake, and certain things that I viewed as not fit would definitely not fly as part of my diet. My friends tried not to hurt my feelings and purposely ate junk food in front of me so I would tag along and feel okay eating these things, too. Going out to eat was not a fun treat for me, but instead, an anxious experience trying to figure out the best option or feeling so overwhelmed I wouldn't order anything at all. This was a battle I fought for a long time. It was an inner battle, a foggy lens that masked my reality. Vivid memories haunt me to this day of my sister giving me sincere yet stern talks, and my dad crying, saying the sparkle in my eyes had disappeared. I could only eat certain things on certain days in

amounts that I felt comfortable with. If I got off of my schedule or nothing was available for me that I thought was okay, I almost had a panic attack. I dwelled on what I ate and obsessed about every meal. I got mad at my parents for trying to help in these instances, and I think they started to get frustrated, too. I was the reason my family was in despair, and I didn't have any idea how to escape.

By the mercy and grace of God and lots of prayers, He performed a miracle after a little over two years. Slowly but surely, I came out of the trance I was in. I could eat a little more without feeling disgusted with myself. After dinner, I didn't need to go on an hour bike ride to compensate for what I had consumed. I remember going to my counselor one day and she said, "I don't think you need to schedule another appointment with me." This was so encouraging! I could finally return to a normal 16-year-old's life. It was like a light switch turned off, and I have no other explanation for my recovery except for the amazing grace of God and the power of prayer. From this moment on, I felt like I was on the right track back to being a normal high schooler doing normal high school kid stuff. I even got my braces off. Things were looking up for me.

I carried these two years of struggle with me without talking about it or dealing with what just happened. After going through an eating disorder, it does something to you internally. The struggles and habits that I picked up along the way fizzled, yet were still there. I was 16 years old. I didn't know how to deal with emotions or how to express the way I felt in a healthy way. My eating disorder had affected how I viewed myself and diminished my confidence. Feelings of being an outsider and shame from having to go to a counselor lingered. My brave and bold self was not there anymore, and instead, an insecure fearful version of myself replaced her.

I distanced myself from the Lord and did things that compromised what I truly believed in to be cool. I wanted to live it up. I felt robbed of my teenage years. I was viewed as fragile, and people unintentionally treated me like I was a toddler which made me rebel even more. If a situation hurt me or didn't feel quite right, I didn't care. It was like adding ingredients to this pot of nasty soup inside me, stirring and stewing. When it got to be too much it would bubble over and affect and burn the people I loved most. I did and said things that I would soon regret. Disgusted with my actions, instead of facing them I simply pretended it was okay, and tried to move on and fix it on my own terms. In my last two years of high school, I created some bad habits that eventually led me down another path, to places I did not want to go. I began the futile game of

running away when things got too hard or I when needed a change, instead of dealing with the problem at hand.

College was a fresh start for me. I could leave the past behind and enter a new chapter. It really was an amazing season of growth and change, but bumps in the road led to some ugly moments. My old ways of not dealing with my emotions, my need for acceptance, and my constant inner battle when I felt like I didn't measure up had followed me to college as well. There was dysfunction in my communication skills that led to relational issues. How could I have healthy strong relationships when I didn't have one with myself? I had a hard time addressing issues and communicating directly. Instead, I swept it under the rug and tried to move on unaffected by situations that caused me unease. I added those emotional ingredients to that stew inside and pretended like nothing ever phased me until I had a few too many to drink. This was never pretty and didn't look good on me.

Somewhere along the way, once again, I lost sight of who I really was. I felt like I was in a rut and couldn't move forward. Why did I continue to live in this cycle? Extreme highs and the lowest lows happened over and over again. I let others dictate my identity, and believed them. I let what I did for work dictate my worth. I played the comparison game and let myself get discouraged with where I was in life, what I was doing, and how I looked. I lived my life on autopilot; letting my old bad habits creep in, and old voices in my head play over and over and over until I found myself once again in the pit. I would spend days, or even weeks, analyzing a scenario where I thought I did something wrong.

Did I say something to offend this person?

Is that person mad at me?

What could I have done differently?

I was crippled in fear. Crippled with unnecessary expectations that I set for myself, and in reality, could never meet. Some of the things I thought about weren't even true! I thought my twenties were supposed to be the best years of my life. After graduating, I had painted this picture of myself having my dream job, loving what I do, getting paid well, and having the freedom to do all the things I wanted to do. When my dreams and expectations became distant memories, it took a toll. This time around it had the opposite effect on me: I became numb to all things and feelings. I didn't feel excited. I didn't feel sad.

The life got sucked out of me, and I honestly didn't care.

I let myself go, and let food, alcohol, and endless hours of Netflix take over and mask what was really going on inside. I was embarrassed. I got my degree in Health Promotion, and I couldn't even get it together to take care of myself. I was completely ashamed of how far I let things go, but I tried to put on a good face and encourage others to be happy and healthy. Again, my actions did not measure up to my values and left me feeling frustrated and defeated. As a 20-something-year-old there was pressure, and a little bit of competition, with how life should look post-college, and I felt like a big ole failure. What I didn't realize then is that what I was searching for had been right in front of me all along. My broken puzzle would be complete if I just added the most important piece: God.

I was at the bottom of the bottom, and I hated everything about my life. Nothing I did was good enough; I wasn't enough. I wasn't thrilled about my job and didn't take care of some close relationships. I started thinking more about going back to church. I had always been a believer but fell through the cracks. My relationship with God was there when it was convenient for me. He was always there when I needed help, but it was definitely a one-sided relationship. I was so desperate and in need of change that I was open to just about anything.

Through church, Bible studies, and the Fellowship of Extraordinary Women (FEW), I slowly but surely came around to the idea that God wanted something more for me. I realized that I should never have shut him out of my life. He was always there waiting, wanting to help me, but I remained stubborn and blind believing I could fix myself. I wasn't supposed to live in worry, doubt, and fear. God made me unique with all of my flaws, but he saw me completely differently than I saw myself.

I began to believe that what God says about me is the truest thing about me. When I tried to control my life without Him, things got messy, and I would end up in the pit for the hundredth time. I learned that I let my emotions take control of my actions, which would eventually land me back in the exact same spot. You don't know what you don't know until you know. Then, it's up to you to take responsibility, and either stay the same, or change with the help of the One who is in charge. I imagined God looking down on me as I ran around in circles all worked up and angry, and He would simply say,

Are you done running now? Can I show you a new way? A way of dealing, healing, letting go, and moving forward?

I had to take responsibility for my actions. All of them. The good, the bad, the ugly, and the scum at the very, very bottom. I had to stop playing the victim card, the "these are the cards that I was dealt" card. I had to ask myself some hard questions and deal with events that brought me to tears. I had to learn how to forgive myself first, and then forgive others. I thought I had done that a long time ago, but trust me, you would be surprised who comes to mind when you pray and ask God, "Who do I need to forgive?"

This is a one-step-at-a-time process. Those lies were ingrained in my mind, haunting me; always there waiting for their shining moments. I had to revisit them even if it was uncomfortable, painful, and messy. I had to work them out, write about them, pray about them, make peace, let go, and take in the wisdom that came from it all. God will allow things to happen to you not so you can think, "Woe is me, my life is terrible," but because he wants to train you. He uses everything for good. Something else I needed to discover was what healthy really means. Even though I spent most of my high school and college years learning about health and wellness, it seemed as though I was missing something big. What is a healthy relationship with food and exercise? What does it look like? In order for me to get this in alignment, I went through a lot of trial and error while searching for correct answers. I came across this amazing devotional called *100 Days to Brave* by Annie Downs. Some of her devotions really resonated with me in how God views your health. I had never thought about health in that way. God made me, so of course He wants me to be healthy, and of course, He cares about how I treat my body. Just a few quotes I highlighted include:

"You need your muscles and your bones to be strong enough to do all the things you were called to do for as many years as you're meant to be here."

"If we don't take care of our bodies, we are limiting our ability to do His work."

"If we aren't kind to our bodies, if we aren't treating our bodies well, we are shortening our impact on the planet."

"Start viewing your body as a temple of God that you get to spend your life caring for and using for His glory."

These words were pivotal, and the long-awaited answers I was searching for. Yes, our bodies are made to move, but not to the point where it consumes your thoughts, time, and physical well-being. We should actually enjoy what we

do for exercise! Imagine that! It is scientifically proven that exercise is needed for health, wellness, and it aids in stress relief. But exercise is just a little piece of the wellness pie. I was so focused on eating and exercising that I forgot about my spiritual and mental health. God did not make you unique and wonderful only to feel trapped inside your own prison. He wants you to live a fulfilling, healthy, vibrant life. What I put inside my body matters. What I think about matters. How I view myself matters. You have to spend time learning about yourself and how your body works. Discover your triggers and what makes you tick. We all have different bodies, different minds, different views. There is no one formula that fits all. That's what makes our wellness journeys so unique and different; that's why we need to consider the whole equation.

Most important in my new revelations was remembering that God had a plan, a very strategic detailed plan, that He wanted to show me if I was willing to see. I had to acknowledge that He had given me some talents, and it was okay if they were not athletic talents. I also saw that most of the time, other people were not the problem; I was! I pointed my finger and made excuses but forgot to ask myself the hard questions. Maybe I was the one who really needed to change. Maybe I was part of the problem and not part of the solution. Every day I wrote down the true things that God says about me. I wrote down the truth that his mercies are new every single day, I wrote the truth that I am forgiven, I am cleansed, I am whole, I am loved, valuable, beautiful in His eyes, and that my story is not finished. Some of my chapters were pretty brutal and ugly, but chapters are only chapters; they are necessary to complete the masterpiece that God is writing. I envisioned the person I wanted to become. I wrote down goals mapping out how I could become this person. I prayed every single day about it. Through repetition and discipline, my thought patterns started to change. Those old VHS tapes got an upgrade. Even if the upgrade was only to DVD, it was still progress.

Who I am today in Christ is not the person I once was. (Praise God!) I can be fully free to be me without being bound by the chains of the opinions of others that weighed me down for so long. I truly believe that God uses each part of your story to help someone in need. We need people in our circles even when we feel the need to close up and hide out. I learned not to be afraid or ashamed of who I was or my story. I also learned to open up a little. Maybe someone needs to hear what you have to say. Maybe someone struggles with the same issues as you. God puts specific people in your life for a reason in a specific season. If you are willing and you fully trust God, He will perform miracles in

your life and completely transform you and your situation. There is no shame in who you are. Acknowledge where you once were, but know that you are not there anymore. Believe the things that God says are true about you, instead of the stories you make up in your head.

Know that there is no final destination on your wellness and life journey. There isn't a point when you arrive, it's a journey. As you change as a person, your circumstances change. Sometimes we encounter an unexpected detour. This is why we need the ultimate Guide, the One with the master plan who is fully in charge. We do not get our identities from the things that we own, our career, or our family and friends.

"Our core identities are grounded in the reality that we are God's beloved sons and daughters. The Creator of all the beauty that surrounds us has adopted us into His household and called us to enjoy Him fully. This era of slow and steady growth is the time to remember again that I don't *get* my identity from my car. I *bring* my identity to my car. I don't *get* my identity from my house. I *bring* my identity to my house. I don't *get* my identity from my career. I *bring* my identity to my career. My identity is anchored in *who* I belong to, not what *belongs* to me" (from *Satisfied* by Jeff Manion).

My identity went from what others thought about me and the lies I believed, to my real identity: my true identity in Christ.

I praise you because I am fearfully and wonderfully made.
—Psalm 139:14

My Oma had it right all along. There is no need to worry all the time; especially about who we are. God has a plan for us and has created us uniquely and perfect in His sight. So instead of being a worrier, become a warrior and fight to embrace your true identity in Christ.

BETH ZASTROW

After facing an identity crisis which turned life upside down, Beth Zastrow has relied on God's Word to enjoy the blessings she has been given. A wife of thirty-two years and mother of one, Beth lives in Watertown, WI. She is an Accounts Manager at a parochial high school, and although she works indoors, her free time is spent outdoors: camping, boating, hiking, cycle riding, and fishing. Contact Beth at AuthorBethZastrow@gmail.com or follow her on Facebook @AuthorBethZastrow.

Chapter Ten

Who am I?

by Beth Zastrow

I grew up in a small rural town in Wisconsin where everyone knew everyone, and everyone knew my name. I lived amongst people who knew more about me than I did. I lived with my mom, dad, and older brother. I graduated from high school and went on to Oshkosh for cosmetology school. At age 20, I met my husband while cutting his hair. After a short courtship, we got engaged. We married a year to the date of our first date, bought a home, and I moved to Watertown.

Living on cloud nine, we were off to begin our lives as the fairy tale says, "happily ever after." Then came infertility issues due to endometriosis. Wanting a child in the worst way, I prayed continually only to be let down and disappointed over and over again. Finally, after four years of marriage, we were blessed with our son. Lesson number one: it is all in God's timing. He does answer prayers! I just needed to be patient. I still have not mastered that. After three days of labor and delivery complications that put both our lives in danger, I knew this was going to be my only child. My miracle!

Life settled into a "normal" structured routine of working, raising our son, and becoming part of the sandwich generation. We were raising a family and caring for parents at the same time. We would go to my parents on the weekends to visit, help with whatever needed to be done at the house or in the yard, and help cut wood to heat their house. It wasn't all work though; we played cards or games, went out for ice cream treats, and enjoyed Mom's home-cooked meals. She was a great cook. Visits also consisted of playtime for my son with his grandparents. Grandpa teased, tickled, and chased until one or the other

tired out. There were lots of miles traveled between my parents coming to visit us and when we visited them. We were even lucky enough to have them go on summer vacations with us to Tennessee and Shawano to a cabin on the lake.

As my parents aged, they moved to Watertown to be near me so I could take care of them. They only lived here for two years before my mother became terminally ill.

I remember her calling me to tell me she had been diagnosed with cancer. I took her to every appointment and encouraged her to stay strong along the way. We spent two years going to appointment after appointment and treatment after treatment. She went through several surgeries, scans, and tests only to discover she also had a second cancer unrelated to the first, and the first one had already come back with a vengeance. I lived with my parents during my mother's last 30 days, working from my laptop and caring for both of them. She also developed terminal restlessness and had to have an alarm on her bed that alerted me every time she got up. After 30 days I was extremely sleep-deprived, and it was clear she was progressively getting worse. I had to make the very difficult decision to take her to hospice for a week to rejuvenate myself and get some sleep. This was one of the hardest things I ever had to do. I felt like I was giving up on her or surrendering her as you would a cat or dog to the Humane Society when you can no longer care for it or want it. I left her there and cried the entire way home. After only three days, she forgot how to feed herself. The nurse had her bed alarmed and video surveillance on her at all times because she was still trying to get up. She told the nurses I had been there, but that I had forgotten to take her home. I told her when the angels came, to go with them and I would take care of Dad. I kept my promise traveling on this journey with her. I promised I would be with her to the end. When I arrived at the hospice on Saturday, I knew this was going to be the day that she would travel on to her heavenly home and that she would take that part of the journey on her own. So, I crawled into her hospice bed and hugged her and held her until she took her last breath.

Six short weeks after my mom had passed away, I learned I was not who I thought I was; my dad was NOT my biological father. Along came a mind that wouldn't stop spinning. I wanted answers. Where do I go? Who do I ask? This was not the kind of news you just start talking about with your friends. How could I be 49 years old and only discovering this now? Who was I?

When I was 14, I remember a boy telling me my dad was not my dad. When this boy told me about the rumor, it was because his mother told him he

couldn't be friends with me. It always bothered me whether there was any truth to that. Again, I lived in a small town where everyone knows everyone. Surely this couldn't be. Who was I? I lived believing that my identity was what people thought about me. In high school, I was tall and thin. People teased about being too tall or too thin ... too whatever fit the description of what people thought. I dealt with depression and anxiety because I couldn't be everything that people thought I should be. Before I got married, I told my soon-to-be husband about what I had heard. We talked about everything in life, from growing up to his military career and travels around the world. We had dreams and goals. We planned where we wanted to travel. We dreamed of buying a house.

In grieving the loss of my mother and caring for an aging father, I remember thinking, "When he is not with me anymore, I will be alone," only to find out that wasn't true either!

I was truly led by God to send a friend request through Facebook to someone I knew from my hometown. We grew up living in the same unincorporated village prior to small-town life. We probably had a total of ten neighbors who lived in the "wide spot in the road" as we called it. She accepted my friend request. We chatted almost every day for about a month, at first through Messenger, then on the phone. We talked about all the people we both knew: old neighbors, teachers at school we both knew and remembered the penny candy store. We did a lot of reminiscing. We asked about each other's families and what they did. Then, a week before my 49th birthday she asked if I wanted to meet for supper at a Mexican restaurant in another community that was about equal distance for us.

I said, "Sure." I felt a connection with her. Conversation always flowed. We talked and talked...little did I know that I was sitting across the table from my half-sister! She and my other half-sisters have known about our relationship their entire lives, but I didn't. She knew my mom had passed because of the obituary in the paper, and the funeral was in the town where we grew up. So, when I friend-requested her, she thought my mom had told me about our family connection during her final days. Mom NEVER told me! When she brought something up about OUR father, my jaw hit the table! This was the moment I found out who my biological father was and that I had three half-sisters! My sister could tell by the look on my face, she had just told me some news that I was totally unaware of. She felt horrible for thinking I already knew. I experienced every possible human emotion there was. I wanted to talk to my MOM, and I wanted to talk to her NOW!

I came home and woke my husband. I said, "Do you remember when I told you I heard a rumor about Dad not being my dad? You are not going to believe what I just found out tonight."

How do you delicately, respectfully, ask a 96-year-old grieving husband about this? When my mother passed, my parents had been married for 67 years. I could not possibly do that to him, not now. Both of my biological parents are now deceased, so I called my older brother instead and asked him what he knew and what he could remember. He shared, and this was the deepest discussion I ever had with him my whole life. It helped me to understand him, and understand the strained relationship he had with our mother. I felt paralyzed and unable to leave the house. My bed and home became a safe haven for me. No one could hurt me there, especially if I didn't let them in. But how long could I stay inside and hide? Or maybe I would never go out again?

I called my dear friend and sister in Christ, bawling hysterically. "I need to talk" was all I could say. She asked if I wanted to come over and I said, "No," so we decided to meet at church. It was later in the evening and no one was there. This was a place where I felt safe to meet. She was there waiting, met me in the entryway, and before we could go through the next set of doors I told her, "I don't know if you will still want to be my friend after I tell you this." I remembered that day way back when I was 14 years old, and how that boy's mother wouldn't let him be friends with me. She assured me there was nothing I could tell her that would change our friendship. She was right! Life as I knew it was forever changed. The next day when I couldn't face the world and get out of bed, she even came to my house and made me tea.

The following week, we were checking in and visiting with Dad, and my loving supportive husband who served six years in the military started to make conversation with him about war stories. Dad finally told us he was injured in WWII, and it had caused him to be sterile. Again, my jaw dropped! I thought, "How am I 49, and first hearing this?! WHERE have I been all my life? Who am I?" I didn't even really know the people I lived in the same house with and ate dinner at the same table with. I just couldn't let this rest. I started looking for my birth certificate. My mom and dad's names were listed as my birth parents. What was going on? I was so confused. Was this a nightmare or reality?

I prayed, "God please help me sort this out."

Apparently, back during the time when I was born, if you were born to a married couple, you were presumed to be their child—no questions asked. My

birth certificate did not satisfy my need to know. I wanted substantial proof, so I ordered a DNA kit. My dad and I did the swab test, I packaged it up following all the instructions, and waited for the results. When they finally arrived, I stared at the paper in disbelief. It said there was a .02 probability match that the man I called "Dad" for 49 years was not my biological father.

When my birth certificate did not match the DNA results, I checked my baby book again. While searching, I discovered that my first visitors were my biological father and three half-sisters. I dug through the old photo albums that I brought home from the apartment, and sure enough, there in black and white was not only one, but several pictures of me and my biological father.

Why did she keep these if it was a secret she didn't want me to know? So many unanswered questions. Some questions will always remain a mystery and never be fully answered. My sisters and brother have told me what they know, but I take comfort in the Scriptures.

> *For you created my inmost being; you knit me together in my mother's womb. I praise you because I am fearfully and wonderfully made; your works are wonderful. My frame was not hidden from you when I was made in the secret place. When I was woven together in the depths of the earth your eyes saw my unformed body. All of the days ordained for me were written in your book before one of them came to be.*
>
> —Psalm 139:13-16

> *The words of the Lord came to me saying, "Before I formed you in the womb I knew you; before you were born I set you apart.*
>
> —Jeremiah 1:4-5

I remember weeks of feeling like I was at an amusement park. Life was like a roller coaster ride, first the scrambler, then the tilt-a-whirl. I went from ride to ride not knowing how long this was going to last. There were many times I was dizzy and nauseous and just wanted to get OFF this ride. The whole time, people who knew me just thought I was having a hard time grieving my loss. I simply wanted everything to be normal again. Well, friends, this was my new normal. I prayed and prayed and prayed. I had daily, nightly, and sometimes hourly talks with God.

"God please give me the strength and the words to tell my son in a way that he will understand, and it won't change any of the wonderful memories he has with his grandparents." My son still has fond memories of time spent with his grandparents and the things they did together. Praise God!

Meanwhile, my half-sister and I spent time together getting to know one another, and she was able to tell me a lot of things. There were days that turned into nights of talking. The more I found out, the more I realized that people in our hometown knew for years what I hadn't. She also arranged for the other sisters to come to her home to "re-acquaint" themselves with me, and meet me as an adult. We shared laughter, memories, tears, and hugs. They each introduced me to their children as time went on. My husband and I invited the sisters, my brother, and their spouses to come over to talk through whatever anyone had to say. We welcomed them all into our home from the beginning. We don't count them as halves; they are all just family. My recommendation was that we go forward and make our own memories—if we didn't this could consume us. Romans 12:16 tell us to live in harmony with one another. 1 Corinthians 13: 4-5 tells us:

Love is patient, love is kind. It does not envy, it does not boast,
it is not proud. It is not rude, it is not self-seeking,
it is not easily angered, it keeps no record of wrongs.

I have always lived by the motto, "Faith, Family, Friends." I continue to walk on the paths where God leads me. Sometimes you have to let go of the picture of what you thought life would be like and learn to find joy in the story you are living. I decided this was what my attitude was going to be. I have been given the blessings of more family, many nieces, nephews, and great-nieces and nephews. I even have one great-great-nephew!

I met one of my sister's sons, and his wife and their son. I couldn't help but stare at these people who looked so familiar to me. I suppose they would. Coincidentally, one week prior we were all camping at the same campground, sitting one picnic table away from each other playing bingo. We did not even know each other, much less that we were related. Once we figured that out, after being officially introduced, we laughed and laughed! We still camp together every year, only now we sit at the same table. In the most confusing and difficult times, I didn't know where to go and who to ask for my answers. Some have

been answered by my siblings based on their account or recollection and some will never be answered.

Trust in the Lord with all your heart and lean not on your understanding; in all your ways acknowledge him, and he will make your paths straight.

—Proverbs 3:5-6

I have been blessed to share holidays, visits, and meals with this new family for the past four years; all while making new memories. One of my sisters has congestive heart failure, and she always dreamed of meeting Brett Favre. When he came to Madison, WI, a few years back, I was privileged to go with her and see her live her dream.

Life still presents its hurdles and obstacles. With my blessings came having to change medical records and owing an explanation to the doctor I had been seeing for 20+ years. At the age of 20, I had married and moved to my husband's hometown, so people knew I had a brother. Now, I couldn't keep my family a secret as people had in the past. When people asked what I was doing, I said, "Going to my sister's." This caused some confused looks. I would have to explain the best I could. To be honest, it was like pulling a scab off over and over again. My concept of identity was what others might think. Were these people not going to want to associate with me anymore? My friend once told me, "You have become really good at protecting yourself." I put on a smile and pretended everything was okay when deep inside I was a hot mixed-up mess. My head. My heart. My stomach. I tend to put on a protective coating, kind of like the hard shell on an M&M: the inside is still soft and creamy, but very protected. When you are in a dark place you tend to believe you have been buried. Perhaps you have been planted to BLOOM?!

Faith, family, and friends have helped mold and shape the identity I walk in today. I compare this chapter in my life to road construction in Wisconsin. After putting up all my barriers and road closed signs, I began by digging out all the bad material and hauling it away to a pit to be buried. My next step was to bring in the new materials (forgiveness, God's Word, and my true identity). Once I laid down the new subgrade (making new memories with family and friends and enjoying the blessings), I sub-compacted it (with repeated prayers). I was then able to pave a new road. Will this road always remain new and

BETH ZASTROW

smooth without potholes? Probably not. The storms of life will have their effect, but I know where to go to get the patching materials (the Scriptures) I need.

My dad will always be my dad. He is the one I spent my life with. Who is my father? My Heavenly Father! He's equipped me with life tools. He provided me with a husband and best friend. After our infertility issues, He gave us the blessing of a son, along with the joys and struggles of parenting. He made me a wife, a mother, a daughter, a sister, and a friend. I can live with that! He led me to a job in a Christian high school, where I've worked for the past 19 years. It's my Heavenly Father that taught me my worth. He showed me my value lies in who I am in Christ, and in what Christ has given me to do.

God walks with me and He talks with me and He tells me I am His own. That is where my identity comes from. Identity is not the name on your birth certificate. Identity is not defined by your circumstances. Identity is definitely not determined by what others might think or say about you. Identity is who God created you to be.

Who am I?

I am a child of God!

So do not fear, for I am with you; do not be dismayed, for I am your God. I will strengthen you and help you; I will uphold you with my righteous right hand.

—Isaiah 41:10

For I know the plans I have for you, plans to prosper you and not to harm you. Plans to give you hope and a future.

—Jeremiah 29:11

Footprints by Margaret Fishback Powers, 1964

One night I had a dream...

I dreamed I was walking along the beach with the Lord, and across the sky flashed scenes from my life. For each scene, I noticed two sets of footprints in the sand; one belonged to me, and the other to the Lord. When the last scene of my life flashed before us, I looked back at the footprints in the sand. I noticed that many times along the path of my life, there was only one set of footprints.

~122~

I also noticed that it happened at the very lowest and saddest times in my life. This really bothered me, and I questioned the Lord about it. "Lord, you said that once I decided to follow you, You would walk with me all the way; but I have noticed that during the most troublesome times in my life, there is only one set of footprints. I don't understand why in times when I needed you the most, you should leave me.

The Lord replied, "My precious, precious child. I love you, and I would never, never leave you during your times of trial and suffering. When you saw only one set of footprints, it was then that I carried you.

MARLENE DAWSON

Marlene Dawson is a two-time #1 Best-selling Author and retired Special Education Paraprofessional. Other jobs include Executive Assistant and Deputy sheriff. She comes from a broken family background, raised to think the worst about herself. When she learned God loves her and has a beautiful plan for her life, she became a born-again Christian. God placed a desire in Marlene's heart to tell others about His love for them and the plans He has for their lives. Marlene and husband Jim live in Southeast Wisconsin and have four adult children and eight grandchildren. To learn more, visit marlenedawson.com.

Chapter Eleven

But God ...

by Marlene Dawson

"If I plead innocence, I am a liar. If I plead guilty,
I am condemned. So, I plead the blood of Jesus."

—Marvin Winans

Throughout my childhood, I was expected to be more aware, more alert, and more conscientious than anyone I knew. I was supposed to let my folks know whenever my siblings misbehaved. I did not comply very often, but I did become an expert at telling my sibs what they needed to do differently or better. Sadly, instead of helping them and growing a closer relationship as I had hoped, it caused division and separation. But God always has a plan.

When I was six or seven, I became aware of a cruel pattern my biological dad developed. When one of us was naughty, he asked, "Okay, who did it?" If no one owned up, he would take his belt, working his way up chronologically. When I was seven, my siblings would have been two, three, four, and eleven. I could not stand to watch him hit the little ones, so if someone else didn't speak up, my "I did it, Dad," was enough to satisfy his need to punish. If you read my story in *The Miracle Effect* (FEW Publications, 2017), you will know about the regular physical, mental, and sexual abuse I suffered from my biological dad. I learned to cover for him and tried protecting my sisters and brothers. PTSD was not on the radar sixty years ago, so there was no support for those like my dad, who were returning from the war, or their families.

When I was ten, my mom suffered a nervous breakdown. After the ambulance, the police, the priest, and the neighbors left, Dad pulled me aside, an-

grily growling, "This wouldn't have happened if you had only done what your mother said. You're the reason she was taken away from us!" I did not know what he meant, so I guessed that it had to do with taking care of my younger siblings. When they misbehaved, I often got into trouble. It would be many years before I understood his manipulative and controlling ways that kept me scared enough to keep his secrets. But God ...

Perfectionism found a secure home in my life for many years. One secret of a perfectionist is acting perfectly normal no matter what else is happening. I became an excellent actress, pretending my way through life. I was told many lies about myself, all of which I believed at the time. Many lies were covert, rather than overt; words were scrambled in ways that, if called out, the abuser could say I misunderstood him. I never told anyone what my home life was like until I had been married for nearly ten years. My biological father abused me from the time I was in diapers until I was seventeen years old, but he was not the only one. I have also suffered at the hands and words of a dozen or so others.

I remember inviting a neighbor's son to a cookout at my grandparents' house. He was not there by dinnertime, so Mom said, "Go see if he's still coming, Marlene!" Running and skipping, I hopped up on their porch and knocked. His dad answered the door. "Oh, hello, Marlene. Andrew* is in his room. You can go get him."

"Yes, sir!" But he was not in his room. Turning to ask his dad where Andrew was, I instead ran straight into his dad's legs, blocking my path. He picked me up and threw me on his son's bed, covering my mouth. Even though terror filled me, I tried to bite his hand. He abruptly left after doing unspeakable things. I didn't know where he went, and I was scared. I quickly put my clothes on, ran home, snuck in the back door, and fled straight to my bedroom. Our families were supposed to go to the ocean together the next morning. I didn't know what to do. Mom found me in tears a few minutes later. Choking and crying, I told her what happened. She assured me it would be okay.

"I'll take care of it." She smiled and kissed my cheek, wiped away a few tears, and left me.

The next morning, she beckoned, "Marlene, I want to talk to you."

Reaching for my hand, Mom guided me to the sofa. "I've decided to let you stay here today. We'll pick flowers, make a pie, and have fresh lemonade

with lunch!" Her light, airy voice calmed me. "What is everyone else doing?" I wondered aloud.

"Well, they're going to the ocean, but we are staying home, so you don't have to be near that man again."

"You mean, I have to stay home from the ocean, and they all get to go? I didn't do anything wrong, Mom! Why can't I go?"

"Well, this is the best I could do. So, we'll just have to try and have fun here."

I cried again. It was a time when children didn't whine or complain much, especially in front of parents. So once more, I pretended. I never saw Andrew or his family again. Two weeks later a friend at school told me they "just up and moved." But God…

The summer I was fourteen, I joined the Civil Air Patrol, with friends who liked airplanes and flying as much as I did. There was a high school boy who led my group, and all of us girls had a crush on him. He seemed to like me, too. He was throwing a party for his sixteenth birthday, inviting the whole group. The party started at 2:00 pm, but he asked me to come over early to help his mom set up. I walked the short distance to his house. When I arrived, I noticed his car was the only one there.

"Hey, aren't your folks supposed to be here?"

"Mom's car is in the shop, so Dad took her to get some ice and more pop."

"Oh, well. What can I do to help?"

"Well, first of all, you can come here, beautiful!" he smiled, holding his hand out to take mine. "Ahhh, alone at last!"

He planted a gentle kiss on my willing lips. We sat on the sofa, "but only for a couple of minutes," he assured, sensing my hesitation. The gentleness suddenly turned rough. He grabbed my shoulders, forcing me onto my back, his kisses becoming more intense. I pushed him onto the floor and dashed for the front door, but he grabbed my ankle and pulled me to him. I pushed against him with my other foot, managing to get up. He stood between me and the door, so I stood with my back against the kitchen wall to keep him in sight. I felt desperate, wiping away my tears.

"Where is everyone? What about the party?"

"My folks went to the store. The others will arrive when the party starts, in

about ninety minutes." His smirk made me realize how naive I was. Fighting to keep my mind clear, I continued asking questions, thinking of some distraction so I could get to the door.

"Why me? You will never get away with it, you know! What if I tell your parents?"

"My parents never believe the girl."

Okay, that one scared me...a lot! I knew I needed to get out of there, and fast! So I did the only thing I could think of: pretend I was interested in him. When he reached around me, I punched him in the gut, shoving him backwards and ran for the front door, slamming it as hard as I could. I didn't look back, and he didn't follow me. I never told anyone what happened. I quit the group, one of the few places I had felt safe before that day. But God...

These are thumbnail sketches of just some abuses I have suffered. As I look back now, I can see God's protection. The devil will do everything he can to get Christians to disbelieve what God says about us. He tried to make me think I was useless and worthless. I believe Satan often knows what is happening in the spiritual realm because he can see what God is lining up for us. He wants to destroy us before we have an opportunity to respond to God's call. When I was four, I made a vacation Bible school profession of faith. I do not recall that at all, but God never forgot me.

We each have people in our lives who have impacted the trajectory of our lives, whether positive or negative. We place trust in the opinions of others, and sometimes that trust is misplaced. Some people I hoped would help me grow in my faith placed unspoken expectations upon me I could never live up to. A couple of years after I committed my life to God, I was part of a women's Bible study, led by a beautiful lady from England. One day, after the study where I shared how God let me minister to someone on the street, one of the ladies approached me with a look of deep concern on her face. At least that's what I thought.

"Marlene, when you lose weight, God is really going to use you!"

I was still easily wounded then, and I thought she meant God would not use me until I lost weight and praying for the street person did not count. I began believing the lies of Satan, thinking nothing I did for God counted, even when I knew God had directed me.

The weight has been an issue for most of my adult life. As a child, and on

into college, I was very athletic. When the weather kept me indoors, I would read and write stories and poetry. I began reading at least one book a week in elementary school, and even more as I got older. I became a writing tutor in college, so I was offered a speed-reading course, which helped me read three or four books a week, even after I married. The weight issue continued.

When our youngest son was eighteen months old, I became a DJ for our local Christian radio station. God was walking me through the healing of my childhood abuse issues, and He was teaching me that I actually *am* someone, because I am in Christ. This was new thinking for me. Although a home church we attended presented God as a loving Father, I never believed it applied to me because of the shame of my past. My boss at the station and all the staff spoke God's love and life over everyone, and I became a sponge, thirsty for both of these. The station had a designated prayer room, open 24/7. During the summer and holidays, I would often go in at 6 AM, spending hours in that room. The presence of God was lifegiving, and I received much healing.

The station sponsored a concert by Harvest, my family's favorite Christian band. There were hundreds in the audience, and each song by Harvest ministered to me. When they began singing "You'll See a Man,"** I was crying so much I moved to stand in the back. While going through abuse counseling, I had a question for God that I never dared ask. But when Harvest began singing the chorus of this song, that question jumped into my mind and out of my mouth! I can still hear all those soft voices joining in on the chorus; it was a beautiful canvas for what God was painting in my heart:

> You'll see a man acquainted with your sorrow,
> You'll see His eyes sharing in your tears,
> You'll see His arms never lost their hold on you,
> Lift your eyes, you'll see the Lord.

I flashed back to an out-of-body experience when I was eleven. Hovering over my lower bunk bed, I watched my biological dad abuse me. Jesus was hovering next to me, His left arm around my shoulders, His right hand holding mine. I finally posed the question.

"Lord, where were You when this was happening to me?"

He tenderly looked into my eyes, kissed me on the cheek, and pulled His arms away. I felt bereft as He moved. I turned to watch Him leave, but He stopped about five feet from me.

"I was right here," He said, raising His arms out from His side, showing Himself hanging on the cross. His next words changed everything for me.

"My precious daughter, I not only died for the sins you committed; I also died for all the sins committed against you."

I collapsed onto the concrete floor, tears pouring down my face. The lady to my right gave me tissues, sitting and praying for me until I could compose myself. But God...

I started seeing my life through a different lens. I looked back and saw God in situations I thought He would never be near. I was able to see God's protection, stepping in to rescue me too many times to count. The biggest change was becoming free of the shame I carried most of my life. My father told me that all the abuse was my own fault. I could never figure out how I caused the abuse, but I believed him. I had always assumed abuse happened in every home, but no one ever talked about it. I was fifteen before I realized this wasn't true, but the shame and personal blame had become firmly entrenched in my belief system. I carried these until that glorious evening at the Harvest concert. I learned that Jesus took my shame, real and imagined, and nailed it all to His cross! It was no longer mine! Looking at the Bible anew, my heart opened to believe God's life-giving words.

Twenty years after the Bible study lady made that comment, we attended a nice, family-friendly church. I taught children's church and was involved with drama, hospitality, and outreach. I also cleaned the church each week. Occasionally, the Lord gave me an encouraging word to speak in front of the church. A few days after I shared such a word, while I was cleaning the fellowship hall, one of the church leaders approached me with a big smile. Turning off the vacuum, I asked if he needed something. Even though I was now less sensitive to what others thought of me, his response was so unexpected, I was speechless.

"God may not care how you look, but I do. You will not go up front again until you lose weight."

He spoke with a slight laugh. It seemed like he thought this would either disarm me or make his words less destructive. It did neither. It broke my heart. I pretended it did not affect me, but of course, it did. I mean, if my pastor didn't think I was valuable and available for God to work through, who was I then? I questioned if what I did mattered to God, and this sealed it. I would never be good enough until I mastered my weight issues. Believe me, I tried! Over the

years, I have joined numerous weight loss programs, enjoying some success, but then failing again and again. I have prayed, fasted, cried, asked for help, and always I hoped and cried again. While attending this church, the Lord directed me to go on a forty-day fast. I had done many shorter fasts, at God's leading, and I always asked, "Father, when am I to start the fast?" He answered, "I will let you know." It would be two and a half years before He gave me the clearance to begin the fast. I was learning so much about God and His ways during those years. He continued to reveal Himself through the Bible, using many verses to change my thinking about Himself, myself, and my purpose.

Reading through the Bible dispelled the fear that I was not Christian enough to ask God for help. In Hebrews 4:16 we find instructions on approaching the Most Holy God:

> *Let us, therefore, draw near with confidence to the throne of grace, that we may receive mercy and may find grace to help in time of need.* (NASB)

This confidence is also known as boldness. God, Himself, is telling us we can boldly come to Him for whatever we need. I remember a magazine cover from the early 1960s. The picture shows President J. F. Kennedy sitting behind his desk in the Oval Office. The photographer was situated behind the President, off to his right. JFK is signing some papers and smiling. The camera angle allows us to see under his desk, where little four or five-year-old Caroline is playing with her dolls, on her daddy's feet. It was an intimate family moment shared with the world. This is how we get to approach our Heavenly Father! We are His children, and He loves us, and He only and always wants what is His best for us!

Another ploy the devil uses to deceive God's beloved is convincing us our sin is too big for God. That was certainly true for me. I have given you a few glimpses into some of my broken and nearly destroyed life. The enemy had me convinced for many years that God could not use me because of those painful secrets. "But God" are two of my favorite words in the Bible. But God has a different idea, which He clearly shows us in Romans 8:28 (NASB): "And we know that God causes all things to work together for good to those who love God, to those who are called according to His purposes." God will use everything we give Him! He wants us to trust Him with all of our heartbreaks and pains. He

can take care of us, and He can use our most difficult places to minister to others who do not yet know His tender love and mercy. God has taken each and every one of my pain-filled experiences, and He softens me so I can see through His eyes of love, and then He frequently touches others through my story.

My story. It would be so different without my mom, and it almost was. When I was eighteen, she attempted to take her life again. This time was different, though, because I found her and the note she left. This particular day, I walked by her closed bedroom door; we were never allowed to go in if the door was closed. It was the first time I ever felt a nudge to check on her. Turning to see who tapped my back, the hall was empty. I gingerly opened the door, whispering, "Mom, are you awake?" No answer. Well, she didn't yell at me, I thought. I stepped into the curtain-darkened, smoke-filled room, glancing at the ashtray and Mom's cigarettes on her nightstand. Tiptoeing to her bedside, I made sure the last cigarette was out. "Mom?" I paused, bending low to hear her breathe. It was very faint, but it was a breath. Next, I tiptoed to her dresser, spotting an unsealed envelope on its side. Turning it upright, "TO WHOM IT MAY CONCERN" was clearly inscribed on the front. So, I opened it:

> To whom it may concern: If you found this note, I am already gone. I am sorry I couldn't stay with you longer. I took too many sleeping pills, so there is no hope for me. Tell my husband and children I love them.

Thank God for shock! Even though numbness was setting in, I managed to stumble outside to tell my stepdad, a former EMT, a man I trusted. He yelled, "I'll go to her, call an ambulance!" The next few hours are a blur. I remember going back into the room, seeing dad doing CPR, and looking for the note, which I did not find. Dad kept Mom alive. I later asked him about the note. He showed it to me, saying he would make sure the doctor got it. Thankfully, Mom survived and did not need much aftercare. It was months before I discovered the doctor was never given the note. Dad said he wanted to protect her. Soon after that, I began dating my future husband and didn't think about this detail very often until writing this chapter. As I began note-taking for *The Identity Effect*, I thought of that day, and the many pivotal parts Mom plays in my story. Three months after this attempt, she tried again; this time one of my brothers found her and the note. My mom tried to end her life at least six times. The devil did all he could to take Mom's life and keep her from impacting her children for the Lord. The devil lost. Fifteen months after my brother found mom,

she became a born-again Christian, and it was she who led me to the Lord six weeks later.

Learning who we are in Christ takes place throughout our entire lifetime. For instance, when we need patience, God does not just say, "Oh, you want more patience? Here you go!" No, instead He allows us to be in situations where we get to choose patience. As we grow in patience, we are given more opportunities to grow even more patient. It is the same process with most every area of spiritual growth, including learning our true identity. Fortunately, there are some tools to help us on this journey. The best tool is the Bible: God's written instructions teaching us how much we are loved by God. When we read the Bible, we learn the history of what He has done to bring us back to Himself, despite our sin and brokenness. Another tool is believing what God says about Himself and about us. In His mercy, God never expects us to have it all together. As we continue to pursue Him, He reveals more of our need for Him, but He also reveals more of His love for us. God really does have plans and purpose for each of our lives! I used to think God would only use me when I did what others expected of me, not even knowing what that looked like. So, I decided to ask God. His response helped me to choose His truth over others' opinions.

"How can You use me when I'm weak and struggle so much in these areas, Lord?"

"Look at all the places where I have ministered through you. No one can thwart my plans for you (Job 42:2 NASB); I have always known your heart."

When we are in Christ, we take on the humility of Jesus, and we are never useless or worthless. Our stories become the story of what Jesus has done and is doing in and through us. I am a firm believer that God meets each of us where we are. My journey could only look like your journey if our lives were identical. The common pieces will be our pursuit of God, and how His love fills in those broken places. But God always has a plan, and He will make it happen!

*Not his real name.

**Lookup Harvest Christian Band's song, "You'll See a Man," on YouTube. Several of their albums and other songs are there, also.

BROOKE KANGAS

Brooke Kangas is currently entering her senior year of college and will graduate in Journalism with a Strategic Communication degree, paired with a minor in Business Management. Her plan after graduation is to go where Christ leads her. She is known for her bubbly personality and "go-getter" mentality. She has a passion for blogging and recently co-founded a business with her family called Ola Soul. Brooke loves to be personable with others, talk stories, and adventure outside as much as possible. Her love for Christ continues to grow. For more information, visit brookekangas.blogspot.com or ola-soul.com. Contact Brooke via email at brookekangas@yahoo.com.

Chapter Twelve

I Know

by Brooke Kangas

"You have no faith," he said.

His blue eyes were ice-cold.

With emotions through the roof, how was I supposed to recover after such a cruel, heart-wrenching statement from someone I thought understood and shared my deepest faith? This was someone I had previously looked up to for spiritual growth and discernment, which made his words pierce even deeper. Immediately the lies, the doubt, and the brokenness were unleashed and began to overwhelm my heart.

Deep breath. Walk away, I whispered to myself as tears streamed down my face. I couldn't bear to look at him anymore. I quickly turned my body away and felt my feet running as fast and as far away from him as possible. I knew he was wrong, yet I couldn't help but second-guess myself. There was still that faint whimper in the back of my mind repeating the words, "I am a child of God and this is my identity in Christ."

I was 20 years old and on the beautiful Island of Hawaii when these four words were spoken to me. I had just finished a weekend-long church retreat that grew my faith and walk with Christ to an immeasurable deeper level; nevertheless, the enemy will still use anything and anyone to try to shake the ground beneath you. In this case, he used someone who was dear to my heart and close to me, but who was also in a hurtful state. God's word tells us in Proverbs 18:21, "Death and life are in the power of the tongue and those who love it will eat its fruits." We know this to be true because, at one time or another, I am sure we have all felt the joy and the pain that can accompany others' words, along with our own. We then have to decide who and what to listen to. I may

have second-guessed myself and my faith for a moment after those words were spoken to me, however, I consciously chose to listen to God and not the enemy that day.

This is my life and my journey of continuing to find my identity in Christ.

I was blessed to grow up in a family that attended church and was surrounded by those who helped teach me to love God as my Lord and Savior. However, that doesn't mean I never fell short of loving God with all my heart, and I still fall short today. I was baptized as a baby, and I decided to be re-baptized in 7th grade because I wanted to make the decision for myself to follow Christ.

Entering high school, I joined YoungLife, which is a global organization that introduces adolescents to God with a mission to help them grow in their faith. YoungLife created a positive environment that enabled me to be surrounded by a group of girls who were seeking the same faith and path as I was, along with inspiring female leaders to help guide us. It was the last night of camp and our last worship service when we were instructed to be silent for thirty minutes all throughout the retreat area. We were high up in the mountains of Colorado, surrounded by thousands of bright shining stars and peers from four different states. The atmosphere was completely silent; all you could hear was the faint whistle of the wind through the trees.

I sat alone next to the camp pool and laid my head beneath the stars. At this moment, I had faith in the Lord, yet still struggled with what it meant and what it felt like to have God move in my life. That night was when I bowed my head to pray for God to reveal himself and show me the ways he could work in my life. From such a simple prayer, a wave of incredible peace and calmness flooded my body. It was a feeling I had never experienced before, and this was when I knew I would be able to fully feel God's presence working in my life because I finally allowed Him into my heart.

After this retreat, I was so excited to start my junior year of high school with girls who I thought would walk alongside me while we grew in our faith together. It was now fall of 2014, I was halfway through high school, and I had spent the past two years with the same group of girls; all of whom belonged to YoungLife. What I did not know was that I was going to be betrayed by just about every single one of them.

We had just played the girls' powderpuff football game for homecoming week. It is a tradition for T.P. wars to occur throughout homecoming week; juniors and seniors would toilet paper each other's houses for fun. (It can be a harmless tradition if you are only using toilet paper and keep within the boundaries of a junior "toilet papering" a senior, or vice versa.) After the game,

a group of us junior girls had plans to go out and T.P. together later that night. Once home and showered, I received a text that I couldn't come with them anymore because there wasn't enough room. Bummed, I decided to watch for my house instead, just in case any of the seniors tried to T.P. me. Around the late hour of 11:00 PM, I witnessed a group of cars parked in the cul-de-sac next to my house. Ready to defend our house from whoever this was, my dad and I peered out of our glass back door and prepared ourselves to run if they were to enter our yard. Sure enough, a group of shadows began to creep toward my house. My dad and I quietly snuck out the back door and started sprinting towards them. Shocked, they all turned to run back to their cars. My dad and I had outrun them at this point and were waiting at the cars when I witnessed all of their faces in disbelief. Every single one of these girls who were my so-called friends had just tried to T.P. my house! I remember looking at them in confusion, feeling humiliated and betrayed by those I once thought were my *true* friends. They had no explanation for their actions, except to think it was funny. I found it especially difficult to understand their actions considering we all just went on the YoungLife retreat together, and we were supposed to be lifting one another up as *sisters in Christ*. This was when I developed mistrust for some of my peers, mistrust in those attending YoungLife, and was just trying to navigate what it meant to be a young, high school Christian. I want to say junior year was one of the highlights of my high school years, but I suffered a difficult amount of heartbreak. My friends turned their backs on me, my boyfriend cheated on me with one of my best friends, and I was being publicly bullied by girls.

And we know that in all things God works for the good of those who love him, who have been called according to his purpose.
—Romans 8:28

Two years later, in 2016, after I graduated from high school, I made the decision to attend the University of Minnesota. I was ecstatic to finally start over because no one from my high school was going to be attending this university. However, plans changed. The week prior to my graduation, my cousin of the same age was diagnosed with cancer. It hit our family suddenly and that summer was full of many trips to the hospital for chemo treatments and prayers on prayers on prayers.

Then, two days before my first semester of college started, I received a phone call.

My friend, Erin, was calling me. *Hmmm,* I thought, *she never calls me.*

"Hello?"

"Hey Brooke, did you hear about Max?"

"No ... what is it?"

"He committed suicide."

Max was someone I grew up with since kindergarten. Over the years, we spent many times together that brought us super close, and then towards the end of high school, we ended up rarely talking. Prior to this phone call, I remember my mom telling me to text Max to see if he was enjoying his college choice of Alabama.

I never did. I never sent the text.

Guilt flowed in quickly along with the questions and the regrets and the pain. Before classes had even started, I was already on a bus ride home to the funeral. I wanted to yell at myself and to yell at God and ask Him why this was all happening. Graduating from high school and entering college is supposed to be one of the most exciting times in our lives, and I was dealing with so much grief.

The Lord is close to the brokenhearted
and saves those who are crushed in spirit.

—Psalm 34:18

A few weeks after the funeral, a friend confided in me about his own suicidal thoughts after Max's death, and I spent the entire fall semester trying to help someone who was depressed. I did not realize how serious it was until he would call or text me when he was having negative thoughts and then would turn off his phone. I wouldn't be able to reach him for extended periods of time; sometimes an hour and other times not even until the following day. I soon acknowledged that this was taking an emotional toll on me, especially since I was not a professional who knew how to handle these types of situations. Even worse, I was trying to handle each situation by relying on my own strength instead of seeking God in moments of silence and prayer. This led to an unconscious decrease in my faith. I would pray but didn't truly trust that anything would come out of it. Anger had flooded my body from the previous months leading up to this point, and I had allowed my heart to harden. I forgot the good God provides on a day-to-day basis.

By the second semester of my freshman year, I completely lost sight of who I was. I was dating someone from high school who I had also met through YoungLife. We had been navigating a long-distance relationship from Minne-

sota to Florida, and after the hardships, I encountered that previous fall semester, all I wanted was to feel more and more loved. This led to an immature sequence of events and an unfixable gap in our relationship. Instead of pouring my love and energy into God, I was pouring it all into someone who was leading me farther away from my faith and from myself. It wasn't until we broke up in April when I started to find traction again. This was when I bought a journal from Amazon, picked up a pen, and began to write. Writing became my therapy for a while. I started to pray while I wrote.

Also during this time, my cousin found remission from her cancer and my friend was receiving the professional help that he needed. This created an increase in my faith again, and I felt like I could finally take a few deep breaths ... sort of. Once I started to find my feet solidly underneath me again, my uncle, who has had cancer for years, was told he had six weeks to live. His multiple myeloma cancer turned into leukemia; it was everywhere. Once I found out, all I did that night was weep and pray.

During this turmoil, a good friend of mine mailed me the *Jesus Calling* devotional book by Sarah Young. This was the first devotional I had ever received, and she and I used to read it each night together. Because it was so powerful for me, I bought one for my uncle, who was stuck in a hospital bed. I was finally beginning to grow back into my faith and lean on God, not for my own understanding, but for His.

I then found out about the National Student Exchange program through the University of Minnesota, and the opportunity to study in Hawaii. I needed a fresh start and I thought this would be the perfect place to go: as far away as possible and a breath of fresh air. So, without hesitation, I applied to the program and made the decision that I would be attending the University of Hawaii at Hilo. Little did I know that this was a completely God-sent situation.

The moment I stepped onto the plane from Los Angeles to Hilo, Hawaii, God placed the most wonderful woman, Karen, in the seat next to me. We naturally began talking and she helped me begin this new journey. I realized God was showing me that I was not alone. Karen provided everything that I needed in Hawaii. She introduced me to a Christian group on campus called BCM (Baptist Collegiate Ministries). The first week, I met everyone in BCM, and they took me in like I had already been a part of their family for years. To this day, I am still so incredibly thankful, because my faith has significantly grown ever since. BCM established a community of individuals who not only love but help serve the Lord. They are such encouraging, non-judgmental, and Godly people who help walk with you through all life circumstances. I learned this quickly through the way they treated others as it is written in the Bible, "to love your neighbor as yourself" (Leviticus 19:18). They became my go-to

people when I needed encouragement, prayers, and a home-away-from-home. I found a church to attend each week in Hawaii with my new friends, and I finally found my faith again. I wasn't just praying on a regular basis as I would normally do; I was immersing myself along with individuals who strived to live Godly lives. This meant that I grew apart from the whole "Big-10" party scene I knew at Minnesota. The regular sinful temptations subsided a lot, and instead, I directed a great amount of focus towards attending church and being with those who led me closer to God.

Since I had such an amazing semester that spring, I struggled with the idea of transferring to Hawaii full-time but decided not to. I had already signed a lease for the fall semester of 2018 back in Minnesota with four girls who were my best friends from college. I wanted to keep my commitment to them, so I compromised with myself instead to go back to Hawaii for one more spring semester in 2019.

Entering the fall semester of my junior year, I was very hesitant to be back in Minnesota. I didn't know how my roommates were going to act and what I was going to do once I was back. I was nervous about finding a church there, the whole party scene, and missing Hawaii. The first two months were okay—I found a church to attend each Sunday and it was the only thing I actually looked forward to each week. It was my safe sanctuary. Then in November, my roommates grew more and more distant. But I couldn't pinpoint why, and one of them had even confronted me to ask if they made me feel left out. I was relieved that we could have this conversation, so I explained the way they were making me feel, and they said they understood. The air was cleared, and we moved forward ... or so I thought.

Well, things only got worse. I was completely invisible. My roommates would come home, ignore my presence, go into their rooms or each other's rooms, and make plans over text because they would all suddenly be gone from the apartment. The times I was invited, they would leave me at places, or just completely ignore me. After multiple conversations where I asked if I had done something wrong, they just abandoned me with no explanation.

It's ironic that the same experience happened during both my high school and college junior years. It's been a humbling experience and makes me wonder if something is wrong with the person I am. But then I remember this passage from a book I read, "Nothing other people do is because of you. It is because of themselves. All people live in their own dream, in their own mind; they are in a completely different world from the one we live in. Even when a situation seems so personal, even if others insult you directly, it has nothing to do with you. What they say, what they do, and the opinions they give are according to the agreements they have in their own minds..." (*Is that the Best You Can Do?*

by Jim Philhower). Sometimes we see someone's best potential, and not who they really are as a person. It seems I had to learn this lesson twice.

The scar tissue reopened. My heart ached for the younger version of myself who poured her love and energy into a group of high school girls four years prior, and then the same thing happened. These two different, although very similar, groups of girls grew into learning lessons. God placed them in my life for seasons and removed them when they no longer served a positive purpose.

I think a huge factor that led to my roommates and me drifting further apart was that I moved away from having a typical college lifestyle. I was the only one seeking a Christian lifestyle through attending church, reading my Bible, and searching for a Christian community - while they had opposite motives. Almost all of our similarities diminished. Although, I am not perfect; I am still learning how to navigate a Christian life in a college setting, but I am so blessed God saved me and gave me a life that is so much more. Jesus explained that we are going to suffer as Christians and that those with worldly motives are going to point their fingers against us. This is exactly what my roommates did.

Fortunately, I only had one semester with those girls and returned to Hawaii at the beginning of January. Entering the 2019 spring semester, I could finally take a deep breath. I had returned to my favorite place in the whole world, and to those who genuinely and honestly love Christ. I completely immersed myself back into an environment of people who know and love the Lord. I was reunited with BCM; the place I could go to feel loved and accepted. I joined multiple Bible studies; one with a group of young women like me, and one with strangers I had never met, led by my pastor. Joining a group of individuals whose names I didn't even know at the time was terrifying. I was nervous, but now I can say that they are some of my closest friends. This is when the Lord is *really* working. He takes us outside of our comfort zones and turns it into a blessing. God has taught me how easy it can be to simply trust in Him, and His promises will always provide.

This is my comfort in my affliction,
that your promise gives me life.
—Psalm 119:50

These experiences in Hawaii helped teach me the importance of a Christian community. Additionally, I learned that having faith is so much more than believing in God and praying (even though those are extremely significant). It is knowing our identities in Christ through loving His Word and reading the Bible. When we know our Lord, we find our identities.

Just as we have borne the image of the man of dust, we shall
also bear the image of the man of heaven.
—1 Corinthians 15:49

By allowing Him to work in our lives (which can be challenging and difficult), we can never go wrong. Our Lord has a mission for each one of us, and He will work through us to serve and bless others. I have no idea what He has planned for me in the upcoming months. I will be part of a team of five people working with churches around the Hawaiian Islands ministering to children. This will be an internship with UW Sports Ministry for six weeks. UW Sports Ministry works with local and international churches to empower them through the use of sports as an evangelistic and discipleship tool. Our entire goal is to save children's lives through Christ. I had never imagined God would lay this opportunity at my feet and want me to serve. He has blessed this entire process and showed me that through staying obedient in His callings, we can accomplish anything. The Lord has the power to turn anything sour into something sweet, just like turning lemons into lemonade.

Despite everything that has happened over the course of my high school and early college years, I can finally feel cleansed from my past. Looking back, I see that I was so enslaved to the approval of others. I believed my identity came from the boys that liked me and the number of friends I had. All of this just led to disappointment, aches, and pain. I searched and searched for intangible things to fill me but it only led to continual emptiness.

While we do not look at the things which are seen, but at the
things which are not seen. For the things which are seen are
temporary, but the things which are not seen are eternal.
—2 Corinthians 4:18

Now I look to the things that are unseen: God and what He says about my value and identity. He is the only one who can fill the emptiness that we all feel. Although people will let us down; God never will. The past can never define you if you don't let it. God defines us. I know I am a child of God. I know He never wants me to feel unwanted or hurt by those in my life. He is good, He is faithful. He loves us and never abandons us.

I am writing this at 20 years old, and that shows the Lord can use anyone powerfully at any age. I am reminded of this with a tattoo I recently received. The tattoo is a simple wave that flows into a cross, with the words *Psalm 46:5*

written below it. The wave represents my time in Hawaii and it leads into a cross to represent how I rediscovered my faith there. This tattoo represents exactly where I am right now in my life. I have never felt so present and strong in my faith before; I can fully feel the Holy Spirit working through me. This tattoo will remind me of Hawaii, as a special time in my life, and how God is constantly with me, working through me, each day.

God is within her, she will not fall;
God will help her at break of day.
—Psalm 46:5 (NIV)

So, when the enemy stares at me with his ice-cold eyes and declares I have no faith, I can humbly laugh back and proudly state that I am a child of God. No one and nothing can take that away from me. I know my identity and it is in Christ.

AMY HAUSER

Becoming a published author was always on Amy Hauser's bucket list, and admiringly, with The Identity Effect, it became a reality. Tending to be a thrill seeker, she's learning to bloom where she's planted even if that means adapting to a simpler way of life. With a quirky sense of humor, a continuous drive to reconnoiter her purpose in the world, and a hint of rebellion, she holds a passion to help others make sense of this life through grace, forgiveness and faith. Contact Amy via email at amyhauser@outlook.com. Follow her on Instagram by searching @silverlining414, or connect on Facebook here: facebook.com/amyjhauser30.

Chapter Thirteen

From All Eyes to God's Eyes

by Amy Hauser

"For I know the plans I have for you," declares the LORD,
"plans to prosper you and not to harm you,
plans to give you hope and a future."

—Jeremiah 29:11

Remember the dreams you had for your life growing up? What you wanted to be; where you would live; when and whom you would marry; how many kids you would have; the vacations you would take; the money you would make; the great impact you would have on this world according to your ten-year-old self. Wasn't it fantastic?

Do you remember your plan? I sure remember mine! It was to be engaged at twenty-two after graduating college, land my dream job, marry at twenty-four, have two to three kids between twenty-five and thirty, live in a beautiful house with a husband who would surprise me with lavish trips to Fiji, because we were, of course, going to be rich. Life was going to be perfect! Just like it's supposed to be, right?!

I hope you're chuckling. Because we certainly know better now. But, isn't that skewed view of perfection how we sometimes compare the reality that plays out in our lives? And when it doesn't, we feel slighted. We fault God for not giving us what we think we deserve in this life. We see other people living

the life we want to have. We say that life isn't fair. That "this" shouldn't be happening to us.

Consider the saying, "Comparison is the thief of joy." Does that ring true for you? It's a human reality of the world we live in. When we see our view of perfection happening for others around us, but not for us, it can disappoint, and we ask, "Why? Why not me?" As a Christian, however, we can read that saying with a different understanding. We don't always know the "why" of every experience in our lives, yet we have faith and hope that they prepare us for exactly what God's plan is. His plan for me alone, and His plan for you alone. No one else.

Life isn't always a bowl of cherries. It's a series of joys and traumas alike, decisions and consequences, and a constant process of growth towards His plan. Your story is unique to you as mine is to me. As you read these stories, allow yourself to find comfort in the familiar, vulnerability in what is not yet known, and a growing confidence to seek His plan for your true identity through His eyes alone. No one else's.

Living as a "PK", or Pastor's Kid, was a challenge. My dad is now a retired Lutheran pastor, although pastors never truly retire. Not only is my dad a pastor, but so are my uncle, cousin, and brother-in-law. Spreading the Good Word runs deep in these genes! While I am thankful for this strong faith-based upbringing today, I didn't always feel that way.

Those of you who attend church may at times feel the pressure to look, act, or talk a certain way. From early on, I felt the need to act differently in front of others, family included. Church and service to the congregation were ingrained in our everyday lives. It felt like we were living in a glass house and could never do anything wrong because of how people viewed us. We were the pastor's family. We had to be perfect.

I saw the absolute sacrifice both of my parents gave every single day for the congregation, from sunrise to sundown. It made me angry and sad when I only saw my dad at breakfast and dinner, but back to church he went for meetings and more work that didn't stop until he slept.

Mom was always baking for something, directing church choirs, calling prayer chains, writing cards, cleaning or paying bills. Work never stopped. They never stopped. My mother did all this on top of raising three children, working a full-time job, making home-cooked meals, and keeping a spotless

house. I watched my parents live for others to the point that it seemed like the thought of doing anything for themselves was unspeakable. It was heartbreaking, and suffice it to say, home was a lonely place to be.

Furthermore, our family DNA was deep-rooted in generational mental and emotional instability. It affected us all. I never knew what to expect on a given day. I walked on eggshells in my own home, every single day.

So, I did what I could to escape. The good Lord blessed me with three best friends early on in my life. I loved being with them, in their homes, with their families. Their families were around and involved in their activities growing up, and thus in mine. Making any excuse to be out of my house and with these friends was my focus. I felt free to be me. I felt no judgment to be perfect. They were a comfort to me. A release. They were my constant companions. But there was one other constant companion that soon became my worst enemy.

Food was an enormous part of life growing up and ever-present in our home. It was my go-to when I felt lonely or [insert any feeling here]. I was a very overweight child. And, while food became my companion and comfort, the shame and judgment that came along with it added to the storm that was brewing inside of me.

While my best friends never once said or behaved in a way to cause hurt feelings or judgment because of my weight, others did. Comments from people at church. Looks from other kids my age when I tried to shop and wear clothes that were "in." A grandpa and grandma who told me, "You'd be so pretty IF you exercised." Or, "You have a pretty face. You'd be so much prettier if you lost weight, my little fatty."

And, in my young mind where I longed for confidence and encouragement to just be me, those words and experiences significantly damaged my developing psyche. I felt as though who I truly was inside and outside were not acceptable. I needed to be someone different. I was not good enough as I was.

I weighed 197 pounds at fifteen. I hated myself. On a typical morning during my freshman year of high school, I went to brush my teeth after breakfast with the family. I gagged on the toothbrush, and food came up. Then it happened.

I stood up straight, looked in the mirror and said, "SELF. THIS. IS. IT. This is the solution. I can throw up my food. I will be skinny. I will be acceptable. My life is going to be perfectly changed."

And changed it was—in a traumatically, horrifying 20+ years of bulimia kind of way. At its peak, I binged and purged up to 20 times a day. It legitimately became my sole purpose. I lost fifty pounds between freshman and sophomore year. I finally felt worthy because I was no longer fat. Instead of judgmental looks and snide comments, I started receiving the opposite. "You look SO good!" "Wow! You've lost so much weight. You're so pretty!"

Bulimia filled me up with false confidence, but it was a confidence I hadn't had before.

I binged and purged every chance I could. My days and nights revolved around it. My every waking thought was consumed with it. It was my emotional best friend and the worst enemy I couldn't escape. What had begun as a comfort to fill the void of loneliness, judgment, and the feeling that I had to be perfect in a completely imperfect world, turned into a personal obsession.

The eating disorder continued well into and after college. Along with it came bouts of deep depression. The alcohol and drug addictions that followed were an effort to mask the pain of depression. The relationships with men became a mask to convince others I was fine. It was a vicious cycle of this personal hell I had created to somehow make sense of who I was. Yet, in it all, I was drowning, panicked, lost, and plain numb.

I longed for love and acceptance. I didn't seem to care who it came from or what it looked like. If he said he loved me, it must be the person I should be with; despite his actions, broken promises, and empty lies. I just wanted someone to say the words and magically make my world perfect.

It was visible to those in my life that the men I was choosing were a reflection of the unhealed mess inside of me. Yet, I continued to mask it all with the demons that comforted me behind closed doors.

I became engaged to a young man while still in college. Tim appeared to be the type of person I should be with—Christian, intelligent, athletic, musically talented and funny. I did my best to convince myself I should marry him because he told me he loved me. And because he was my 'first.'

Six days following our engagement, I received a call at 10:23 PM that I will never forget.

He was calling from a hospital room after a troubling drive back to school to start the new year. It was there they discovered a lemon-sized tumor in his brain. Surgery was imperative.

Hours later, the surgery was finished. However, they were not able to get all the tumor. We then heard the word we had been fearing. Cancer. Tim had brain cancer. And the outlook was unknown.

The next year was filled with weekend trips to his parents' home and the hospital with a joyful hope for him to return to full health. Throughout his cancer journey, I was even more of a mess inside than usual. There came a time when my mind and body realized I could not marry this man once our relationship came back into focus. It wasn't because of his health, it was the realization that this relationship wasn't a true depiction of who I was, and I couldn't fake my way through it anymore.

I broke the engagement. I gave the ring back. I grieved the loss of the relationship, his family, and the knowledge that I was a total mess. I still loved him for who he was.

My college roommate and I went to visit Tim at his parents' home a few short weeks before he passed away. His affirmation of faith and strength in fighting the good fight had a lasting impact on me and many other lives he touched. I am grateful to have lived that short journey together here on earth.

Life for me continued, and after graduation, I moved back home and started dating someone I had known since seventh grade. Jason was the life of the party. He made everyone laugh. He was also a big teddy bear. Most of all, he was a Lutheran, which meant my family would be accepting. Again, I convinced myself this was who I should marry because of that. He showed me the attention and love that I so desperately desired.

We had a traditional Lutheran wedding that was mostly planned by my mom. I went along with it because I wanted to feel her acceptance. We bought a house. I had a good job. He went to trade school. We had fun together. I joined the bell choir because my mom needed another ringer. We served on the Evangelism Committee because I wanted to help my dad and continue the façade that this is who I should be and what I should be doing in life. From the outside, we looked happy and lived a good little Christian life—just like I was supposed to.

Marriage, of course, is much more than having fun and putting on a front. We both had our demons. I was still bulimic and experienced bouts of depression and years of insomnia. He struggled with an estranged relationship with his biological father, and a mistake he made as a young adult that took him out

of the running to move forward with the career he always wanted.

I quickly realized that the promises he so freely gave to me of the dreams he would build for us were not going to happen. I supported us financially through his numerous jobs and attempted schooling. I supported us domestically, emotionally, and in every way I knew how. And I was completely drowning.

I also began to see the depression in him that he was in denial about. We were two unhealed, messy people trying to cope and live the life everyone around us appeared to be living successfully.

It was a time in life when others were starting a family. In raw honesty, I had never had a strong desire to have children. I didn't want to bring a child into the world if the experience of life would be anything like mine, but Jason wanted children. Once again, I convinced myself that the acceptable thing would be to have a family because he wanted one.

After several unsuccessful years, I went to the doctor and endured a year of fertility treatments and testing. While I did have a few chemical pregnancies, I lost each one. I was medically diagnosed with infertility, reasons unknown. Even though I didn't necessarily want children, it was a proven fact that I could not have them. As a woman, I felt *less than*. Yet, life kept moving.

I would come home from work to find that nothing in or around the house had been done. The excuses for why it couldn't be done were always at the ready. This was a continuous theme in all facets of our life.

Our laundry room was in the basement (the basement I re-did one weekend he was away as a surprise so he could have his "man cave"). One day, I folded the towels and put them on top of the couch near the stairs. I asked him to grab them and put them away on his way up. At this point, I was so fed up with feeling as though I had no help that I told myself, "Amy, whatever you do, do NOT touch those towels. Do not do it for him anymore." Those towels sat downstairs. Untouched. *For three years.*

I was at the end of my rope and felt as though I did all I could do to repair our relationship. I prayed, I screamed, I cried, I encouraged, I built him up, I read *The Five Love Languages* with him and posted goals around the house. I did whatever I thought I could do as his wife. Little did I know that my actions enabled him to remain in this dysfunctional pattern. I tried to control it all and live life in this narrow view of what I thought it was supposed to be, but I couldn't.

I asked him to attend Christian marital counseling, and he agreed. I had hope. One week, she had given each of us an assignment. His was to read two paragraphs and return with his thoughts and "ah-has." Driving to that next appointment, I asked him what his ah-has were. His response was, "Can you just read it and tell me what you think?"

I was trying to save our marriage. He couldn't bring himself to read one page.

I was in complete despair. I needed help. I asked my dad to meet for coffee. I needed a dad, not a pastor. To my relief and comfort, my dad listened and validated my struggles. He had known things were not well, but he had not known the details. He led me through the conversation with words of encouragement, knowing I was contemplating divorce, a word that was never to touch my lips. I desperately needed to hear that he would still love and support me, even if it meant my leaving a marriage. And I received it. That conversation with my dad gave me the courage to move forward with the once unthinkable act of divorce. My husband was an absent partner in what a marriage relationship was designed to be.

Even through that intense heartache, and now, I hold love in my heart for Jason as a person. Happily, he is now a father to two young children and remarried. I pray this marriage for him is a blessing and his healing to flourish in all areas of life.

After the divorce, I lost the house. At 31 years old, with my tail between my legs, I moved back in with my parents who had, by this time, finally retired. While they welcomed me with open arms, I felt like a failure. Although, at that time, none of us knew what a true blessing it would become for me to be there.

At my wedding, my mom was going through breast cancer. Since then, she had been on oral chemo that was only allowable for five years. Once that five years was up, Mom's cancer returned. And returned with a vengeance. It attacked her lymph nodes, her lungs, her bones. Radiation treatment became her only hope.

My failed marriage brought the opportunity to live with and discover the mom I had always known was there. As her physical body began to fail, and she could no longer feel her fingers, and her ribs broke when she sneezed, she still persisted. She persisted in making homemade meals for my dad and herself. She persisted running errands, cleaning the house, sending cards, and bought

gifts "just in case someone gets married." Nearly every day she would say, "Today is the best I'm going to feel from here on out so I'm not going to stop."

I was by her side when she began sleeping more than she was awake. I was able to tell her how I truly feel about her and Dad in a letter; how their lives of sacrifice and love for us was always apparent. I was able to tell them how much I truly loved them as I got to know them in my adult years. I was able to tell them how much I so badly wanted them to enjoy their lives to the fullest because of it all. I was there to read Proverbs 31 to my mom while she laid in bed, and whisper, "This is who you are to me, Mom. I love you."

I was there during her last weeks and days when she drifted in and out of consciousness. I was there during her last days when my sister and I ordered Chinese because we were too tired to cook. Mom was sleeping. The restaurant had given us four fortune cookies even though there were only three of us eating. We each grabbed our fortune and said the fourth was Mom's.

You see, the fortune cookie was a very important symbol in our family. It was the way my dad proposed to my mom. Dad had put the ring inside of a fortune cookie the night before and arranged for it to be on the plate with the other cookies at the restaurant. My dad made sure my mom picked the right fortune. How sweet that story was and will always be for us.

After we ate, my dad, sister, and I read our fortunes. I grabbed the last one we set aside for Mom. As I cracked it open, wondering what her fortune would be, I gasped. With tear-filled eyes, jaw dropped to the floor, I looked up at my dad and sister. I turned the broken cookie towards them. There was no fortune. It was empty. Empty. My dying mother's fortune cookie we set aside was empty.

That moment will never leave me, and it still brings tears to my eyes. While growing up in a pastor's family was a rollercoaster, it was also a lifesaver. Literally. That moment was the truest human experience I've had toward understanding the promise of the empty tomb. Although our hearts were and are so deeply saddened and will forever mourn the loss of Evelyn as a mom, wife, sister, and friend, and her physical body is no longer present with us here on earth, the joy and promise of eternal life and an assured reunion is real! Not because of anything we have done or could ever do. But because of His grace, forgiveness, and love for us, His children. My longing for heaven became stronger that day.

It's been six years since the day Mom went to her eternal home. Much has

happened in life since then. Several of those years were the lowest I have experienced. Worse than divorce. Worse than feeling judged or overweight or worrying about the next time I would binge and purge. There was intense grief over my divorce and the death of my mom that I never addressed. There were broken relationships. There was verbal, emotional, mental, sexual, and financial abuse in ways I never expected I could ever let myself endure. A self-induced job change brought my standard of living to an all-time low along with my view of myself and who I was meant to be.

In comparison to all of those around me, I was a hot mess express. And I wasn't slowing down.

I entered a relationship with an anti-social, narcissistic sociopath who successfully conned his way into manipulating and brainwashing my terribly broken shell of a self into supporting his drug and alcohol obsession—just to hear those three words I longed to hear. He said he loved me, but it was never love. It was attention. Traumatic attention. All on his terms. Not to mention his scare tactics in an effort to control me. I constantly watched my back and feared that he tracked my every move because he told me so. I felt paralyzed in a daily living hell.

How did I let myself get here? Why did I think this terrifying, abusive, and completely fake relationship was in any way humanly acceptable?!

I got out. Twice. It wasn't until that second time that I realized I had been slowly self-destructing in exchange for love, for acceptance, for some tiny hope at a slice of that perfect plan I envisioned for my life since I was a child. I was at the bottom of the barrel. I was *desperate*.

I sought out help in the form of a counselor who helped me understand my past traumas; who taught me that I had been feeding a beast inside for so long and it was time to feed Amy; who told me it was okay to be, feel, act, and love exactly as I truly was because of who God made me to be. For so long, I had convinced myself I was unworthy. Unworthy of respect, of loving relationships, of anything "good" in life. But these were all lies. Ephesians 2:10 tells us that he created His children *for good*. "For we are God's handiwork, created in Christ Jesus to do good works, which God prepared in advance for us to do." He created me with specific talents and passions for the goodness of His Kingdom. He created you with a specific talent and passion for the goodness of His Kingdom, too.

But, like David who wrote in Psalm 51:3, "My sin is ever before me," I carried that weight of sin and lies with me constantly. I needed to acknowledge and accept the truth that He had already cleansed me of my past sins on the cross. It was only then that I began to accept myself exactly where I was. Because He already did! And had since before I was born! Jesus came to save sinners like me. And you. And, I was finally able to look in the mirror and forgive myself.

Incrementally, the misguided punishments, grief, and confusion I let consume me for so long, turned in to prayerful acceptance, self-awareness of what needed to change, and a confidence in knowing that in God's eyes, I am finally free to be me.

Don't get me wrong. I definitely still struggle in life. But, I have learned to pause when that beast still comes prowling and pray that God feeds me with the truth of who His Word says I am. And, now there is peace. And there is joy. And there is a different perspective in my heart that guides my identity and actions. My drive to and from work is for prayer and time to listen to a Christian station. My email is filled with daily devotionals. I now choose who to surround myself with, instead of letting others choose, so I continue to grow in the path of God's goodness for my life. I finally gave myself permission to receive so much goodness from a man who exhibits genuine love through words and behaviors each day that I never knew would be permissible for me.

I have known deep-seated hurt and sorrow, especially when I found myself living for others' expectations and assumed perceptions of what and who to be. *Comparison is an ugly thief of joy in this world.* But when the outlook and plan for your life are eventually fueled by His Word, forgiveness, and acceptance of His undeserved grace, your true identity comes into focus. A focus that is ultimately perfect for what He had planned for you and me, all along. A focus that becomes crystal clear only when understood through the eyes of God.

May you continue to allow yourself to find comfort in the familiar, vulnerability in what is not yet known, and a growing confidence to seek His plan for your true identity, through His eyes alone. No one else's.

SARA JUNIO

Wisconsin native, Sara Junio, is a recovering Corporate Banker eager to discover the next big opportunity God sends her way. She is the proud mother of three grown sons who actively remind her to take more risks in life. She thoroughly enjoys speaking to organizations about identifying their God-given strengths, and empowering others toward their best selves. When she needs a little quiet time for reflection, she travels the countryside on her Harley Davidson Softail motorcycle. She is excited to share her journey embracing her power through her identity in Christ. Follow her journey on Facebook by searching *Empowered by God's Love.*

Chapter Fourteen

From Power in Fear to Empowered in Love

by Sara Junio

Anytime you want to care for something, you have to understand it. If a car is tuned, fueled, oiled and aligned, it is capable of amazing things. You need to understand the car and how all the parts work together in order to truly understand its capabilities. I realized, in order to take care of myself, I needed to really understand myself in body, mind, and spirit. My story—the story I'm sharing with you—is what I learned on my spiritual journey to uncover the real me and my identity in Jesus Christ.

On a Friday in October 2012, I was finishing my appointment at the salon with my hairdresser, Maelyn. She had been my hairdresser for eleven years, working out of a one-room shop in our small town. She was also a good friend for just as long. My cut and updated hair color were beautiful after my visit with her, but I needed to purchase some hair care products to keep that look. She was out of the supplies I specifically needed and said she would pick some up that weekend. We agreed to meet on Sunday afternoon following church, so I could purchase the items from her.

Sunday morning, I went to church, as usual, taking my position as a lead singer in the praise band for our 10:30 service. It was mid-October, and the

weather was still beautifully warm for a Wisconsin Fall. The windows of the church were open, and a gentle breeze blew through the sanctuary. The light shone brilliantly through the stained-glass window, illuminating everything. I remember singing several songs about angels among us and feeling like they truly were in the church that day. Following the service, I texted Maelyn to arrange a time for our meeting. I knew she was working at another salon, thirty miles from our small town. She planned to pick up my product from the wholesaler on her way home from the other salon. No response to my text.

I texted again and still no response. At this point, I assumed her Sunday must have been busier with clients than expected, so I gave her some time before I attempted to connect with her again. Several hours passed. I decided to call instead of texting. No response. This was so unlike her, as that phone was connected to her at all times, even when she was cutting my hair. As she always said, "I have four kids, and this is how I stay on top of them." Shortly after leaving her a voicemail, I began preparing dinner. I turned on the TV for the local news and saw the featured story: "Shooting at the Salon." My heart sank and I was paralyzed with fear. The reporter didn't have to mention any names. I knew Maelyn was involved.

The salon was not very busy that day according to those who were there. They estimated about 19 people in the salon, mostly clients searching for spa treatments, hair services, or manicures. Normally, it was always a busy place due to its size and the fact it was a well-known and respected business in the community. The large salon had a spa that occupied two floors in its building. Each floor had several rooms for individual spa services such as massages, makeup, aromatherapy—you get the picture. The main floor was reserved for hair services. It had a large base of clients and that Sunday many of them were in the salon.

Maelyn was working on the main floor that day focusing on hair services for her clients. Her long-time colleague (to protect her identity I'll refer to her as "Sue") was working with Maelyn that day. Sue's daughters were also in the salon, for whatever reason. As the afternoon progressed, the beauticians didn't realize Sue's estranged husband was on his way to pay a visit.

It is believed that "John" came to the salon for retaliation after Sue filed a restraining order against him when he slashed her tires on her car just a few weeks earlier. John came into the salon with his illegally purchased gun intending to kill Sue and anyone who stood in his way of ending her life. And, he did

just that.

John was ruthless when he entered the salon as he waved the gun around ordering everyone to drop to the floor. Sue, according to witnesses, attempted to calmly diffuse the situation but it only escalated. The beating she took, in front of everyone there, was not one worth describing.

People were attempting to run away out of fear. Since he blocked the front door preventing anyone from going outside, clients hid in the various rooms throughout the spa. It was reported that Maelyn, whose stylist chair was adjacent to Sue's chair, stepped in front of the two young daughters to protect them from their father. That sealed her fate.

Within a short period, Maelyn was shot twice—in the face and chest is what I'm told—and did not survive. Sue and another hairdresser did not survive either. Four others were shot by John but miraculously lived. His daughters survived, too. John ended his life in the salon after the chaos.

I could no longer focus on dinner. The news reporter was talking about the shooting, but it was too premature to report on how many people were fatally shot. It didn't matter. I knew my friend of eleven years was gone at the age of 38, leaving behind her husband, four children, and a new grandbaby.

Women love their hairdressers and stay with them for years. Decades. A hairdresser is someone you visit every six weeks for a haircut or a color. You can spend an hour or two at each visit and it turns into a counseling session. You walk into their salon looking terrible with lifeless and colorless hair, and when he or she is done, you leave feeling fabulous on the outside. You walk in feeling emotionally drained and, because you just unloaded your issues and everything is off of your chest, you now feel beautiful on the inside, too. They know everything about you, perhaps even more than your spouse. Your stylist knows about your children, your husband, your relationship with your parents—everything. I was no different; she was my therapist. My friend and counselor who I confided in for eleven years had just been murdered. The person I depended on for making me feel beautiful, inside and out, was gone. I couldn't do anything about bringing her back, and I wasn't sure how to move forward. I felt powerless.

I learned years later this traumatic incident triggered suppressed emotions from a childhood event related to feeling powerless.

We believe our lives are shaped by a series of events and a culmination of people that pass through our lives. I know God has brought people into my life—and removed them—for specific purposes. Just four months before the death of my hairdresser, I was spending the weekend with a friend at a bed and breakfast in a quaint, historic town with lots of unique shops in Northern Illinois. I had taken a break from the shopping that Saturday afternoon and decided to sit at a small table in a brick courtyard between two old buildings in the downtown area. I was sitting at a small table under the shade tree, enjoying the cool breeze while watching people with their shopping bags pass by on the sidewalk.

Another lady was sitting in the courtyard at a small table not too far from my location. We picked up a conversation—like any strangers would—about the weather, the unique shopping experiences, and what brought us to that town. I wanted to tell her I was on a getaway trip to find some solitude and figure out why I was having an emotional struggle lately, particularly about my marriage. But I kept that to myself. We continued our casual conversation as we attempted to learn more about each other. During our conversation, she quickly asked, "How are you? Everything ok?" I'm sure the puzzled look on my face caught her off-guard. I had only known this lady for maybe ten minutes, and I thought she was getting a little more personal than what I normally divulge to strangers. She indicated she had something on her heart to tell me. I sensed she was legitimately concerned. She leaned in and told me there was a darkness around me. (She apparently sees things within the spiritual realm.) She talked about how that dark cloudiness usually means the death of something around me: a person, a relationship, something. She encouraged me to be mindful of my surroundings. Be mindful.

I wasn't sure how to continue that conversation and miraculously felt ready to get back to my shopping. I thanked her for the conversation and the courage she had to say something, albeit not something I was expecting to hear. I quickly ducked into the door of the closest shop, not really caring what was in the shop to see. While I wanted to move forward quickly from that conversation, I kept wondering if she was referring to my marriage and if that relationship was over. After all, I came here to find some solitude and quiet time to pray about my family. It was an eerily weird conversation that left me wondering the remainder of that evening what she would have been referencing, and powerless to do anything about it.

I blocked out the memory of that conversation for seven years following

that weekend, until Facebook's memory page highlighted it for me in 2019. In hindsight, that conversation in the courtyard may have been referencing the event that would take place four months later with my hairdresser. Or, it may have been referencing the series of events in my personal journey that would take place over several years when I would lose myself and find my new identity in Christ.

Where Is Your Power?

He uses all sorts of events to shape us, but sometimes He uses a single, significant event to catch our attention and jolt us into remembering He is in charge. Those single events have certainly shaped me tremendously, not always in a positive way at first, but as a foundation to position me for bigger opportunities. My first significant event happened during the formative years early in my life when I experienced the feeling of overwhelming powerlessness.

When I was entering second grade, my parents moved from the suburbs of Chicago to a house in the country in Wisconsin. The move was related to my father's job with a large telephone company at the time, where he was transferred for a bigger opportunity with more responsibilities. The country home was positioned on top of a large hill, with a creek in the valley to the west of the house and a low, spring-fed water line in the valley to the east. Later, these natural springs were used to build a pond stocked with fish and became a natural playground for our family. The farm to the west was owned by two brothers with a large herd of milking cattle. They introduced our family to the love of farming in that area. The notion of having a farm of our own soon became a reality when my parents purchased three young calves: Angel, Bambi, and Carrie. Mind you, my father was raised on a large farm and knew what to expect on their new journey. My mother grew up in Milwaukee, daughter of an accountant, and was only exposed to the farming life through her husband's family. But that didn't matter. Dad was going to stay working with the phone company and my mother set out to begin the farm. Sky King Farm was created with my mother as the primary owner.

Years later, the farm grew from three young calves to a much larger operation. There were generally 75 pigs on hand at any time—some feeder pigs (those raised for butchering) and some breeding sows. There were, on average, 50 head of beef cattle, around 100 head of sheep, two horses (one we raised from birth), one pony, too many chickens, two dairy cows (one milked for the family and one milked for the calves), two dogs, and way too many cats. There were about 200 total acres to the farm where crops were planted and harvested

each year with my siblings, a few friends, and my parents.

Our family belonged to a small, country Lutheran church about two miles from the farm, with maybe 75 members in the congregation. There were two families in the congregation with six children each, and a few other families with two or three children who attended. The rest were farming couples from the area. Each week we all attended Sunday School. My siblings and I attended a Lutheran grade school during the week about eight miles from our farm, and the other families attended the public school in the same community. Even though we heard the same Bible stories during the week in our parochial grade school, we enjoyed the time with the locals more so than the education itself, because it was our community.

People in our church community supported each other. The Ladies Aid was a group of women supporting the church and its families. I saw them as the chicken-butchering team because that's the only time I personally saw them acting as a group. They came to our farm, set up wood sawhorses, laid planks on them to create a working table in a long assembly-line fashion, and helped us butcher all of our chickens. Our pastor was at the front of the assembly line cutting off the heads of the birds, and the ladies were in charge of plucking, cutting, and packaging. They were efficient in their process and demonstrated the meaning of a church community where everyone pitched in. Each one of them also had other roles in the church: organist, Sunday School teacher, funeral planner, gardener, and so forth. They lived for their community and knew how to pull everyone together. It was a group you could depend on.

As I grew older, I was involved in 4-H and the Future Farmers of America (FFA). I showed animals at the county fair each year, learned about crop management, and became close with all the farmers' kids in the area. Unfortunately, the stress of managing a dual-income household in the 1980s when the economic situation wasn't the most robust, coupled with raising six young children, caused some angst in our household. The tension may have been normal for most families, but for me, the oldest teenage sibling, it was paramount. As a teenage country girl, my favorite place to escape was amongst the cattle and horses who provided a sense of peace about them.

At night, I would sneak out to visit the animals. They would be lying down in the pasture resting comfortably. It was easy to lie next to them, lean against their warm bodies, and marvel at the stars in the sky. I was easily taken by the calming effect they had through the warmth of their hides and the quiet subtle

groans as they settled down for the night. It was easy to see God in the stars as I lay in the quiet pasture looking up. Peace. Tranquility. There was no light pollution that far out in the country. The sky was ink black, and the stars, so bright and plentiful, reflected off the darkness. I could easily imagine God and Abraham (Gen 22:17) in the desert having the conversation about "[making] your descendants as numerous as the stars in the sky … "

The cattle, just like any indoor animal in the suburbs, became my confidants. I could talk to them and they wouldn't talk back. I felt I needed to be with them. I wanted to be on the farm forever. It was a great escape from the stress within the house between my parents, five other siblings, and the life of a teenager. If you've had a cat or a dog, you know how they become part of your family. For me, the cattle and the horses were my family and I depended on them to find solace.

Unfortunately, the economic downturn in the '80s caused financial hardship for many farmers, and our family was no exception. One day, I was home from high school with my mother. Dad was at work, and the other kids were elsewhere. We were outside working in the yard tending the gardens when I saw several large vehicles traveling down our back-country road. This road was barely traveled, so seeing numerous vehicles in a caravan was a unique opportunity. I watched as each one pulled into our driveway. All of them turned from the road and drove straight to the barn. Trailer after trailer lined up. I was baffled, clueless; bewildered as to why they were there and why there were so many. That is until I saw them hand a paper to my mother and begin loading up all our farming equipment. Tractors were leaving; hay balers were leaving. Any large piece of equipment was being loaded onto the trailers and leaving the property.

Next came the animals. Every one of them was loaded into the various vehicles that could hold them. Sheep, pigs, horses, cattle were all being captured. I watched in horror as my mother screamed, trying to stop the process. Men were everywhere. Dad was at work. I stood on the side of the driveway, frozen. But the bank was firm on their stance. They were there to take anything of value as an effort to repay the loans. In the end, I watched all my confidants, MY animals, leave the property never to return. The environment I depended on for making me feel safe and providing a sense of belonging was gone. Life as I knew it was over. It was devastating.

It took a long time for my family to recover from that day. Watching it all

unfold and feeling helpless like you have no power would traumatize anyone—especially a teenager—for a long time. I was traumatized but didn't realize the extent of it until years later. I later learned that any time I experienced a significant loss, I felt powerless. To overcome the feeling of powerlessness, one should turn to God to plug into His power. I didn't. Instead, I tried to build an identity through control. I was going to control my destination to ensure I had power over my identity.

About a year after the incident with the bank at the farm, I graduated from high school and moved an hour away to my first year of college. I attended a program at the university known as the Farm & Industry Short Course. While I completed the coursework for my certification in animal science, my love for farming quickly died as I no longer saw the dream of running a family farm.

If It's Going to Be, It's Up to Me

Early in my marriage, I worked for a bank (ironically, yes!) and my husband worked in the field of science. We had determined that any financial growth for our family would come from my industry, not his. So, I returned to school, moving from an animal science education to business management. I received my Bachelor of Science degree in Business Management when my oldest son was six months old. Several years later, I received my Master of Business Administration through an executive program at the local university when I was pregnant with our third child. This education, along with the support of key managers, launched my career at a large financial institution. I was becoming very independent. I was successful, by my definition. I learned that having money meant having choices, freedom, and power. No more feeling powerless.

While working at the financial institution and growing in my career, I also poured myself into nonprofit work as a volunteer, primarily in my church: a 1,800-member congregation with a grade school and early childhood center. I had joined this church three years earlier because it had a better school for our two boys who had some learning challenges. The decision to move the children was agonizing because you believe if you make the wrong decision, you'll scar them for life (a silly thought in hindsight because it showed I wasn't really trusting God at this point). I took the leap and joined. The kids did well in the school and I immediately joined the congregation's stewardship committee which focused on managing the financials for the congregation and educating members on Biblical stewardship practices. Coming from a church where

women were limited in their roles, this was an amazing opportunity that greatly strengthened my faith.

After serving on the stewardship committee, I was asked by my senior pastor, at the time, to consider being the executive director of our church, otherwise known as the congregational president. I immediately said no, out of self-doubt more than anything. But he saw something in me that I didn't and encouraged me to step out in faith. I finally said, "Yes," and it was the best decision. The leadership skills that were valued at my company became highly valued in the congregation. I felt this overwhelming sense of responsibility to guide the church in the right direction. Yes, I felt more responsibility, and more power, than what I controlled at the bank dealing with billions of dollars in financial transactions. This church felt like the community I enjoyed growing up. I belonged to a community again, and I loved it. I had influence. I had power, or so I thought.

Another Messenger

In addition to serving as the executive director, I was also involved in the Praise Team, singing for the church's contemporary service. One summer, the team was attending a worship conference with several churches from around the area. The conference leader was able to bring some well-known specialists to teach the teams more about a variety of topics such as sound systems, enhanced instrument techniques, and vocal coaching. In between each learning session we were given breaks to network with other band members, vocalists, and instructors.

The vocal coach was a phenomenal singer from California who happened to be married to a well-known Christian bass guitarist (who played with Ringo Star, Elton John, and several other celebrities). She, too, was well known in the music industry performing as a back-up singer for a few celebrities. This vocal coach, before I had my session with her, would always walk past me, glance at me with a tilted head and smile. At one point early in the day, she quickly asked, "How are you? Everything ok?" Mind you, we had never met and the tone in her questions was not the simple Wisconsin-version of saying hello. I sensed she was legitimately concerned. After my vocal coaching session, we met again during a break. This time she pulled me aside and said, "God has placed something on my heart to tell you. He wants me to tell you to stop fighting. Don't be afraid. You have too many gifts and He wants to use them for a bigger purpose."

Whoa.

Stripping Away the Wrong Identity (My Perceived Power)

Over the course of three years on my journey, following the visit from the special messenger, is when I felt God changing my life story. In hindsight, I see now where distractions were stripped away. The distractions that I had placed ahead of Him. The idols in my life:

Friends who were close confidants. My friends at church, friends in the community and even family, slowly started leaving my life. My small, close circle of influence became distant, emotionally and physically, in the most bizarre turn of events. The death of my hairdresser several years earlier was just the beginning. One close friend decided to sell her business, buy a home in Mexico, and move there permanently. Another confidant found true love, married just over a year later, became focused on raising a new stepfamily and moved me out of the picture. A friend of twenty years, whom I always knew focused on church, family, and her job as priorities, became a grandparent. Exciting, yes! However, I wasn't in the category of her church, her job, and now her expanded family so I became a distant friend fighting for her time. The season of many treasured friendships was over. My identity defined through these relationships was gone.

A family business that occupied too much of my time. My parents, who later opened and managed a successful small floral shop business close to me for 20 years after the farm, had miraculously received a generous offer to purchase their store building. The building and business weren't even for sale. On top of that, they decided to downsize their house and move two hours away, near my sister. In five months, their lives had changed, and they were no longer available in the capacity they once were for me. The days of visiting my parents in familiar places were over. My identity defined through my parent's store was gone.

Perceived value in a job title. My company experienced reorganization. My job as I knew it was over and I left the financial institution with all the lucrative benefits behind. My identity in that company and everything I worked for was over.

Power associated with money. When your job is gone, that income is gone as well. We had to determine how to live on one-third of our income. The challenge was teaching the family that some items, while they might be considered basic necessities, were really luxuries. We had to keep adjusting our mindsets on the minimum amount we truly needed to spend. The power of money is tremendous. I remember hearing Ruth Bader Ginsberg talk to an assembly about

healthcare and the fact that the quality of your healthcare is tied directly to your income. That is true, and so is the quality of your life. We got to rewrite a new definition of quality of life because the life of luxury was over. My identity defined through my purchasing power was gone.

Status symbol. Several years ago, we told the children that once they were out on their own, we would sell the house. Ironically, two of our three boys had just moved into their own places at this time. So, we decided to sell the house; partly because we didn't need 3,200 square feet, and partly because we wanted to save money. It sold and closed within two months. The big house, our status symbol, was no longer ours. The life I lived and loved in our family home was over. My identity defined through a large, well-decorated house was gone.

Materialistic items. We moved into a small two-bedroom apartment with the understanding it was only temporary. When you downsize, you have a lot of stuff to find a home for. As we moved furniture to either the kids' apartments, the local charity, the storage unit, or the dumpster, we packed up all our memories with those items. It was a continuous reminder that they were just things and God wasn't going to let us take them with us. The season of accumulating "things" was over. My identity defined through my materials was gone.

Lack of attention in a relationship. My marriage had been deteriorating for almost ten years. I didn't realize just how distant we had become; at this point, we were more like roommates. My husband knew before I did that a wedge had formed between us. We attempted to find help through his priest, counselors, and even a pastor, but it was too late. We started the divorce process. The marriage was over and so was my identity as a wife.

Power in leadership. The church—the one where I had served in a senior leadership role for six years—determined our divorce wasn't Biblically based. As a result, I was told I could no longer publicly teach God's Word for six months. I had to step away from the Praise Team, leading the Women's Retreat, and leading the women's bi-weekly Bible study. I felt like I had just been given the scarlet letter to wear. My identity as a leader in my church was over.

Learning in The Wilderness

These losses occurred within a three-year period, just after I met that special messenger at the music conference. However, the most intense time was the last 15 months of those three years. I truly believe God was stripping away, in the form of protecting me, anything I had lifted on a pedestal and anything I had accomplished myself; the places where I was full of pride. I firmly believe

God removed these in order to move me into a place where I could find Him, in the Wilderness.

And so, the true transformation began, unbeknownst to me. God was about to unravel me. I can just envision Him smiling so fervently because *I had finally given Him permission to change me.* As Psalm 147:11 states, "The Lord takes pleasure in those who fear Him, in those who hope in His steadfast love." But it was the promise of Psalm 18:19 that I held in order to understand what was happening because...

He brought me out into a broad place;
He rescued me, because He delighted in me." (ESV)

Yes, He delights in me. In order to rescue me He needed to pull me into the Wilderness, His 'broad place,' to remove everything that was in the way of my relationship with Him in the Promised Land.

A distant relative of mine, a pastor in Florida, said: "If you aren't continuously amazed by God every day, you aren't trusting Him enough." This journey with Him in the Wilderness was enlightening and full of wonder—an awestruck experience—as I started to see the movement of so many mountains in my life. It was a painful journey; I won't lie about that. However, I learned so much about how God prepares us, then positions us, so we feel empowered to grab hold of His promises and reach the Promised Land.

I struggled with those major disruptions in my life: the loss of a job, the loss of a marriage, the sale of a large house, the distancing of friends, and a few more. My mind wanted to constantly think the worst because it took me back to my childhood memory that had a traumatic impact on my life. It was associating the feelings of loss in the Wilderness period with the feelings of loss I had experienced over 30 years earlier, resulting in feeling powerless. Yes, an experience from 30 years ago was still affecting me. But God EMPOWERS us. Self-pity is not from God because it drains us, it doesn't empower us. When you're feeling drained emotionally, your attitude reflects that. I had to learn how to check my attitude and believe in the power of God for healing.

Deuteronomy continuously speaks of God positioning his people so they can see the Promised Land. He positions us so we can possess His promises. Jeremiah 29:11 reminds us He has a bigger and better plan for us to prosper,

not be harmed. So, all this loss couldn't be for harming me, right?

He positioned me to meet and develop relationships, during an 18-plus-month period of unemployment, with many new people in ways I never could have imagined. He positioned me with several large audiences to teach on the topic of building upon our strengths and our spiritual gifts. He positioned me to coach people on retraining our brains to remain positive (using Philippians 4:8 as my basis), which resulted in ministering to hundreds. He showed me that vulnerability is a strength. For God's strength is perfect in our weakness, our vulnerability.

I Am Empowered With A New Identity

I have found my identity in Him. I am on my path to "influencing many through God's empowerment." I am much more aware of God in my life every day and strive to let my light shine as bright as can be. I am much more aware of the messages He sends me through His Word and through people He places in my life.

Once I forgave everyone, including myself, surrendered everything to Him and dealt with my fears, I felt at peace; I had the peace of God that surpasses all understanding. I now understand what St. Paul meant in Philippians 3:8:

> *More than that, I count all things to be loss in view of the surpassing value of knowing Christ Jesus my Lord, for whom I have suffered the loss of all things, and count them but rubbish so that I may gain Christ.* (BSB)

Seven years earlier, a lady in a courtyard told me to be mindful as a dark cloud was around me. I'd like to think she may have been forewarning me that God was about to remove my old, powerless way of thinking, which was how I determined my identity, and transform me into my new identity in Him.

ERIKA VILLANUEVA

Mother to Emma (15), Adrian (11), and Emmanuel (3), Erika Villanueva is seeking God, His truth and knowledge. Her priority is to share His Gospel with the world. Erika is always striving to further develop the artistic talents God has bestowed on her: photography, painting, and cake decorating. She is currently studying to become a fitness trainer. Contact Erika at Adrianemma08@gmail.com.

Chapter Fifteen

From Outcast to Daughter of the King

by Erika Villanueva

As I sat there and asked myself, "Who am I in Christ? What is my identity in Him? How has He changed my life?" I couldn't help but wonder who I no longer was, with Him in my life. I am no longer depressed, defeated, resentful, lonely, angry, unwanted, and most of all, I no longer feel unloved. I am no longer an outcast.

It all started before I was even born. One day, while talking with my maternal grandmother, I needed answers. She told me that my father treated me horribly because he believed I was the product of an affair he thought my mother had. Had she? I have no idea … but I do think I'm his biological daughter. My siblings and I look very much alike; we especially look like my dad's side of the family. You see, I had always been treated as an outcast. He hated me, and he made sure I knew that I was not wanted, nor was I part of the family. He always left me out of everything. I never got to go out with my brothers and sisters. I always had to stay behind. I don't think I ever recall getting a present from him—not birthdays, Christmas, or any other holiday.

It wasn't only that he made sure I always felt unloved, there was also daily abuse. A day never went by when I did not get hit by whatever was in his reach at the moment. It ranged from a twig branch to cords, but his favorite was wetting his leather belt while smirking at us, taunting us that we—my siblings and I—were going to get it. Every day the same nightmare over and over. The physical abuse was exhausting. My mother—never to be found. Not once did I

see her stand up for us and defend us. I have no idea how the schools did not notice all of the many whip lashes all over our little bodies—perhaps because my mother would cover us with long-sleeved shirts and turtlenecks. Then there were the days when I would wake up to my father fondling me. At the time, I had no idea what he was doing. It was when I was very young—before I even attended school.

I got sick as a little girl, which led to my mother taking me to the hospital. Exam after exam, they concluded that I had been sexually molested and sent my mother away. A social worker got involved, and that was the last time I saw my mother or any of my family for almost a year or so. I spent the first six months at the hospital, where they had no idea how to make me talk and confess who had raped me. So, I remained there for months, quiet and crying for my mother to come back for me until one day, a social worker told me if I didn't talk, I would never leave the hospital. So that got me thinking, was I never going to see my mother again? My brothers and sisters? I had to think fast. To avoid breaking up my family, I decided I had to somehow accuse someone who was not in my immediate family so I could go home. I no longer cared that I was treated as an outcast, unloved, or even that I was beaten and abused every day. After all, it was better than being alone. I was around six or seven years old when I was ripped away from my family.

While I debated about who to accuse as my molester, they released me from the hospital, only to put me in a shelter for children. It was the most enormous building I have ever seen. It was probably eight blocks long in distance, and six to seven floors tall in height. Everything was on-site in this facility. There were thousands of bedrooms, lunchrooms, a school, and they even had doctors there in case we got sick. There was no need to leave the building at all! You can now envision how huge it was, and I was there for a couple of months. Of course, I was rejected there as well for being quiet and crying day and night. I wasn't like most of them. Yes, I had been sexually abused, but I was not sexually active. That led most of the children there to make fun of me, saying I was weird, and I deserved to be there. Children can be evil. I was a loner, and slowly but surely, I was becoming broken, depressed, and angry. They finally found me a foster home. My first foster home. They were very loving people. They were a nice, educated couple, whom I believe could not have children, so they adopted a little girl, and were trying out the whole foster parent thing. They had a perfect little family. Then there was me: a broken, dysfunctional, reckless mess. They tried so hard to do everything and anything to make me happy. But

how do you make a child that was traumatized by being ripped away from her family, staying at a hospital for months, going to a shelter, and wondering if her mother abandoned her, happy? I thought to myself, "How could a perfect family who has never been through what I've been through relate to me? They don't know my pain; we don't have anything in common. How could they make me happy?" Even trying to talk to them was awkward, and they had no idea how to respond. There was no connection. All they could do to make me happy was to feed me, which led to excessive weight gain, which did NOT help my case. I was already broken, now add excessive weight. That's where my eating disorder problems started, as I turned to food for comfort.

They eventually gave me up because I was too much for them to handle. They said they couldn't stand to see me crying 24-7, so off I went to another foster home. My maternal grandmother wanted to help, so she took classes to become a foster parent and got her license. I ended up staying with her for a while, hence finding out the story about the affair and not being wanted. I stayed there until the government found out my mother stopped by without consent. Apparently, that's enough to get you placed elsewhere. Honestly, I lost count of how many more foster homes I lived in. The world basically stopped turning for me. I was living just to survive but had no purpose, nothing to live for. It was all about new rules, new people, new religions, new everything, every couple of months. I could never build bonds with people because I had no stability. The years went by when finally, I found something I actually enjoyed doing at school. They had a program where if you read a certain number of books, you would win a pizza from Pizza Hut. Hey, what's to lose? I loved food, right? My love for books began with that contest. I built up to reading a book a day—my only escape from reality. I like to think of it as a gift from God to sustain me through the storm.

Living in courtrooms, going to therapy sessions, and visiting my family one hour a week on Thursdays quickly became a way of life for seven years. Finally, after those seven years, my mother tried to get us back. She finally broke it off with my biological father. She was pregnant with her seventh child. They did a DNA test to see if it was my father's, and it wasn't, so they gave back custody of all her six children who had been taken away. The day my siblings were taken away, I couldn't help but blame myself. If only I hadn't gotten sick that one fateful day, I wouldn't have ruined my life or my siblings' lives. I carried that guilt into my adulthood. I blamed everything on myself for many years.

When I returned to live with my mother, I was a teenager—a broken teenager. At this point in life, nothing mattered. I was already bitter, I hated life, and I hated everyone. I thought humanity had no compassion. I turned into a rebel. I was a very mean person. I had all this anger and confusion built up inside me. To make matters worse, when I returned home, I found out my mother had built a relationship with the man I had accused of molesting me. She chose him over me. I felt betrayed. First, she never stood up for me. Then, she didn't fight for me for years. Instead, she chose to stay with my father, making our case much longer than it should have been because one of the stipulations to getting us back was for her to leave my father. But she had refused, and now this?! I knew I had lied about him molesting me, but I never told a soul that I had lied about it in order to keep my family together. That betrayal hurt so badly because I had sacrificed all for nothing. The arguments with my mother became very intense. It led up to the day I will never forget. The day when my mother told me we needed to talk, that it was very serious, and she needed my full attention. She proceeded to say, "I'm saying this in the calmest way possible so that you know I am not saying this out of anger, and that I'm being honest. I think it's better if we part ways and live separate lives. I no longer love you, and our lives would be much better apart from each other." Here I thought that those last seven years had been hell, but it turned out that with just one sentence, she completely destroyed me in a second. I have never felt pain like I did that day, and to this day that remains the worst pain ever. Your own mother telling you that she doesn't love you can destroy you in so many ways. As the tears streamed down my face, I ran outside. My sister must have heard the conversation because she ran after me and shoved me out of the way of an oncoming car. All I wanted to do was die, and I wasn't even good at killing myself! It felt even worse to know I was still alive. To keep feeling that immense pain in my chest, her words repeating over and over in my head, was like a blade stabbing my heart and it wouldn't go away.

I was homeless at fourteen. She had kicked me out. That's when I found my only way of releasing the pain. I turned to cutting myself. The deeper I dug the glass against my arms, the better I felt emotionally. Finally, I could take my thoughts away from my emotional pain and place them on physical pain. It felt great not to think about what had happened over the last eight years of misery. I soon realized that I was going to end up dead if I did not grow up and fend for myself. If I wasn't good at killing myself, then I intended to sustain myself and see what the next chapters of my life would bring. I had an uncle who lived in

Wisconsin, and so the next chapter of my life began. I left Chicago behind, and with it, all the bad memories. I swore never to return to live there again. It was too painful. I never got to finish school—I was still a teen who needed to work to survive. I started working two jobs and lived with roommates. I was finally earning my own money, and it felt great! Of course, living without any kind of guide or parental figure, I had no idea how or where to use my money, so I spent it as fast as I earned it. I was a people pleaser and it brought me happiness to make others happy, so most of the time I used money to please others. I was buying people's love, or so I thought.

I worked at a job where I met my daughter's father and was that a disaster! He watched me cry myself to sleep every night as the memories invaded my mind, until one day he earned my trust. I opened up to him, only for him to turn my story against me. He was verbally abusive and made me feel less than nothing, but I stood there for five years taking all his trash because, believe it or not, he was the first person in my life to tell me he loved me. I was finally loved by someone. Thinking back on the mentality I had before Christ is very eye-opening, especially when I see other women putting up with this same abuse. If only I could have seen my worth through His eyes, I would have made so many different choices. But then again, as it says in Romans 8:28:

And we know that all things work together for good to
them that love God, to them who are the called according
to his purpose. (KJV)

If I could go back in time, I would not have changed a single thing! Even though it was not a fun ride, and I still have more to tell about what has happened to me, I still believe it all happened for good. I was not wanted by my biological parents, but that's ok because God says, in Psalms 68:5.

A father to the fatherless ... is God in his holy dwelling. (NIV)

He gave me a family in Christ, the family I lost and yearned for. He replaced them with amazing godly people in my life I can count on with my eyes closed. Little did I know that all the trials were part of the plan to help build my character. They were to help me know what it's like to be alone, unloved, homeless, and abandoned. I've lived and breathed pain! I now have compassion

for all people, especially the lost who have no idea where God fits in the picture or if He's even real. I have a special spot in my heart for children and their innocence. I know what it's like to be mentally and physically abused. I can relate to so many people's hurt. You see, we might not see the big picture while we're going through trials and storms, but God does! And He KNOWS you are one of His strong ones, and that you will make it through! He gives the hardest tests to His strongest soldiers. We have to remember that this is a spiritual fight, and through the process, He is, was, and will always be there by your side. He will never forsake you or leave you alone. He will finish in you what He started!

It was not easy to give my life over to God; submission was not my strongest suit. I wasn't raised in any particular religion. It was different in each home I was placed, but originally my family is Catholic. We only attended church if a child was getting baptized, or perhaps Easter? I don't recall. The point is God was not the center of our lives. He was the last resort if someone was dying; that's when we'd call out to Him to perform a miracle. But I slowly found Him once I realized I had no other way out of life, and after many more attempts to end my life, which He saved me from. I kept failing. I felt so stuck and ashamed that I was at a point where I even hated God. I would cry out to Him, and beg for Him to answer my question, "What did I do to deserve all of this?" I was a child. What sin did I commit so greatly to deserve punishment this severe? The people who created me did not love me, so if my own parents didn't love me, what could I expect of any other human? And as the partners came and went, my expectations of humans deteriorated.

I remember the last straw. I had given birth to my two children and was still depressed, lost in the world with no hope, sleeping and living with my boyfriend at the time. On Independence Day, I found out he was cheating on me. He sat there on the bed and confessed that yes, indeed, he had been talking with another woman, and what was the problem? I felt completely devastated.

I told myself, "I'm done, this is the last straw."

Before I attempted to end my life, I thought about my children and wrote them each a letter explaining why they were better off without me, and how I was going to leave this world in order to spare them. I told them they were too amazing to have a completely broken mother, that they deserved someone who was complete and could show them love the way they deserved. I went outside with the letters in hand. Staring at them with my head down, as I watched my tears wet the cement step, I heard this still small voice.

It said, "But what if there is a God?"

I looked up to the sky, mustering the only strength left within me, and in my mind, I said, "God ... if you ARE real, take this pain away. I am completely broken to the point of no return. I don't even care about leaving my kids alone here on Earth."

That's how severely I was torn apart.

I continued, "And fill me with a peace that I have never felt before. If somehow you manage to do that, I promise to do whatever you want from me. After all, I'm about to end my life. I have no purpose dead." I sat there quietly waiting, when all of a sudden, I felt the warm sun on my skin. To this day, every time I feel the warm sun on my skin, I feel as if He's hugging me, as the warmth fills my body. I felt a peace that I had never felt before in my life come over me. It was as if everything lifted up off of me, and I had no worries whatsoever—or pain. For the first time in my life, I was free—free of myself and the thoughts that had kept me prisoner in a world of misery. Feeling overwhelming peace, I stood up, walked inside, gently grabbed my children, led them to my room, and told them we were going to sleep.

My body was extremely tired from crying out a lifetime of agony. As I held both of my children tightly against my body, I thanked God for them; for the gift of being able to hold them again. I thanked Him for another chance at life and slept peacefully for the first time in 31 years. I felt a peace that surpasses understanding. The next day, I woke up and realized what had happened. I had been too tired the previous night to understand it. I acknowledged what God had just done for me, but I was shocked as well.

As the impact of this enormity emerged, my mind was saying to my heart, "Oh my gosh, GOD IS REAL!!!" He answered me and showed me He was real. He withdrew every last drop of sadness out of my body. I started crying again, only this time it was out of happiness. I thanked Him over and over again... I was ecstatic! Then He brought back to mind the promise I had made to Him: that I would seek Him and do things His way. I mustered up the courage to tell my boyfriend he had to leave because I was going to start doing things the right way. God's way. I knew to sleep with someone outside of marriage was a sin, I just had never taken it to heart. This time was different. I gave my life over to God and I owed Him my life. He gave me a new chance. A new opportunity. A new identity in Christ.

That day, my life changed. It took a complete 180-degree turn. I kept my promise to seek Him and get to know who He was. I didn't know much about Him, but the search began. My sister was a follower of Christ, and she had been planting seeds all along within me to seek God, but I had always chosen to ignore her. Since I was in misery, I hadn't believed He existed. But when He performed that miracle in my life of removing all my sorrow (which I had tried to do myself the worldly way many times by reading self-help books, and nothing ever worked), I knew it was God and that God was real. So, I asked my sister to be my guide. She took me to a Christian store, and I found an amazing book called Not a Fan. It broke down everything in simple terms I could understand. It told me that God didn't want a fan: someone who only has a fish bumper sticker on her car or only went to church on Sundays. It explained how He wanted an intimate relationship with me. He wanted me to seek Him in my daily life and include Him in every single choice I made. That book changed my whole perspective on God.

It helped me to see Him in a different light. I bought a Bible and more books. I eagerly sought Him daily and my love for Him grew as I watched how He started changing my life. He gave me a new identity; I was now His daughter. I was now loved. I was now part of a new family in Christ. He restored everything in my life I had lost—just like He had for Job. Then He added even more blessings. I prayed daily for Him to help me die to self, and for Him to continue changing me little by little. I knew I couldn't do it by my own strength. He was there along my side all the way as I matured in Christ. He's been giving me the wisdom to help other women see the value they have in Christ. Every time I see someone down, I run to them and lift them up, just as I was lifted up by people with more wisdom them me at the beginning of my walk with Christ.

I can honestly say to this day that God completely changed how I view my identity. He replaced anger with happiness. He helped me forgive all those who hurt me, and now I actually thank them for it, because if I had not been pushed to the point of breaking, I don't think I would have EVER sought out God. I needed a Savior, and we won't naturally seek God if we don't need His help. So, from all of these experiences I learned that sometimes it's when everything is taken away from you, that He shows you the real you He created you to be. It's when you're most empty that He can fill you with Him, and with His presence, love, and grace. Even though life is not peachy perfect, it's okay. I now understand that we will have trials to be able to identify things we need to change within ourselves to be more like Christ. Or perhaps we have trials to be able

to know what it's like to have gone through that pain and to be able to relate to others and help them through their pain. We can show them that if God managed to change our lives around, then there is hope for everyone else. No one is so far gone that she is unsavable. Just as God completely gave me a new life, He can do the same for anyone else who has been to Hell and back. He can restore you and give you a new life of abundance and love, just as He did for me. I no longer feel unloved. I am no longer an outcast.

I am a daughter of the King.

JONI JONES

Joni Jones has the overwhelming passion to share the hope, peace, and love of the Lord, that saved her from a lifelong battle of poor body image and the stronghold of bulimia. She is the founder of Be Waitless Ministries, LLC, where she encourages women to live out the Word of God in everyday life through speaking, daily devotional blogs, Bible teaching, and as a Certified Biblical Counselor. She is the author of the books *The Breakthrough Effect* & *Weightless Flying Free*. Joni loves being a wife, mother of three adult children, and a "Jojo" to her grandchildren, at the New Jersey shore. Visit her website at www.bewaitless.com.

Chapter Sixteen

Broken into Beautiful

by Joni Jones

Daughter, your faith has healed you; go in peace.

—Luke 8:48b (NIV)

As I stood in front of the mirror, I didn't see anyone or anything because my eyes were closed. I just couldn't look, because I knew I would see not-good-enough Joni staring back at me, pointing the finger that she could be oh-so-much better than who she was right then. If I ignored her, maybe she would disappear. But that version of Joni was so persistent that she followed me wherever I went. She was so trapped inside that she just wanted to break free and be herself. But first, she had to figure out: Who was she, really?

Was she the little girl who could never do enough to be loved enough? Was she the little girl whose excitement would be wiped from her spirit, because those who were called to love her most couldn't love her in the way she so craved? Who was the little girl who was always striving, yet never arriving? Oh, she was that little girl, but now she is a woman who can stand before the mirror and smile as she looks at every imperfection, thank Jesus for coming into her life, and transforming her from Broken into Beautiful. You know, He came to heal the brokenhearted (Luke 4:18) and Jesus always delivers on His promises. Living in Him isn't an either-or-scenario, as I am always who He says I am.

Who was that little girl? Not the woman I am today, who now is able to soar above as His new creation: a butterfly transformed from Broken into Beautiful.

Once upon a time, it happened, to you and me, on that one miraculous

day: God breathed life into our lungs, and we sounded our first cries. Then life quickly followed with people, places, and things that made us, shaped us, and at times broke us. So, we sought that one thing that would take us from not being good enough to being so much better in others' eyes, and in turn, our own.

How others saw me was so much more important than how I saw myself. I would recreate a better version of myself so that I would be seen, heard, and accepted by others; and then I intended to accept myself. That is what I did, without even knowing I was doing it until I found myself less than who I believed I was when I first started the journey. No longer me because I was transformed into a "better" version.

Who was that little girl who was afraid of her own shadow? Who was that little girl who was so shy that she tried to be invisible, yet so desired to be seen? Who was that little girl who spoke, but no one ever listened? She believed she was unheard, unseen, and unacceptable. That was who she was and who she would always be because it was confirmed day in and day out; defined by invisible, as she believed she was. Maybe if I didn't feel anything, I would go away, because I was unworthy; not important enough for anyone to validate my feelings or care about. I felt rejected, insignificant, and insecure because I was rejected every time, no matter how hard I strived for perfection. Therefore, I will be unseen, unheard, and unaccepted, and I will live as such and run and hide and not trust anyone ever again.

Broken.

Down deep, I hated myself. Such strong words, but it was true. I didn't want to feel, because when I did, I felt unlovable me. All I saw was a cracked reflection of myself because I allowed the world's distorted mirror, and the critical comments of others, to reinforce the message that I was unworthy to be loved. So, numbing myself with food worked for some time, but you can't run away from yourself forever.

If I wait for me to like me and for you to like me, I will be waiting for a very long time.

Living in me is not a pretty story. When you live in yourself, you believe the lies that feed your spirit. I devoured those condemning voices inside my head as if they were truth when actually, they ate me up from the outside in. Living in Christ shields me from the outside distorting who I was created to be. I looked up and questioned God.

"Do you see me, God? Do you hear me, God? Do you even care that I exist? Who am I really? Who am I that You would even choose to create me?"

There just had to be something more to life, and to me. In the midst of a 14-year battle with bulimia that I was losing, in my desperation, I craved this God, and my question became "Who are you, God?" I had to look up because I was so low. Crying out to a God I thought I knew in my head, yet I didn't know at all. I invited Him into my heart as I began the search. It took a year of purging my heart with my questions and my heart-cries, reading Scriptures, and attending a new church. There I met a God who I had never heard preached; a God of healing who transforms broken lives. I had new hope.

Through this process, I was able to trust God with my whole heart, and not just with my religion. There He was, wanting to be a part of my life, yet He had always been there. God answered. He cared about me even in my fallen state. He heard me. He saw me. He accepted me even when I didn't know that He was with me.

He began to speak to my brokenness from the moment I read His Word. He became real to this now grown girl, even though in my childhood loneliness, I was unaware of His Presence. He had been there. In my searching, He was there all along, He never let me out of His sight. He had to be present; how else could I still be alive as the bulimia should have killed me.

I was powerless to heal myself, yet He continued to draw me into His presence as I sought more of Him. I was a sponge absorbing all He was and all He said I was created to be. As I shared my broken heart honestly with Him, He responded with His truth and never pushed me away. I finally met God as my Father whom I could trust with all of me. It was through getting to know Him that I met the real me.

The me who He loved, even though He knew everything about me. The me who He created on purpose. The me who was all His from birth, as I am His workmanship. The real me, who was accepted, significant and secure in a Real God.

He saved me from myself so that He could shine through me. Who would believe that Joni of yesteryear is the Joni of today? That Joni almost died at the age of 14 months due to dehydration from an illness at a time in her life when she couldn't understand what was happening.

This was the day I was defined as broken, due to the constant reminder

of the pain that I caused my family and how they told me, "You should be thankful to be alive." I took ownership of my illness as my fault: a brokenness that fueled my search for love since shame, guilt, and self-condemnation were birthed at a young age. I carried its burden into adulthood. Yet, how could a baby be faulted? It brought an emotional brokenness, always a part of me that welcomed every opportunity with fear.

Yet He was there. He kept me alive. If only I had known then that His healing hand was upon my life.

Would I have made different choices in my life? Would I have lived as one who is worthy and valued? I didn't, but that didn't stop God. He pursued me until I finally looked up into His eyes and surrendered to Him who had always been with me. He would never leave me, no matter how hard I tried to push Him away.

Oh, our persistent God; He began putting me back together piece by piece. As our relationship grew, I fell in love with Jesus, who loved me as I was being healed and transformed, and as I received all He said I was, and not who I thought I was. No longer defined by unseen, unheard, or unacceptable, because the Creator of the world saw me, heard me, and accepted me just as I was. God met me right where I was in the midst of not-good-enough and made me more than good enough in His eyes. My life hasn't been the same since. What a journey, as I shed the shackles of the past, and allowed Jesus to heal my brokenness so that I could live as His. The revelation that I almost died as a baby, and it was not my fault, opened my eyes to the brokenness that had become my identity. My heart was in need of healing. I asked Jesus to heal me so that I could live as His. Meeting Him as my healer was what I needed in order to live in Him as His daughter…

Beautifully unbroken!

He was the missing piece that I had been searching for. When I first came to Jesus, it was a once-in-a-lifetime moment, yet I believed I arrived. Oh, my theology was wrong. Walking with Him isn't a once-in-a-lifetime occurrence as it is a moment-by-moment choice seeking to live in and to experience all that He does in us.

I was afraid to fly because I was always falling short of my own expectations. God didn't create us to stay as we are now. He sent Jesus to do it for us. All we have to do is show up as is, and He takes us into His presence forever.

Now what? What happens after you are healed and saved by Jesus? Even though Jesus had healed my broken heart, I still didn't know how to fly free. I knew the truth in my head and knew it set me free, but fear enveloped my heart as I continued to live in bondage. So, I spun a cocoon around myself. I felt like a butterfly trapped in my cocoon, unable to fly. It became my armor, my shield. Even though God was my armor and shield, I continued to create my own for protection. A broken heart hides in fear of being hurt again. He told me He loved me, but it was never enough. I believed it for everyone else, but not for me.

What was blocking me from living free to be me? Fear. Fear to live as God intended. Fear to be loved. I was stuck in my cocoon as a butterfly staring at all the other butterflies flying. I so wanted to be one of them, even though I didn't realize I already was. God reminded me that I belonged, yet fear loomed, blocking the door out of the cocoon where I remained hidden. I held on to the fear of the unfamiliar, fear of actually flying, fear of freedom, and fear of being me—the me God created me to be. I was waiting for permission from those around me to see me, hear me, and accept me, but I would be waiting for a long time, as condemnation was always knocking on the door of my heart.

I hid from myself for so long in shame, and then vulnerability smacked me in the face. To be real, despite my flaws just because God loved me, appeared to be an impossibility. What did it really mean to live fearlessly as ourselves? There was still a brokenness that I could not describe, yet I knew that it was blocking me from truly living as God's chosen.

Fear kept me in bondage to the past; in bondage to failure and disbelief. Fear caused me to doubt what God said was true. I lived my life in fear—fear of rejection, failure, loneliness, weight gain—everything. Fear built a cocoon of isolation, paranoia, anxiety, and worry around me. Fear paralyzes yet protects us. It is our friend and our enemy as it keeps us running away, searching for a hiding place. So, I ran to food. Food became fear's silencer that exploded into a fourteen year battle with bulimia. Fear and anxiety continued to rule in my heart. Now what? Why wasn't God's love for me enough? Why wasn't my salvation in Christ enough for me to live in Him?

The answer is: I wasn't receiving it. Believing is the first step. Receiving Him is living in Him. It's taking that step of faith, being bold, living as one who is loved by God whether you feel it or not. It's living fearlessly as yourself just because God says so and Jesus made it so. I took the steps, but never totally

surrendered to live in all He says I am. I lived with the constant conflict of craving attention yet never being able to receive it due to a lifetime of emotional abuse. I craved attention yet remained fearful when it came my way because it might disappear at any moment. If I was not perfect, then I would be nothing. It didn't mean that life would be perfect, or that I would look perfect. It is about walking with Jesus and living in His perfection; His perfect love, peace, joy, and hope.

Oh, how God is never finished with us, as He is always peeling layers. We don't arrive until we arrive—the moment when we see Him face-to-face in Heaven. Even though I was praying and surrendering and immersed in His Word, something held me back from believing that I was allowed to live fully as one loved by God. I needed permission to receive all that God had for me from those around me. I did believe, yet there was a part of me not yet ready to receive the Holy Spirit because I was actually fearful of His power inside of me and all that He would do through me.

God doesn't open doors that He is not allowed to walk through.

God began a process of transformation in my soul as He opened the door to my heart to heal my brokenness. I asked Him how He saw me, and then I finally heard it. "I see you. I rejoice over you with singing. Let's dance." God brought His joy to the little girl who was still trapped inside of me. This was it. The first Scripture I had memorized when I attended my first Bible study, the words of Zephaniah:

> *The Lord your God is with you; He is mighty to save. He will*
> *take great delight in you, He will quiet you with His love, He*
> *will rejoice over you with singing.*
> —Zephaniah 3:17 (NIV)

Now God was calling me to come out of hiding.

I see you. I rejoice over you with singing. Let's dance.

I felt an overwhelming sense of peace, yet it was not enough, as I questioned if this was the real God talking to me. "But I want to see you" was my plea. I challenged God as I said, "I can't receive and believe this unless I see your face. Why can't I see you?"

And then He asked me to trust Him.

I had to have faith that He was there, and then receive Him. I wanted the burning bush. I wanted the revelation above all revelations because I was entitled, right? Actually, I was tired of being so stuck, of having this something inside that I couldn't quite name, and knew it wasn't of myself. Why wouldn't God show His face? Why wasn't it enough that God sees and hears me? Why did I want Him to do something more? Yet God continued to pursue me in the midst of my questions.

Just because I couldn't see God doesn't mean that He wasn't there. He has been there since the day He knitted me together in my mother's womb. God has never let me down. He has been making me fearless to live as His masterpiece. He gave me permission the moment I invited Jesus into my heart; permission to receive and live as one loved by Him. I am a little rag doll girl in a middle-aged body who just wants to dance and play. I finally gave myself permission to do so, because God has been telling me to dance with my two left feet—even if no one else around me wants to dance—because I have a partner who promises. He will always be with me wherever He takes me, and Jesus calls you and me friend, child, His heir, His prized possession. All are allowed to believe Him because He believes in us.

In Him, I stand, no longer in fear because fear no longer defines me. His perfect love drove out fear the moment I asked Jesus to come into my heart decades ago when fear was still my biggest enemy. Abide in fear or abide in love. My choice, your choice. Permission received. Now to live in Him: Broken into Beautiful.

A newness had overtaken my heart and soul, yet there remained some remnants that still needed healing. God caught my attention once again recently, as I had a revelation when I was traveling down the road of self-condemnation. I heard the words,

Take care of my prized possession.

It stopped me in my tracks. Jesus was talking about me. I am His prized possession and I was beating myself up like I was a piece of garbage. The cruel way I talked to myself. The lies I believed. It is so much easier to receive the lies than the truth when you live from a stance of broken. In that instant, I heard Him so very clearly. I was to treat myself as someone worthy of His love. Jesus doesn't require me to clean up my act first. He calls me as I am in the process of becoming so much more. He chose me, and it was time to dance with Him.

Take care of my prized possession.

Permission granted again. Fearless to live in who I am in Christ. Believe. Be bold. Be blessed because...

> *Blessed is she who has believed that the Lord*
> *would fulfill His promises to her.*
>
> —Luke 1:45 (NIV)

When you live in Him, you stop looking to others to fill the void within your soul. Your perspective changes. You walk into a room looking for no one else to give you what you need. You are simply you and that is enough. In the past, I was so depleted that I was like a pauper searching for anyone to please fill my cup. I was covered with expectations and, when I didn't receive affirmations from others, it confirmed that I was not enough. Now I had to choose to abide in Him, to not only believe Him but to receive Him, fully as He fully receives me. He came in and healed me from the inside out. God knows me better than myself, so why shouldn't I believe Him?

Broken into Beautiful.

Fearlessly believing Him. Fearlessly receiving Jesus. When Jesus lives in you, His love takes over, because as C.S. Lewis said, "Your real self will not come out as long as you are looking for it; it will only emerge when you are looking for Him." I stand before the mirror, but not alone. I stand with Jesus, and I see the woman who He sees, He hears, and He accepts. I don't look for the perfect skin, perfect body, perfect hair, or perfect age. I had it all wrong from day one. It was never about the outside, as that was my view from living life in me. From my perspective, the image is not so perfect, but now, as I live in Him, I see me as He sees me. Not only do I like what I see, but I love what I see because I see Jesus looking at me and that is all that matters.

I see flawless me because in Him I am perfectly flawless. How I wish I could tell you that I have this identity thing all figured out and that I walk every moment confidently as highly favored living in Him, but I don't. It's hard. But when you do it anyway, He will take you from less-than to more; not my doing but His. I was trying so hard to fit in when he made me to stand out.

Flawless is not looking, feeling, or doing perfectly. Flawless is being perfectly loved and healed by Him. Flawless is being perfectly imperfect in His

perfection. Flawless is who we become when we accept all He says we are, despite our flaws. Flawless is receiving and believing that you are fearfully and wonderfully made. Flawless is receiving and believing that you are forgiven. Flawless is receiving and believing that you are a daughter of Jesus. Flawless is receiving and believing that you are loved by the Father, saved by His Son; it's having the Holy Spirit living within you, giving you the power to live beyond your flaws.

Amazing Grace, how sweet the sound that took a perfectly flawed woman like me and loved me back together piece by piece, covering me with His perfection, so that I may live moment by moment as flawless. A flawless God loves flawless me and flawless you. Now that is a real God who takes the "not" away from not good enough. Perfectly imperfect in Him. Believe it, receive it, and live it in Him.

Striving to arrive is part of the past. The fun part is that I haven't arrived yet because there is a better version of me waiting in Him tomorrow, and the next day, and the next day until I meet Jesus face-to-face. All I have to do is show up moment by moment, choose to live in Him, and abide in Him. Because when I am in Him, I find the extra I have been searching for my whole life.

As my outside continues to change and time ticks away, my heart does, too. From the moment Jesus came into my brokenness and healed my heart, He took me from just believing to receiving it for myself. Permission to live as His prized possession moment by moment because…

Daughter, your faith has healed you; go in peace.
—Luke 8:48b (NIV)

I've been transformed from Broken into Beautiful.

JULISSA MORENO

Julissa Moreno goes by many names, such as wife, mother, daughter, and granddaughter. She is a companion, partner, and friend. Julissa might be described as a woman, a Latina, a Puerto Rican, a Brooklynite, and a New Yorker, but—most of all—her Heavenly Father describes her as a Proverbs 31 woman. "Her children rise up and call her blessed; her husband also, and he praises her." With God by her side, life has shaped her, trials have strengthened her, and her tears have taught her. Julissa says, "My God has given me countless victories through faith and obedience." Join Julissa's Facebook group here: facebook.com/groups/WOMENofpurposeNY.

Chapter Seventeen

I am a Life-Giver

by Julissa Moreno

As I washed dishes and worshipped, I paused as I felt led to stop and listen. With my eyes wide open, I saw my kitchen turn into a ballroom in a vision. I was wearing this beautiful cotton candy pink ball gown and a royal crown. In an assertive yet gentle voice I heard, "Daughter, do you trust me?" In return, I responded, "Yes I trust you, Lord!" His voice guided me further, "You desire more, you have asked for more. Now, do you see the door at the top of the stairs? You must come up higher. All you need is to take my hand." I extended my hand, and on that day, I took hold of my purpose. I walked up the stairs that led to that door. He opened it and spoke my life's destiny; everything that I experienced and learned up until that point brought me right there. HE spoke my purpose over me, "*As I establish your true identity within you, you will lead other women into their identity and destiny. Who you are is not a fairy tale or wishful desire. Who you are is found in Scripture; it's your promise, your purpose. Christ is life, and a woman full of Christ has life and life more abundantly. She lives out her day dictated by who I say she is and brings other women with her.*"

Reflecting on that vision and that day continues to bring tears to my eyes. Heaven came down and I was in the spirit realm experiencing a Father full of joy and pride showing me how He worked all things together in my life for this time. He desired to give me *my* heart's desire and what a humbling moment to be introduced to my purpose! His extended hand was more than just a beautiful gesture; He brought me closer to Him so that He could give all of this to me, straight from His hand to mine. My mind, my life, and my kitchen have never been the same. He confirmed that my heart's desires were always from

Him. I simply wasn't ready and piecing it all together brought me to a point of surrender.

I am royalty and the daughter of a King. It's not just written in Scripture, it is my reality. There is nothing I am more confident about than this: the King who gave me life lives in me. He is my portion; He is my inheritance. We were created in His image with His heart to love, nurture, and connect deeply with Him. If you know me, then you know God and I are in a relationship where His communication is more than His voice resonating in my spirit. Prophetic dreams and open visions are also a part of the language we share. (He wants to share these with you, too!) Doing my best to seek Him is my passion. The pink dress I wore in my vision was His choice for me because pink represents passion and He sees my heart. How can I not be passionate in pursuit of who He says that I am?!

During the months that followed the day I learned my purpose in His Kingdom, I would never have imagined this, but my husband and I began going through a huge test of faith named "financial crisis." Because sweet Daddy God got my utmost attention during this trial, He took full advantage and proceeded to give me more details on how He sees me. One night, I dreamt about beautiful rings on my fingers. One, in particular, was shiny and silver and featured a beautiful pink stone. I was overwhelmed by how He saw me. A few days later I woke up to…

You are adorned with Munsell's opal.

"Who is Munsell? And why an opal?" I asked aloud.

Immediately, I hopped out of bed, thanking God for Google! Munsell was an American painter, teacher of art, and the creator of the Munsell Color System. Although there are many types of opal stones, the precious stone opal cannot be characterized by the human eye but *only* by the Munsell color system. Opal's value is based on three properties of color: hue, value (lightness), and chroma (color purity). Talk about God giving details! He was showing me that the purest, most precious opal is the opal He placed on my finger. Okay, that did it … I began melting in a pool of tears. This was more than beauty in the eye of the beholder. He was assuring me that no matter what financial trials came, they cannot change the fact that I am adorned with His choice of precious stones. That is who I truly am. Seeing that my husband and I were going through this tough financial season, this wonderful revelation kept me focused on who I am in Him.

I did ask Him, "If this is how You see me, Lord, why do I feel so contrary?" What I was facing contradicted my feelings, yet not my identity as He had shown me. The next morning, I awoke to another vision: I saw the view and sound of an amazingly beautiful waterfall. Once I took focus, the vision immediately centered on a man, bent over dry-heaving. Then I heard God ask me...

Daughter, who do you say that I am?

Like a film montage, an inventory of His presence in my life flashed in front of me. I saw His hand everywhere in my past and present. With tears in my eyes, I felt His love melting my fear over our finances and my conflicting thoughts away.

"You are my Daddy God, my King, my Provider, my Everything!"

> *Then live by who you say that I am! Who I am, is who you are, because I live inside of you! For in Me you shall live from the abundant waters of life. The moment your eyes leave my focus, you permit circumstances to dictate who you are and drag you back into fear and doubt. Like a dog returning to his vomit, so a fool repeats his folly.*
>
> —Proverbs 26:11

He broke through to me! Sobbing, I surrendered. I am that woman dressed in royalty, adorned with gowns, opals, and rings—and circumstances will never change who HE SAYS THAT AM! I AM A DAUGHTER OF A KING!

With renewed strength and confidence in knowing who He was IS WHO I AM, I found peace and then began to speak life into our finances. The promises of God are "Yes and amen." (2 Corinthians 1:20) That day, my husband, Steven, joined me in believing in the power of the spoken Word of God. We locked in agreement with each other and our Daddy God. We would not be moved. We would stand confidently DECLARING His promises. This was all working together for our good. The raging waters would not take us down but we would ride on the wave of the waters of life. We believe together, that He would carry us, making us stronger as husband and wife and drawing us closer to Jesus, "the Way, the Truth, and the Life" (John 14:6).

My desire to know Him at a deeper level only intensified. I was caught in

the net of His love! My visions and dreams increased daily. Our conversations became endlessly intense. I went to sleep speaking in my heavenly language and awoke to continue. Understanding that my dreams had deeper meaning brought such peace. God had sealed upon my heart the truth that the power of life runs in and through my words. I was pregnant with the promise that I shall see this financial deficiency come to an end. We would not live by bread alone but by the words that proceed out of the mouth of God!

All things were working together for our good because we love Him and were called according to His purpose (Romans 8:28)! We believed in the end, EVERYTHING would be to our benefit. Sounds so easy to say when things are quiet in your life, but when the storm is raging, it becomes your anchor.

After some intense moments of ZERO balance accounts, our financial breakthrough began to trickle in like a gentle stream in the desert. It's pretty nerve-wracking when you have five kids and are way behind on mortgage and car payments! Did I mention my boiler responder system broke down mid-winter in Long Island, NY?! Nevertheless, we continuously declared His promises, awaiting our grand deliverance. We wanted to see this mountain thrown into the sea!

While brushing my teeth, I heard,

YOU WERE NEVER IN NEED.

"Wait, WHAT?" Yep, I heard correctly.

YOU WERE NEVER IN NEED.

How could this be, with zero balance accounts? He went on to explain that we did not lack anything with HIM in our lives—only the deeper understanding of who He is and what He promised us. He said, "Financially deficient" was not my identity— certainly not my portion from Him.

And my God will supply all your needs
according to His riches in glory in Christ Jesus.
—Philippians 4:19 (NASB)

I had another encounter during my early morning prayer while reading my devotional.

The heat of His Presence swept by me and whispered,

The enemy will not touch your finances again, because you have proven that money does not stand between your love for me and your passionate desire to see my purpose fulfilled in your life.

I was undone, only to be left with the weight of His love for my husband, my family, and me.

Obedience Vs. Sacrifice

A few months later the unexpected happened. Unexpected is an understatement. God asked something of me during our financial trial that seemed, well, crazy. And impossible. In the wee hours of the morning, I was awakened by the same familiar voice of none other than my sweet, Daddy God.

I need NOAH to come.

"What? I am not understanding."

I need NOAH to come.

"You want me to be obedient, like Noah?" I presumed it was a metaphor. "I am not obedient? Have I not been?"

His love flooded the room. It wasn't a metaphor. Noah was to be the name of my next child; He was asking to bring life from my womb once again. And I was privileged, beyond blessed, to already have five children.

"Another son, Lord?"

Yes, I need Him.

He read my thoughts as I silently cried, "I can't! Not now! Do you see we are just coming out of this financial trial?! Not now! It's hard for me to barely do anything! A sixth baby was not on my mind, Lord, and I have given you five already. The last one was your idea, too! I want to beg You, 'Please no,' but how can I tell you no, Lord? You have provided at all times, and even when I fell short of your grace, You sustained me."

I have never said no to the Lord, and He wasn't asking for a sacrificial, forced yes. He wanted wholehearted obedience—without hesitation. I've always said, "If He says jump, I jump!" But this was more than a jump! He was asking me to go cliff diving!

Sobbing in despair, I answered, "Okay," but I had terms and conditions if I was going to bring forth another life! As if He read my heart and mind, He answered...

He shall be your last, and you will not need a doctor to intervene. This I promise you; he shall be your last. I will prepare Steven.

I cried myself to sleep. I could not believe what God was asking of me. The more I thought about it, the sadder I became. Indeed, obedience is hard, but I was struggling with myself. I was focused on the "ME" factor. The one thing I had was the unwavering confidence that He had provided for the other five, and this one would be no different. Especially with our recent experiences. My faith was growing to expect more provision, but this would really stretch me in every other way.

The next morning as I vacuumed, I thought about Noah, and just as I did with the other five babies, I prayed for a middle name.

He stopped me immediately and advised, *He does not need a middle name. Noah is sufficient.*

He was really serious about me having another baby, and at that, another boy. Like, wow, He really meant business. But what if I was hearing things? It couldn't be me making this up! Lord knows I would have to be crazy to come up with this now. How could I come up with this, or even desire such a thing right now?! I thought I must be losing my mind!

Then, I heard the voice of the Lord say, *Life.*

I didn't know just yet how important the word LIFE is to my true identity. Life only comes from God, and we have an enemy that is out to kill, steal, destroy, and corrupt anything that brings life. This sixth baby was not selfish nor a fleshly desire, as some religious people might say. This was the living God asking me to do what I, myself, and the world think to be absolutely crazy insane—have one more baby.

Now, He knows I am obedient. I have done a lot of things that didn't necessarily make sense in that moment, only for Him to bless me big-time days, months, or years later. But this was different because I really wanted to say no! I just couldn't say it, even though everything inside me wanted to yell, "Heck No!" What if I passed up this opportunity? From my womb could potentially come forth a world-changer. He obviously had taken my husband and me as well as our finances into consideration when He asked us to have another son. I continued to pray and became convinced that baby Noah was coming to bless my home, and most importantly, that he had a mission to fulfill on Earth far greater than my mind could comprehend.

*For my thoughts are not your thoughts,
neither are your ways my ways, says the Lord. For as the
heavens are higher than the earth, so are my ways higher
than your ways and my thoughts than your thoughts.*

— Isaiah 55:8-9 (RSV)

Around that same time, I was asked to speak on the topic "Extraordinary Women are Life-Givers" at a FEW Women's Forum. After speaking, I realized, that's me! That's all women! We were made in the image of God: Life-Givers! And anyone who has life, or reproduces life, is the enemy's target. We have an enemy that is running rampant after the seed and its carriers (that's us!). Since Genesis Chapter 3, women have been his main target. Our natural and spiritual wombs are where true LIFE lives and thrives. Our spiritual wombs are linked directly to our true identities: our greatest purpose as women. He robbed Eve of her innocence, her image, and distorted the truth about her. Disobedience was established when she was convinced that leaning on her own understanding would benefit her! (Ouch! Sounds like me when He asked me to have this baby!)

The enemy is no different today than he was then. What is wrong, he portrays as right, and what is truth, he portrays as lies. Why on earth would the enemy encourage me to give life by having another child? Actually, it would irritate him, and he'd want nothing more than to have me question the Giver of Life Himself.

Noah…his name is mentioned in the Bible as a man of obedience, and the Lord was making a deliberate statement: my seed was my obedience. Noah did not lean on his own understanding, nor should I. It became imperative for me to reread the story of Noah. I learned that Noah means "rest" and "comfort." God's plans did not need to make sense to Noah for him to obey. Clearly, Noah had an outstanding track record for Him to be singled out and considered the only righteous man in his time. Obviously, this was not the first time Noah submitted to His marching orders. It is proven that what appeared absurd—abandoning his reasoning to obey—saved Him. In fact, *his obedience saved his entire family.*

God was not asking me to build an ark but was asking me to abandon my thoughts and concerns over whether it was fair or smart or not. I needed to quiet myself and be obedient. In the natural, I would be giving birth to a baby,

but in the spirit, this baby would represent the foundation of obedience that I was building my life upon.

We know from God's Word that whatever happens in the spiritual realm also manifests in the physical. Just like my friend, Kimberly, told me, women have both a spiritual womb and a physical womb, and God was showing me my identity in both! My husband and I put our feelings aside and accepted our mission to be *that couple* who lives by faith and crazy obedience. We would build our ark of obedience to God.

Surprise, surprise; It didn't take long for me to learn I was pregnant again.

Mommy First

Being a mom takes work. So, my work was about to get harder. I do not have help available whenever I need it. This is tough for a mom of five, expecting her sixth. Home alone with four kids (because my oldest left the nest) made pregnancy more exhausting. Although I am a social butterfly, I've recently let go of a handful of friendships. Things didn't end on bad terms; we out-grew each other. The couple of dear friends I do have live far away. Absence can make the heart grow fonder, but also make a woman feel a bit lonely. This was very hard for a season, but I've learned to enjoy my time alone. My relationship with God is far stronger than in years past. Our relationship has matured into an unshakable bond. The conversations can be deep and serious, but funny, too. God's not boring! What I'm really saying is that I am crazy, and He laughs at my kind of crazy.

Remember how He told me that I needed to be living by who He says I am? Well, I kind of returned to my vomit, as Scripture and my vision showed me. At some point, I fell back into worrying and wondering about how it would all work out. How was I going to juggle it all with another baby? I was foolishly trying to hold my family together for His sake—as to not make God look bad. I was even trying to force myself to be happy, trying to carry this new life with joy, but in my own strength. I wasn't living from the place of rest, from the promises He provided for me, and it zapped me of all strength.

> *Don't be dejected and sad,*
> *for the joy of the LORD is your strength!*
> —Nehemiah 8:10b (NLT)

Have you ever seen a bodybuilder that looks like they can lift an immense amount of weight, but in actuality, they are very weak because their size is due to steroids? Their strength is a facade. That is what I was living like. Forcing myself to have peace and joy in motherhood but from the wrong source. Unintentionally, I had gone back to being foolish enough to think I could hold up the weight of an ark without His assistance. I know that God is the provider of my finances. What I had yet to learn was He also provides my identity as a mom: a LIFE-GIVER! Yes, I had previously understood my purpose as a woman, but I could not yet identify myself as a mother in Christ—a life-giver! I couldn't figure out how to enter into His rest as a mom because *moms don't rest*! Especially those who want to meet all the needs of their babies and maintain a clean house and happy husband.

I finally understood that my joy and strength would come from Him when I chose to rest (Noah) in the promises He had for me, not just as a woman, but as a mother! He would be my source every step of the way. I got it! And in perfect timing, too. I had experienced weeks of baby-growing pains: pain where I could barely walk, bend, or even do laundry. I was down and wanted to tap out! I even became concerned that the baby would come prematurely. God knew I could not finish my pregnancy like this because I would regret not enjoying it with it being my last.

Being a woman is an honor, but being a mom is a true privilege. As life-givers, we are walking in the identity of our God. How can We enjoy and marvel at the blessings of our families if we do not REST? About that same time, my friend, Candice, texted me. She said the Lord wanted me to tell you to REST! Coincidence? NO! My friend, rest is a place we can go, and not just when we are on vacation.

Didn't God rest from His work on the seventh day and say that it was good? He took the seventh day to soak in and marvel at the content of His masterpiece. I was clearly not taking the time to enjoy the fruits of my labor. I was focused on being an obedient, hard-working mama of many: caring for everyone, paying the bills and doing my best to be happy with it. I was starting to get it.

Still having pain and concerns, the ultrasound tech stated that the baby was perfect and in the perfect position at my appointment. Then what was my problem? Obviously, I was not RESTING. Instead of trusting God to supply everything, including joy, I was caught up in the day-to-day routine, forgetting my purpose and my call, and allowing the pregnancy pains to determine my identity.

Of course, the baby was perfect and in a perfectly fine position. I needed to be confident that if God asked us to build the ark, He would also supply all the materials. Obedience brings joy, gives strength, and most importantly brings rest (Noah). God was using this pregnancy to bring me spiritual rest AND Noah! Ahhh, sweet relief! I found a place of rest in Christ. For the first time in my pregnancy, I heard, "Mommy you're glowing!" It took 33 weeks and a lot of surrendering, but yay, Jesus! I was finally at rest in my heart and now it was all Him shining through! What had I been doing and thinking? Obviously, not enjoying the rest and privileges that come with my identity in Him.

Of course, when I began to "get it" about resting, our financial "stream" broke out into a full-on flood! God is so good! And I received more confirmation. As I trusted and rested in Him to supply, my older kids and especially my husband (who had been filling in the gaps at home without even being asked), gave me some pampering and alone time. During this time, God somehow made me know I am an imperfectly perfect fit for my new position as the mommy of six. With rest, came peace. I know with full and complete confidence that motherhood is my first calling, my first position in His kingdom, my privilege, the jewels in my crown, the rings on my fingers (pink ones, because pink is for passion), and my reward from God Himself! I am a life-giver, through and through!

I'm currently doing my best to enjoy the last weeks of pregnancy—enjoying the baby in my womb to no end. To think, after this delivery I will never experience this again. I have birthed in the spirit my new identity, and for sure this spiritual womb will not close up shop; it will go on to reproduce many more spiritual daughters who embrace their identities as life-givers, too!

I'm a mess, but a good mess feeling blessed. HE HAS CONSIDERED ME TRUSTWORTHY TO HAVE THIS MANY CHILDREN. There's so much more to learn and experience in this journey of motherhood, and I am ready. God's purposes for our lives will continue to manifest.

Have you thought about what Noah's thoughts were after the flood? I have. Obedience takes discipline and much more than sacrifice. I may have endured some tough times and I may have had to make some crazy decisions. I may have been judged and criticized for many of my obedient decisions, but the list of the good that God has worked together is way more extensive than what I have endured! My favorites are: I now have Holy Spirit skin (thick)! Covered by Him, I do not allow others' opinions of me and my life to shake my identity. As

a woman, a wife, and a mother hidden in Christ, I have come to the realization that simply because Christ is in me, I'm a life-giver! With my body, mouth, and spiritual womb, I will continue to sow seeds of life in my family and in this world.

The morning I began to write this story on identity, I asked the Lord, "Where do I start? I learned so much, especially in this season." He told me to ask YOU, the reader, this question:

Dear Daughter, who do you say that I am? Because who you say I am, is who YOU are!

Friend, He is living inside you! You are not an accident. Your life-giving purpose and destiny are found in Him just as He is found in you. Faith does not grow in our comfort zones, so there will be trials. But nothing He permits is to hurt you, **only to show you that any lack you feel is a need for more of Him.** Where there is a need, there is a need for more of Him. Faith is the substance of things hoped for, the evidence of things not seen (Hebrews 11:1). You don't see your breath, yet it is what fills your lungs. You don't see God, but He is the breath that fills your life, directing you into purpose with every trial, temptation, and tribulation. Nothing He is a part of goes to waste; He is not a wasteful God. His Word will not return void in your life. Declare who He says you are today, regardless of your circumstances. Don't base your declarations on feelings, but on His promises. He's waiting for His dear daughters to understand that all we will ever need is already living within us. His daughters are life-givers because the Life-Giver lives in us!

Faith in this promise is your opportunity to allow Him to show up and show out in your life. I invite you to abandon your thoughts and ideas of yourself in exchange for HIS thoughts of you. You're flesh of His flesh; blood of His blood. He loves you the same today as the day He gave His life for you. He only wants to lavish you with life more abundantly and make you more like Himself. Limited thinking of your identity leads to limited living. He invites you to embrace your true identity in Him; rest in His peace, fill your cup with His joy, and experience the God that He is, while you live out who you truly are!

God is within her; she will not be moved.
God will help her when morning dawns.
—Psalm 46:5 (BSB)

JASMIN ALMONTE

"In her weakness, she finds His strength." Born in Puerto Rico and raised in the South Bronx, Jasmin Almonte is the youngest of four. Throughout her childhood, amongst the chaos of a bustling household, she found solace in the pages of her journals and diaries. Writing was always a lifeline, a way to be seen and heard, a way to remember that we are not alone. Today, Jasmin finds her purpose as a preschool teacher. She has always championed women and children throughout her personal and professional career. She is blessed and humbled to be a part of *The Identity Effect*. Contact Jasmin at jasminalmonte01@gmail or follow her on Instagram by searching @jasmin_almonte.

Chapter Eighteen

Through Deep Waters

by Jasmin Almonte

I knew I needed a change in my daily routine. My job no longer brought me joy. In fact, my work was becoming toxic to my soul. I wasn't just unhappy; I had become unpleasant to be around. Years ago, this job was supposed to have been my new beginning. After twenty years in the hair business, I realized I loved my volunteer work with children more than my career, so I had taken a leap of faith and hung up my scissors, leaving a salon where I had seniority and respect to switch to an entry-level counselor position at an elementary school. I had followed my passion and started working with children, so, how did I get to this hateful place?

I went to cosmetology school in New York City right after I got married in Puerto Rico. I was 19 years old and excited to start this new adventure as a wife and Manhattan hairstylist. I worked in some of the best hair salons from Fifth Avenue to Madison Avenue and, last but not least, Park Avenue. I learned some valuable lessons during those years, the most important being money really can't buy you happiness. These wealthy clients battled loneliness and unworthiness amongst all the other voids that we all experience. They were busy trying to fill their emptiness with people, places, and things—just like I was. We don't realize those places can only be filled with God, that these cracks in our lives belong to Him.

I quickly learned that being heard and feeling acknowledged were key to my success. It wasn't just about the hair; it was about the personal connection. I learned to be a good listener and relate well with people. I am truly a people person. It's where I thrive. I never shy away from a conversation or meeting

someone new. On the contrary, I welcome it. The hair business brought that out in me. My years in hair hold some wonderful memories and friendships that I still cherish today, but while those relationships were growing, my marriage was, slowly but surely, deteriorating.

That same man I married at 19 in Puerto Rico soon became my ex-husband when we were divorced for six years. We then later remarried for another 23 years. During our six-year divorce, I resided in New York and he ended up living in New Jersey. In his newfound relationship, his girlfriend gave birth to a baby girl. When we found our way back to each other getting remarried came with a beautiful three-year-old girl named Danielle who completely changed the direction of my life in so many ways, yet I know it was all meant to be. They say you go around the same mountain if you don't learn the lesson the first time around. I actually married my ex twice but expected different results. I was never his first priority in either marriage. But then again I did not think I was worthy of that. I valued myself by what others thought of me. The truth is we are who God says we are. After all, He is our Creator. But I didn't know that then.

We were still those same people who didn't know how to love ourselves but were determined to love each other. We were both still broken and navigating through life with our veils on. Sleepwalking through life as we held hands but never bothered working from the inside out. God's grace and mercy softened the blow by blessing me with Danielle. I fell in love with her the first day we met, and I really can't imagine my life without her. This marriage came with a package deal and I embraced her with open arms and an open heart. Because of her, I moved to New Jersey, where her mom lived. I wanted to spend more time with Danielle. I never knew I wanted to be a mom until she stretched my heart. Then my daughter Taylor was born, and I knew I had to get a mommy job, so I started working in childcare.

Those skills I learned in the hair business became valuable working with children, families, and communities. I had good communication skills and was a good listener and a fast learner. The Holy Spirit prepares us for things to come and this transition was no different. I felt right at home. I paid attention and kept life tools I practiced daily. Working with children actually made me a better person. Being a role model made me more aware of what I said and what I did. Respect, responsibility, honesty, and caring were part of our daily conversations with the children and among our coworkers. Taking care of mind,

body, and spirit was promoted daily at the workplace. This was a perfect fit for my lifestyle and my family. I was enjoying working before- and after-school programs but did not realize God was introducing me to my calling. This was not just a job or a career, this was the beginning of my purpose.

In this season, I knew I needed not to move until God told me to. But I got caught up in the money and prestige of management, gave up my joy, and found myself promoted to Director, sitting behind a desk staring at a computer in my office. I remember looking out that office window hearing the laughter of children as they passed by. I felt a tugging on my heart and so I began my journey down that rabbit hole of feeling conflicted about my true calling. There were plenty of times I went out to visit staff and kids at our programs at public schools, but I had become the bearer of bad news. I suspended children from our program as well as suspended or terminated staff from their jobs. I sat down with parents to discuss possible expulsion of their child from our program. I remember when the children stopped running to me to greet me, and my daughter Taylor told me the kids didn't like me anymore. They were afraid because if Miss Jasmin was around, somebody must be in trouble. It broke my heart. I began praying for change.

During my last summer there as a Director, I kept taking a breath and saying, "I trust You with all things in my life, Jesus." This became my mantra that summer. It got me through the whole season, but I was still just barely holding on, barely keeping my head above water, with only small glimpses of joy both at home and at work. Suddenly, everything changed. God decided I wasn't going to just get by with "good enough" but instead be transformed by being completely removed from this position and this company. For the first time in my adult life, I was unemployed.

I dedicated this time off to dig deeper into my relationship with God. For the next six months, most of my days were spent alone. I could journal and meditate and have real conversations with God. I was peeling back my flesh and exposing my spirit more each day, and in the process, I began to experience this peace and freedom that I had been longing for. It felt like healing was taking place on the inside. I wanted His will, not mine. I prayed for happiness. I prayed for a place where I could make a difference in the lives of children, close to home, and with enough income to pay my bills.

This manifested itself in a new job doing everything I hoped for and more, stretching me and working on my heart. This was too good to even see coming.

God truly shows his strength during our weakest times. He hears our prayers and He answers them—in His time, not ours. His time is always perfect. He is faithful and we are His priority. He created us *on purpose for a purpose* and we serve a God who has a plan for our lives.

When I landed this new job to rediscover my true joy, I knew there was a storm coming. Reading the Word gave me clarity, and sometimes we see things we almost wish we hadn't. The Holy Spirit was speaking to me, telling me a storm was brewing. I braced myself by putting on the full armor of God daily, but I had no idea this storm was actually going to be a tsunami!

There were times I felt I was drowning under a tidal wave, being dragged out to sea without any control of my journey. Physically, I felt a constant pressure on my chest and an empty void in my stomach as a daily reminder that life had forever changed. I was heading nowhere but moving fast. I was afraid to sit in my silence with myself because I was sure I would shatter into a million pieces. The first wave came in the form of marital betrayal. The air was snatched away from my lungs as I tried to process the feeling of unworthiness that washed over me. I felt completely blindsided. I never thought my husband would be unfaithful. I looked for answers through my conversations with God and needed to take responsibility for my part in this mess. In my heart, I knew I had been unhappy and restless for quite some time. As the days turned into weeks and weeks turned into months, I stood in my truth and realized I had checked out of the marriage some time ago.

By then, Danielle had her own life with her children, and Taylor was getting ready to enter her senior year in college. With our empty nest came the realization that being a mom was part of the glue that kept me invested. I was a coward and did not have the courage to have an honest conversation, so I waited. I knew I was in a season of waiting. I prayed for change. I did not know how or when this change would take place, but I had faith in God that something would shift. And it sure did.

It's important to be proactive in the waiting and I had carved out time daily to go deeper into my personal intimate relationship with God. I was gaining wisdom, strengthening my faith, and surrendering to God. And then this green light turned on that said GO! The infidelity led to divorce which led to another challenge called bankruptcy. In the aftermath of this divorce, I was now supposed to be financially independent, something I had not been for over 20 years. Bankruptcy actually put me in a position of no longer living above my

needs. I started paying attention to what I was spending my money on and I no longer had credit cards. I felt empowered, but at times it felt so foreign to me and a bit intimidating.

As I moved forward towards peace and financial security, I began a new chapter of turmoil and learning, with the deaths of my parents only three months apart. They lived in Puerto Rico. My dad had suffered from Alzheimer's for years, but his death came as a surprise. I saw him a few months before he passed away and watched him read his newspaper outside, listen to his radio, and drink his coffee. His daily routine. He would smile and repeat over and over how God was the all-powerful God. He would look at the birds and just smile his boyish smile. The last thing I remember is the love in his voice as he told me the wind was playing with the flowers. Most days he didn't recognize me, but I saw a peace and joy in him that was his gift to me when he was gone.

Mom was handling it all so well. This was her husband of forever. She married him when she was a 16-year-old girl and here she was at 81, keeping herself busy in the kitchen. The house was full of family, neighbors, and friends, and then we eventually all went home and back to our lives. I believe my mom died of a broken heart. Her death was shocking and numbing all at once. My mom and I were kindred souls. We shared a special bond and I will miss her until we meet again in the Kingdom of God. The love and laughter we shared hold enough memories to last me a lifetime. The beauty is in the fact that we both knew how much we meant to each other and we actually demonstrated our love for one another. It is so meaningful to let our loved ones know what they signify in our lives. When we are no longer on this earth, our love is all we leave behind. The love we give and receive is what we will recall as we take our last breath. Love gives meaning to our lives.

Losing my job, getting divorced, filing bankruptcy, and losing both my parents was a very heavy cross to bear, but with Jesus, nothing is impossible. Through this process, the Holy Spirit was my comforter, my counselor, and the one who guided me. He gave me the tools to empower me and equip me for the next storm. Life is all about either going into a storm or coming out of one. Adversity strengthens our faith. Sometimes we need to give up people, places, and things, in order to start anew. Just like we evolve in different aspects of our lives, we need to also grow in our spirituality, and I began to feel restless attending the church that had served me well for over 20 years.

This was where I remarried, where the girls took their first communion,

and where they were confirmed. This was where Taylor sang in the church choir for years and Danielle had her firstborn baptized. I volunteered in numerous ministries and sought counseling there during my divorce. I will forever be grateful for the love and support I found there, but I also knew it was time to move on. We need to mature in our spirituality and sometimes elevation leads to isolation.

What and who you spend your time with is who and what you become like. This is why it is so imperative that we spend intimate personal time with God. We will want to become more like Him. I have always had a personal relationship with God, but it is the Holy Spirit who guides me here on earth. During the last supper, Jesus spoke to the disciples about the Holy Spirit so we would know we are not alone. The Holy Spirit lives in us, and when we dedicate our lives and our full attention to God, we can call on Him anytime, anywhere. He will show us, tell us, help us see pieces of where we are headed on this spiritual journey.

I was feeling a bit exhausted. I wanted to ignore this new need for more God. I had this empty nest with no children and no husband. I had a new job that brought me joy and purpose, but I was constantly fighting conversations in my head about my finances. I felt my titles had been stripped away one by one. Wife, director, mother, daughter, and here I stood now and who was left? I just wanted things to be nice and simple and easy. Just me and my journals and my meditation with worship music in the background. Do my job and go home and live a peaceful quiet life. After all those storms, didn't I deserve that?

God has plans for our lives, and like all relationships, it takes two to make it work. We need to cooperate and do our part if we want to see results. The words "Child of God" resonated in my heart and I wanted to give my Heavenly Father more of me. It's not always about what we can get from Him but what He can get from us. I knew He had guided me through every one of those storms and I just wanted to thank Him, so I obeyed and surrendered to the process.

I walked into a church in my neighborhood and decided I would give this place a season. I would give it the summer and if I still felt unsure, I would seek Him elsewhere. I remember all my insecurities creeping in as I recognized no one. The church itself looked so different from what I was used to. The service started. I forgot my surroundings and was swept away by the worship music. I felt this rush of joy and celebration as members openly expressed their love for God. I was so accustomed to quiet and everything always kept at a whisper.

When the pastor began to speak, it was actually refreshing. He was so real and approachable and open. The members were participants and not just spectators. I related to the congregation and the pastor, and as I walked out, I knew I had found my place for worship, community, and praise. I thought it ironic that it was called New Beginnings.

There are tools God gives us to help us stay on our path. Writing has always been my number one place to express myself freely. As a child, I had a diary, and I started journaling as a young adult. One of my ways to empower myself is my journals. I have a gratitude journal because where there is gratitude there can't be any fear or doubt. I am constantly looking for ways to armor up because this earth is full of cracks where the enemy will try to slither through. My goal is to jot down three things daily, but on some days when I am struggling with life, I just need to read it to remind myself that this, too, shall pass.

I also have a journal with the storms in my life. It amazes me to see how the outcome has been a blessing. In the eye of the storm, there is always a lesson to be learned. Being a Christian doesn't mean life is easy. It means we lean on Him. We trust Him. Our hope and faith are in Him. I know my good days outnumber my not-so-good days because of Him. I don't just believe in God, I know Him. I have a personal relationship with Him. You can, too. He waits for you with open arms. He wants to be your friend. He created you and loved you before the beginning of time. All it takes is a conversation. As with any other relationship, you don't have to do life alone.

Whenever I head to church, I always take a journal with me. Here, I take notes so back home I can dig deeper into the Word and the message of the day. We are the church. This building we go to is just a structure. We make it a church because we are His people. We take "church" wherever we go. Serving others and doing good works is the purpose we all share here on earth. My hope is that my story will ignite something in you. That my struggles will remind you that we're more alike than we are different. You are not alone. I am a big believer in putting all my shame out to the light. The enemy wants us to hide in the dark and isolate ourselves. Keep him under your feet where he belongs. Your place is under God and above the enemy.

Besides journaling and reading the Word, my daily armor also consists of listening to worship music as often as possible. Pull up the lyrics and see the message in those words. Be aware of those songs that pull at your heartstrings. I believe that in each song there is a message especially for you. I now under-

stand that worship and praise is our gift to Him, everything else is a gift from Him to us. Worship helps us to prepare our souls. It makes us vulnerable and transparent.

Silence is very powerful and necessary. If we are always talking and doing, how are we taking time out to listen? Prayer is a conversation from the heart. It can simply be a thank you, but there are times we pray specifically for someone or something. I found answers in the silence. I don't always get the answer I was hoping for, but He is always faithful, and my trust is in Him. Going on walks with myself and my thoughts is also healing and satisfying to my soul. But so is a good cry. Tears can be very cleansing. Some days my best is better than others, but I always try my best. At the end of the day, nothing I do surprises Him because He knows it all and He created me. My hope is to please Him, and when we come face-to-face, He says, "Well done."

On those darkest days, I remind myself that He is with me. There are times I will have to move forward even when I am afraid. It's okay to be fearful but I don't let that stop me; I do it anyway. He waits for me with open arms. All I need to do is obey and surrender. I don't want to miss out on anything God has in store for me. I do not want to hinder His plan for my life.

So, even in the season of waiting, I have to trust and believe and be pro-active as I wait. I don't want to talk myself out of a blessing because I gave up. God wants us to live Heaven on Earth. Make your corner of the universe better. Make a difference in people's lives. Do volunteer work. My volunteer work became my purpose. Less of you and more of Him will open a whole new world for you.

I have no doubt that my future has some storms coming my way, but I also know His goodness outshines any obstacles. What I have gained through Him is far greater than anything I have lost. Seek God and let Him transform you from the inside out. You will never be the same.

KIMBERLY KRUEGER

Those closest to her say that she is "a mom to many and a friend to all." With her eyes on Jesus, Kimberly Krueger lives her highest purpose showing women their priceless value and helping them reach their God-given potential. FEW Founder, four-time #1 Bestselling Author, Podcaster, and Keynote Speaker, Kimberly is known as a master storyteller who imparts "unbridled confidence to move forward." She is the proud mama of 7 sons and 5 daughters and says being "Noni" to her 5 beautiful grandchildren is one of life's greatest joys. Her husband, Scott, keeps her laughing, loving, and riding her Harley. Connect with Kimberly on Facebook, Instagram, or LinkedIn by searching Kimberly Joy Krueger. Learn more at www.kimberlyjoykrueger.com.

Chapter Nineteen

Identity Imprints

by Kimberly Krueger

"The more we focus on who we are in Christ, the less it matters who we were in the past, or even what happened to us."

— Joyce Meyer, Beauty for Ashes

I AM A PRINCESS

For a long time, I dreaded going out in public. My family was falling apart, and it seemed like the whole town was watching. We lived in a fairly small (but very affluent) community, and dirty laundry was hard to hide. Not just because of the typical small-town rumor mill, but because we kind of (totally) stuck out like a sore thumb. First off, we were NOT affluent, and there were A LOT of us: my first husband, eleven children, and me.

Yes, eleven. We lived on a main and highly visible highway in an old, dilapidated farmhouse surrounded by cornfields on all sides. And just in case our lone, ancient farmhouse didn't stand out enough, there was a broken-down, weathered barn in the back that looked like a strong wind might take it away. Actually, the barn was so bad, it made the house look pretty nice. (Not.) We drove our family around in a 15-passenger van—a RED 15-passenger van. *The only one in town.* It was always parked in our driveway because it didn't fit in the tiny one-car garage. Nothing subtle about that, either.

To make us even more conspicuous, the eleven kids were usually running around in the yard or in and out of the cornfield. (Nothing weird about kids and cornfields, right?) From the highway, it appeared that I must have been

running an in-home daycare, but alas, they were all mine. The cherry on the sundae was the frequent visits by local police, usually because I called them during one of my first husband's drunken rages. And the police cars always came in pairs—the flashing of two sets of blue and red lights could be seen for miles. *We were that family.* You know, the family that everyone either looked down upon or felt sorry for. *I loathed being that family.* From the time I was a little girl, I dreamed of having a big, happy family. Well, my dream had turned into a nightmare and a public spectacle. I wanted to be *The Waltons*, but we were much better suited for *The Jerry Springer Show.*

So, it's easy to see why I was never psyched about venturing out and seeing people. My least favorite and most dreaded outings were school functions. *Ugh.* I dreaded moving up and down those hallways in a sea of perfect people—perfect parents with perfect families. Being corralled in those tiny hallways meant looks, stares, and worse: eye contact! *Gah!* Eye contact with hundreds of other parents, neighbors, and teachers that would only break when they wanted a good look at my brood. I didn't even have it in me to make eye contact with all the sweet little kids, much less all of those "judgy" adults. (That is the way their looks felt, but I came to learn that in reality, there were many caring and compassionate people who just wanted to help, and did.)

I will never forget one particular evening that one of my "littles" had a concert at the grade school. I had worked myself up into a state of complete dread that day, rehearsing how I would feel during the uncomfortable and awkward hallway gawking. I could manage the program itself, as all eyes would be looking forward, but the before and after… *Ick!* As the time to leave approached, I began to get desperate. I scrolled through multiple scenarios in my mind that would legitimately allow me to get out of this school function…but there were none. No one was sick or bleeding or dying and nothing was on fire. After considering offering some less dramatic excuses, I decided I just couldn't bear to disappoint my excited little sweetie strictly because of my own insecurity and dread. For that child and that child only, I was definitely going to go.

So, I got everyone ready to leave and sent them out the door. All the kids were in the van waiting for me, but for the baby on my hip. Just before begrudgingly exiting my unhidden hideout, I paused to gather myself. In a lame attempt to suck it up, I let out one last sigh through gritted teeth. I grabbed the doorknob while psyching myself up for the coming walk of shame.

The next moment transformed my perspective for eternity! As I stood at

the door, I heard the voice of the Lord whisper gently and ever-so-lovingly to my heart (as if He were saying it with a smile):

Always remember to wear your crown.

Wait … what... my what? Did I just hear....crown? That's what He said: my crown.

Isn't it remarkable how God can pack SO MUCH into so few words? This not-so-little charge packed a punch! "Always remember to wear your crown" meant "Don't forget you're a Daughter of the King." *Kapow!* It took my breath away! As I got into the van and drove to the school, I marveled. I meditated. I pondered! I began cataloging Scriptures in my mind about being God's child and about being adopted by Him. I remembered Scriptures about His royalty and the inheritance we have in Him. I even recalled hearing that I was a Co-heir with Christ! I was blown away; they all lined up! Indeed, The Word of God said I was a royal daughter! I marveled as I put these truths together and rehearsed them in an attempt to wrap this limited mind around such an un-limited promise.

I am the daughter of a King. The King of the universe, in fact. He is my Father and He is royalty! He adopted me and that makes me royalty, too. Yes, and royal daughters are princesses! I am a princess! Wow! Royal daughters wear crowns. He wants me to always wear my crown!

And there it was... the truth about who I really was... a truth that no cop cars or rumors or old crummy houses and barns could change. I was a daughter of the King and nothing could take away my crown!

That night in those hallways, I walked taller. I stood straighter. My shoulders were back instead of slouched, and a new confidence I had never known before filled me. Heart, mind, will, and emotions were all in sync with my true identity as I chose to trust the One who saw me for who I really was...*a Princess.* I was not who I appeared to be. Sure, I looked poor and some may even say like a fool, *but I was Royalty.*

I went to my kids' school differently than I ever had before. I did not show up that night as the local scandal and I did not walk those halls in shame. I went in boldness and confidence in who I really am because He whispered my true identity to me during one of my lowest points. I only had to believe it. And I did! I trusted His Word and what it said about me because I learned long ago you can't talk God out of His own Word. Instead of shrinking back that night, I

looked every single person I passed in those jam-packed halls in the eye...

and smiled like a daughter of the King would. We will never live a life free from judgment. People judge. And we will probably always have fleeting thoughts of insecurity that will sneak up on us and try to swallow us up when we least expect it. But we always have this rock to stand on:

What God says about us is the truest thing about us.

If we choose to believe this, we'll never have to bow to those judgments or to any crushing, diminishing thoughts again. We can always remember to wear our crowns.

Some months after this grade school victory, on a quiet weekday afternoon, I went out to my driveway to load something into the back of my van. When I opened the doors, I noticed a large bag that I knew I had not put there. Curiously, I looked into the bag, and in disbelief, I pulled out a fur coat. A FUR COAT! Attached to it was a note that simply read:

For my Princess

Love,

God

I will be a Father to you, and you will be sons
and daughters to Me, says the Lord Almighty.

—2 Corinthians 6:12

I AM A RUNNER

As far back as I can remember, running was something to be feared and avoided. For me, running meant not being able to breathe, sometimes for days. Diagnosed with asthma at the age of eight, I have hardly a memory of running and playing as a child without the fear of an asthma attack, or worse, death. Three times as a child, E.R. docs told my mom I would not have made it through the night had she not brought me in for treatment. All three of those times, I had been struggling to breathe for days.

Have you ever struggled to breathe? It is torment. During an asthma attack, my lungs tightened up like a vice, my chest ached from struggling for air, and my back would ache from the tensing of each muscle required to take one

breath. I had to sleep sitting straight up with only my head carefully placed on a tall stack of pillows set in front of me, because laying down only exacerbated symptoms; which only made me feel closer to death.

These hours and sometimes days of torment came without warning. Fresh cut grass or a cute puppy's dander could easily trigger an attack. A slight cold or even a typical Wisconsin summer day could be the culprit. I never knew; but one thing was **guaranteed** to bring on this torment: running. So, I never ran. Ever. I didn't even run the mile in gym class! The doctor wrote a note excusing me every single year, beginning when I was eight years old. Running was a foe to be feared. And I feared it well!

Although my asthma improved greatly as I grew up, running remained a severe trigger. During my mid-twenties, in an attempt to get my "pre-baby body" back, I decided to try running. Try is code for: I ran out my door, down the road, and didn't even make it out of my neighborhood before having an asthma attack. I stopped, took a puff of my inhaler, and walked home with the belief that I would never be a runner firmly cemented in my heart.

Running is just not for me. I'll never be able to do it.

"Why would you even want to run? Running is for crazy people." Many people have asked me this when telling them my running story. I know, *running is for crazy people*. Plus, it scared the breath out of me. Literally. The truth is, I did not want to run for over 30 years. *Until suddenly, I did.*

It was the summer of 2010, I turned 39 that July. The best way I could describe how this change came about is with the words of Forrest Gump. "I just felt like running." It's true! I don't know what compelled Forrest, but I do know what compelled me: God Himself.

One of the lowest points in my life took place that summer. On government aid, divorced, and a single mom with seven of my eleven kids still under 18, I cleaned houses to make ends meet. Broker-than-broke, I didn't even own a car for a while there. I was falling behind on rent with each passing month and feared eviction. With no end in sight, my circumstances said, "It's OVER!" But my God was saying, "It's about to BEGIN!"

The Lord stirred my heart so deeply and powerfully during that time. No matter what I experienced in the natural, I just knew He was getting me ready to step into my divine purpose in His Kingdom! At a time I should have been most hopeless, I was filled with hope! He continually fanned the flames of

destiny that had been planted in my heart so many years prior. He led me to the story of the Israelites leaving their 40-year wilderness wandering to finally cross over the Jordan River and enter their Promised Land. He told me I was about to cross over my own Jordan River, too. I would finally be leaving my desperate and dry wilderness behind to enter my very own land of promise! I couldn't see it, but I believed it!

During my wilderness, the promises God made me about my future were many; and they were so good! For almost twenty years, I daydreamed about doing what I was made to do, reaching a lost world, and fulfilling my destiny. I would write books, speak, touch hearts; all for Him. I WAS READY. I was chomping at the bit to get out of the pit I had been in for so long and run my race for God! There it was. *Run my race—I wanted to run.*

Suddenly, running verses from the Bible were popping up everywhere!

> *Therefore, since we are surrounded by such a great cloud of witnesses, let us throw off everything that hinders and the sin that so easily entangles. And let us run with perseverance the race marked out for us.*
>
> —Hebrews 12:1

> *But those who hope in the LORD will renew their strength. They will soar on wings like eagles; they will run and not grow weary, they will walk and not be faint.*
> —Isaiah 40:31

> *I run in the path of your commands, for you have broadened my understanding.*
>
> —Psalm 119:32

> *Do you not know that in a race all the runners run, but only one gets the prize? Run in such a way as to get the prize. Everyone who competes in the games goes into strict training. They do it to get a crown that will not last, but we do it to get a crown that will last forever. Therefore I do not run like someone running aimlessly; I do not fight like a boxer beating the air.*
>
> —1 Corinthians 9:24-26

I have fought the good fight,
I have finished the race, I have kept the faith.

—1 Timothy 4:7

It was like the Lord was saying: **The race to your finish is ON! Run, Forrest, Run!**

Okay, maybe not just like that, but I promise you, the Holy Spirit compelled me to RUN! And my spirit jumped at the idea! I took every single verse, wrote it out on an index card, and taped it to the back of my bedroom door. I put every quote that inspired me there, too. In a short time, you couldn't see any door on the back of my door. I read the verses and quotes almost every day and my faith grew and grew.

I just knew that running in the natural and running my race for God were directly linked. Since running was an unthinkable and impossible task for me, I knew it would take a miracle. I reasoned that if I could do the impossible in the natural, I could certainly do the impossible in the Spirit. If I could physically run without dying, then there was NOTHING that could stop me from running the race of my destiny!

So, the kid with asthma decided to run.

I started with a half-mile. Whew. These lungs were not used to that. They struggled. They ached. Thankfully, there had been medical advances since I was eight, so I had inhalers that actually worked (most of the time). I eased my tired, tender lungs into a full mile. Then a mile and a half. Then two! And three! The physical resistance in my entire body was intense, but it paled in comparison to the mental resistance I encountered.

"I can't run." I must have said it a thousand times since I was eight. Guess what happens when you say something a thousand times? You believe it. And when you believe it, you live it. When you live it, you become it. I became a person unable to run for three decades! And then, at the Lord's prompting, I had to flip a switch and tell myself I could run. What a battlefield our minds can be! These two mindsets went toe to toe. Often.

I can't do this.

YES, YOU CAN! God told you to.

But it makes me stop breathing.

You're breathing now, aren't you?

Am I almost done yet? This sucks! OMG, I only went a half-mile so far! A mile will take forever! This will be the death of me!

God wouldn't tell you to do something that would kill you! Now shut up and run!

I sounded like a crazy person in my own head! Sometimes I would even mentally yell at my legs. "Legs, just go!"

It was a battle all right, but I was determined to win. Every mile I ran began to represent places I would go for God and works I would do for Him one day—and my faith just kept running along with my legs! By summer's end, I was running up to four miles at a time. But, my friend, identity runs deep. I still did not think of myself as a runner. In my mind, *I was still the girl who couldn't run.* In fact, I had an easier time seeing myself reaching the world for God than calling myself a runner. When people found out I ran, they would inevitably ask, "Oh, you're a runner?"

Who, me? No...Um, I'm not a runner. I, ah, just run sometimes.

Seriously...that's how I answered! That is like a lawyer saying, "Who me? A lawyer? No, I'm not a lawyer, I just practice law sometimes." (What!?) To put it into perspective, I was running about four times a week, 12-15 miles each week. I was running the same distance as a 5K race, and I was doing it for fun...but I wasn't a runner. I was running farther than some high school cross country athletes were required to run...but I wasn't a runner. How could I be? Runners are fast. Runners are athletes (and they're cool). Runners win medals. Runners don't look stupid. Runners don't puff on inhalers every couple of miles. Runners own running gear (whatever that is). Runners have always been runners. And I was never a runner. In fact, I was never any of those things, so how could I say I was a runner *now*? I felt like a poser. A fake. I couldn't possibly be a runner. How could I say yes to that question? Yet, God called me to run, and I was running!

During this unforgettable summer, my beautiful friend, Jessica, told me she had a gift for me from the Lord. She came over with a beautiful necklace that the Lord led her to buy for me. Designed by a Christian woman, with Scripture in mind, it was silver and came with a beautiful little charm. The charm looked like a ballerina dancing in all her glory. The name of the charm was "Overcomer." I am not a dancer, but I know what it means to feel your spirit dance at the promise of overcoming! The necklace was accompanied by a hand-let-

tered poem by the same name, "Overcomer," and it was written on a parchment bookmark. The poem made my hair stand on end. It was truly a word spoken over me by the Lord! Everything about this gift confirmed that I was on my way! It was another promise from God that I was about to overcome! My faith was ignited, and my expectations of my future destiny increased. Although I could not see how or when it would come to pass, I believed! I wore the necklace every day as a symbol of my faith *and a reminder of who I was.*

A short while after I began wearing the necklace, I received a very unlikely invitation to have coffee with a woman of significant influence. The future Lieutenant Governor of Wisconsin wanted to meet with me. *Me.* She was smack dab in the middle of campaigning for that office, but a mutual friend told her she needed to connect with me. She took it to heart, and although the election was just three months away, and her campaign team tried to tell her she did not have the time, she carved out a morning to meet me. After our introductions, we took our seats in a local coffee shop. She looked directly at my necklace and opened with, "I love your necklace. Are you a runner?"

Totally perplexed, I groped my neck to try to figure out what necklace she could be talking about.

What in the world? What necklace did I put on today? A runner? What? Ohhh…

As my fingers felt the outline of the charm, I realized Jessica's gift to me was not a symbol of a dancer after all, *but a runner, breaking through the finish line tape.* It was a runner finishing her course in victory! An overcomer! I smiled back at her (and at the Lord), gathered myself from the undoing of my revelation, and said with deep conviction,

Yes, I am. I'm a runner.

I laughed internally at the crazy thought that God set this appointment with a woman of great importance solely to set me straight on my necklace. Sometimes it takes a person of destiny to make you see your destiny.

That morning was the first time I owned my identity as a runner, and I have not looked back. Since that extraordinary coffee date, I have truly embraced my identity as a runner. I have run many 5Ks, half-marathons, and even a full marathon. Once, I even took first place in my age group at a 5K race! Many medals were hung on my wall at home representing the identity I now confidently own. I've run thousands of training miles since 2010, and I am still breathing—because that's what runners do.

My favorite thing about this story is that God worked harder on changing my identity than I did! Sure, I had to run (and that isn't easy), but other than that, all I had to do was believe! He had a whole bunch of jobs to do! He had to convince this thick-headed girl with decades of cemented beliefs that I was not who I thought I was. He compelled me to run. Not once, but over and over again. He encouraged me, nudged me, even coached me! He led me to the verses about running and revealed the truth in them to me. He connected me with running people who knew things I didn't, saw the runner in me, and helped me set crazy goals that I once thought impossible. He even arranged a special meeting for me with a woman of authority and destiny, so she could speak my true identity over me! He wanted me to see myself as a runner so badly, He pulled out all the stops until I did. *He wanted me to "get it" more than I did. He always has.*

And while all of this was going on in the natural realm, He simultaneously taught me what it means to run my race for Christ, too! In such a way that I may win! (1 Corinthians 9:24) As I pounded the pavement with my feet, He set my feet in new territory in the Spirit. He brought me out of the Wilderness, into my Promised Land, and gave me a new life. He empowered me to RUN into my destiny as an author, speaker, and messenger to women. He guided me on the course that He carved out for me from before I was born; my personal racetrack, and He waits for me now at my very own finish line.

It is now so plain to me that I was always a runner; even before I grasped my necklace and declared it out loud. Just because I said "I can't run" 1,000 times, doesn't make it Truth. *Our belief doesn't change His truth!* But agreeing with His Truth always changes our belief! His Word says I am a spiritual runner and that means I have been running my race ever since the day I said YES to living for Him. I praise Him for faithfully coaching, training, and preparing me for the race of my life ever since.

He always saw me as a runner; and He patiently waited until I did, too.

> *Therefore, since we have so great a cloud of witnesses surrounding us, let us also lay aside every encumbrance and the sin which so easily entangles us, and let us run with endurance the race that is set before us.*
>
> —Hebrews 12:1

I AM WONDER WOMAN

Scott, my hardworking husband, was up and out the door before the sun came up—while I stayed blissfully asleep. It was a typical early weekday morning. The sun was just beginning to rise, sending rays of light through the edges of the shades in our bedroom. I awoke before it was time to get up because nature was calling. *Ugh.* I wasn't ready to get up yet. I had no idea how long Scott had been gone; I just knew I planned to get right back into bed after I took care of business, so I better not look at the light!

I crawled out of bed clumsily and made my way over to the bathroom with one eye closed. Entering the master bathroom from our bedroom puts you face-to-face with a large mirror over the vanity, and I didn't plan to look. I was determined not to look too intently at anything for fear it might thoroughly wake me up and ruin my plans to go back to my warm comfy bed. When I pushed the door open, I noticed something odd with my peripheral vision. I was so perplexed by what I saw! Something in the mirror had me thinking I must still be sleeping ... and in a dream! I had to look closer ... my reflection looked ... well, *good.* I mean, it looked really, really good! My thoughts began to race.

It is the crack of dawn, right? Yes. And I just woke up, right? Yes. So I should look awful, right? Yes.

Even after mentally confirming that I MUST, in fact, look hideous, and therefore be seeing things, my reflection still looked incredible! What the what?

How can I possibly look so good? Am I dreaming? Am I seeing things? It is dark in here...

I zeroed in on my face and the more I focused, the BETTER I looked!

Dang, girl!! You look amazing!

Surely my half-asleep state along with having just one eye open were to blame.

This must be an optical illusion!

Curiosity got the best of me and I just had to know why I looked so good! No longer concerned with light invading my eyes or falling back to sleep, I opened the remaining eye, reached over to the wall, and flipped on the light switch. I just had to know how in the world I looked this good at this ridiculous hour of the day! As I looked into the well-lit mirror, it took a second to register.

"Oh my gosh! You did not!" I giggled as I spoke to Scott as if he were still home. I knew he was behind this and he had outdone himself this time.

The reason I looked so darn great at crazy o'clock is that I wasn't actually looking at me! Before leaving for work, Scott taped a full-sized poster of Wonder Woman over my mirror! I looked amazing because I was looking at Wonder Woman! And not the Linda Carter version... The Gal Gadot version. You know, the tall, gorgeous, Israeli actress with legs for days? And I knew exactly why he did it.

Scott and I saw *Wonder Woman* when it first came out and both loved it. We're huge superhero movie fans; well pretty much just huge movie fans. I loved the theme of that movie and the fact that a woman saved the world didn't hurt. I was struck by the ending when Diana's enemy destroyed her sword, which she believed was "the god killer." She thought she was doomed until she learned that her power wasn't in a sword or a tool of any kind—it was within. *SHE was the god killer!* And defeating evil was her destiny. What a metaphor for women of God today! I was so inspired! Diana was a rare combination of pure-hearted, and fierce, just the way God calls us to be. She was bold and fearless and all the while her hair was perfect! She was a freaking miracle. How couldn't I love her?

Scott and I talked enthusiastically about how much we liked the movie all the way home that night. He always patiently listens while I tell him what spoke to me the most after a great movie. The next day, he took our discussion to a whole new level. During our morning phone call, he said, "You know who Wonder Woman reminds me of? You."

What?

He told me I reminded him of Wonder Woman! He claimed I look like her, have a heart like hers, I'm bold like her, and would do anything to help people *just like her.* I was really touched and moved, but I silently thought this guy was crazy! Thank the Lord that love is blind!

When the movie came out on cable TV, Scott must've watched it ten more times. I'd walk into the bedroom and ask, "Whatcha watching?" And he'd say, "You."

I'd find him in the family room with the TV on and ask, "Whatcha watching?" He'd say, "You."

I'd look at the screen and there was Diana Prince, doing her pure-hearted,

world-saving thing again. I'd smirk at him and he'd smile back. I'd think, "this guy is crazy!"

"Come here and watch with me!" He'd say patting the couch cushion, "Come see how amazing you are!" I'd laugh and even roll my eyes a little because come on! This was a hard one to swallow! I mean, SHE'S WONDER WOMAN. Yeah, it felt great to hear, but it wasn't true. I mean, my husband's love for me wasn't just blind, it was over the top!

So, when I saw the poster that morning over my mirror, I knew exactly what it meant. But I am a woman, so I called him so I could hear it directly from his lips. (Insert mischievous grin here.) He answered the phone and I said "Hi," while giggling. I asked coyly, "What did you do?"

We could hear each other smiling through the phone.

He played along and said, "Who me? Nothin'."

"Well, I got up while half asleep to go to the bathroom this morning and had quite the surprise—thought I was losing my mind!"

He laughed and said, "Oh yeah?" He knew what I was talking about.

"What made you do that?" I asked in a serious tone.

"Do you really want to know?"

"Of course," I said.

I put that there this morning because I wanted you to see what I see when I look at you."

Okay, I was a puddle. This was probably the greatest thing he'd ever said or done to show me how he sees me. It melted me! He went on to tell me more reasons why I am Wonder Woman to him, and I got lost in the romance and his incredible display of love. I didn't say much during the call because, well, I was sort of speechless! After a thoroughly gross display of gushy-I-love-yous, we said goodbye and hung up. Throughout the day I couldn't stop thinking about it.

Wow! The way he sees me! How can he really see me like that? And how hard he had worked to make sure I would see myself the same way! I thought about the planning that went into that surprise in the mirror—how had he even thought of it? And oh, how far he had gone to show me, *me*—through his eyes. Then it hit me.

This is what the Father does for His daughters!

He has set something before our eyes, taped something to our bathroom mirrors, and He perpetually invites us saying, "Come! Look and see what I see when I look at you. THIS is who you are. Not what you see. Not what you think. Not even what somebody else told you! This thing I've placed over your mirror; **this is who you really are**."

My friend, the thing He places over our mirror is His Word! Inside the pages of His Holy Word, there is a mirror with a huge poster showing you how you look to the Father. And on that poster is a picture of JESUS. That's right— pure-hearted, flawless and fierce, JESUS. The Father wants you to fully grasp that He can see no flaw in you because when He looks at you, He sees His Son.

He simply invites you to come to the mirror and see what He sees.

With that beautiful revelation, I've stopped dismissing my husband's Wonder Woman comments as crazy and chalking them up to the "love is blind" cliché. I finally get it.

Okay, Lord. I am Wonder Woman.

> *You are altogether beautiful, my darling;*
> *in you there is no flaw.*
>
> —Song of Solomon 4:7 (BSB)

JENNIFER WEBSTER

Jennifer Webster's first love has always been writing. She is notorious for the bite-sized dissertations that often accompany her social media photos. In her youth, she became keenly aware of the power of words—their ability to bear up the weak and encourage the weary. It's become her mission to reveal the goodness of Christ in every word she pens. Jennifer resides in Milwaukee, Wisconsin. When she isn't tweaking her Facebook status, she enjoys hanging out with her family (#loyalty), curating social events, thrifting, and traveling. Follow Jennifer on social media by searching @RockingwithJen.

Chapter Twenty

Ward of His Grace

by Jennifer Webster

*"And the God of all grace, the One having called you into
His eternal glory in Christ Jesus— you having suffered a little— will Himself
restore, support, strengthen, establish you."*
—1 Peter 5:10 (*DLNT*)

It was as if it were taken directly from the 100th episode of The Jerry Springer Show. It had all of the elements: sex, drugs, unfaithful men, and the promiscuous women who lure them into exchanging their currency for climaxes. It was a dark and dangerous lifestyle, certainly unsuitable for children. Yet, there she was, pregnant and prostituting. Strung between yesterday's high, and tomorrow's hunt *stood my mother*. It had been a year since she had begun using cocaine. She already had two children at home, and could not fathom adding another to the picture. She denied her pregnancy. In fact, she increased her drug usage, in hopes of terminating it. By this stage, prenatal appointments would have been customary, but she avoided those. Finally, she came to terms with the idea that the baby inside her might survive. She made the necessary arrangements and opted for the child to be adopted.

It wasn't until she laid across the delivery table that she discovered the truth. She wouldn't just be giving birth to one baby, but rather two. Though, her heart leaped, the arrangements were already made. Upon delivery, her newborn twins were swiftly taken and united with their new family.

That would have been the last time she saw them, had it not been for a mail delivery she received a few weeks later. It was certainly a mistake on the hos-

pital's behalf when the photographs of the twins arrived in her mailbox. It was seeing them, then, that she realized she wanted her babies back.

Immediately, she devised a plan. Though they were aware of her drug usage, she was able to convince the child welfare system to release the twins into the care of her sister. However, after a dispute, she'd later take them from her sister's home, and bring them to reside with her.

Her addiction would drive her to forsake her maternal duties, one-too-many times. It was her own mother who reported her negligence. After leaving them unattended for hours, she returned home to find her children gone.

<center>~~~~</center>

We'd gone out to eat all the time, but this time was special. This time was a celebration. My twin brother, Jeffrey and I, were the honorees. It had been four years since our mom had taken us in as her foster children. We were babies then, and because of that, she had been the only mom we knew. Apparently though, to our innocent ignorance, after three-and-a-half years in the system, we had been put up for an adoption bid. We had no clue that pending a ruling from a 12-person jury, we could have been placed in a totally new home, or worse—separated.

I'm not sure how long the hearings lasted. I was told that my biological mother had taken the years since our birth to become sober and stable enough to demonstrate to the court that she was indeed, fit to be a parent.

My biological father denied any paternal relation and chose not to enter the running, to begin with. Usually, in cases like ours, the biological parents are given a certain advantage. It is the aim of most state agencies to preserve the biological family unit, if at all possible. However, there really wasn't much to preserve here. We had been taken into Child Protective Services months after being born. Ms. Webster, our foster-mom, had been the only family we knew. Removing us from her care would have been extremely traumatizing. With that in mind, the jury reached their decision. They decided it was in our best interest to remain in the care of our foster mother. They granted her full guardianship and parental rights. The adoption was final. So there we sat, nestled in the neighborhood Sizzlers', celebrating the ruling. We had long been family, but now it was official.

It was never a secret that we were adopted. As we grew older, my foster

mom assured that upon our 18th birthday, she'd commit to reuniting us with our biological mother. She kept her word, and after our 18th birthday, the somewhat awkward reunion happened.

By then, however, I wasn't particularly interested in getting to know the woman I perceived to have chosen her addiction over me. While the relationship between Ms. Webster and I wasn't the best, she was still my mother. I couldn't wrap my mind around now extending the title to this other woman. The entire situation made me uncomfortable. I truly did not understand how a mother could give her children away. I held tight to my belief, that had she truly wanted me, she would have never stopped pursuing me.

~~~

I couldn't wait for her to get home. We'd find some reason to playfully chase each other around the house until finally falling into one another's arms, and settling for the night. She was my weakness. I could run my fingers through her hair for days, especially when she wore it the way I liked. She was brilliant. My knees basically melted at the sound of her rambling on about politics, history, finances, or global issues. *Sigh.* Did I mention, she was my sweet spot?

It was during my sophomore year of college when I tested the rainbow-colored waters. The university I attended had a large LGBTQ community, providing plenty of prospects for the "try-sexual" I secretly identified as. I was in full-fledged rebel-mode. I was tired of being the "good church girl," and was ready to spice up my life.

Believe it or not, I pursued her. My first girlfriend. I'd somehow convinced her that I was a much better catch than the girl she had been crushing on when we met. My aggressive persistence paid off, she and I would spend a year ensuring our private romance, avoided the public eye. I think, sneaking around made things exhilarating. She was my little forbidden fruit.

Publicly confessing my same-sex love affair was never an option. I knew it wasn't a lifestyle honorable and agreeable to the Christian tenets I had placed my faith in my entire life. Plus, this was just a phase I was going through! I'd one day ask God for forgiveness, repent, and marry a man! We would get a dog and live happily ever after. This was literally what I told myself. I'd spend the next three years, on that campus battling between my desires for women, and my honoring my Christian convictions.

My school was about a 45-minute drive from my reality check. The weekends that I decided to visit home, often included attending Sunday service (not to be confused with Kanye West's Calabasas revivals). I'd throw on some loosely-fitting church attire, grab my bible, notebook, and head to church, as usual. I had become a pro at deception. I could lift my hands in worship, all the while imagining my girlfriend. No one suspected anything until she and I could no longer bear to spend the weekends apart.

I persuaded her to attend church with me. It wasn't her thing, but to appease me, she agreed. She stuck out like a sore thumb. She wasn't black, though my predominantly African-American church family was. While her ethnic differences did not stop her from being embraced with love from the congregants, I believe it aided in their pause.

Despite the c-cup sized breasts that testified of her womanhood, she wore baggy clothing to conceal her feminine physique. In laymen LGBTQ terms, she was the quintessential "stud." As time progressed, and those around me began to see more and more of my so-called "just friend," the chatter began.

"Who's that girl?" "Why are they always together?" "Is Jen gay?" "Are they dating?"

It wasn't just people back home asking questions. Suspicions had begun to spark around our campus, too. We denied the rendezvous accusations and insisted we were simply good friends. Eventually, the guilt of my double life got to me. I'd find myself breaking up with my girlfriend what seemed like, every Sunday, only to beg her to return the following Monday. It was shameful confusion. I was confused. I couldn't reconcile my feelings with my beliefs. She would soon become fed up with my antics and withdraw completely. I could have called it quits then. I could have gathered my lessons learned and ran in the direction of the cross.

But, I didn't.

I went on to establish another relationship, this one, more complicated than the first. It would last a little over a year, before ending. Due to some financial hardship and stress, at the start of my senior year, I abruptly dropped out of college. I needed a break. I need some clarity. I needed God.

I longed for His peace, presence, and approval. It seemed it had been so long since I had it. I pushed the memories of the young woman I was masquerading as, far behind me. I pleaded with God to change my heart, and my

desires. I confessed in faith, John 8:36 (ISV) "So if the Son sets you free, you will be free indeed!" and 2 Corinthians 5:17 (KJV) "Therefore if any man be in Christ, he is a new creature: old things are passed away; behold, all things are become new."

Pretty soon, I figured, I was back in God's good graces. I'd become actively involved in ministry efforts within my church, again. I would even go as far as professing a personal call into ministry, in front of the entire congregation! My pastor confirmed my call, and months later, I gave my first trial sermon.

Though I had taken a spiritual detour in college, the radical zeal I carried for Christ in my youth was back! Despite the pressures that came with being a part of the clergy, I enjoyed it deeply. It offered a sense of validation and prestige that I discovered I subconsciously needed. Still and all, in about a year's time, I would decide the church I had been raised in was no longer a fit for me. I was in search of mentorship that I didn't believe I had there. I said my goodbyes and began a journey to find a new church home. It was during this quest that I met her.

We were co-workers. I knew she liked me, so I kept my distance. I knew the game she was playing. I had played it years prior. She wanted me. Honestly, I think that's what intrigued me the most.

I put my heart and soul into serving well. Whatever that meant. I'd held down this position for five years. It was technically the longest job I had ever had to date … except, it wasn't a real job. I wasn't getting paid for it. No, this was better than that! This was something I felt called by God to do. Sort of like the promptings a pastor might feel when they come to realize God has called them to shepherd His people.

Eh … well, maybe that's extreme. No, no…I think it's accurate. I wholeheartedly believed God had entrusted me with such a task. I had never heard of an armor-bearer until then.

"Armor-bear-er." "Arm-or-bear-er."

I recall mentally breaking the words apart and putting them back together again in search of understanding. What in the world was an armor-bearer? I had just turned 24 and was overjoyed by my recent discovery of a new body of

believers to regularly fellowship with. Even more appealing was their pastoral leadership—a young and fashionable married couple who gave the best hugs.

It didn't take long for me to become completely immersed in the church's culture. I joined various auxiliaries and shared my ideas wherever they were needed. I loved my church! And everyone around me knew it. However, if it were at all even possible to love something more, I had begun to establish a great affinity for my pastor's wife. Like most churches, we referred to our pastor's wife, as "First Lady."

Our bond sparked at a Starbucks near her home. I was one of the newest members, and she wanted to get to know me better. To break the ice, we each drew timelines of our lives and shared about the monumental moments that influenced who we were. She was so nice. I could tell she really cared about the details I had scribbled on the paper in front of me.

I left the coffee shop in awe. I had First Ladies before, but none were as warm and welcoming as this one. Our relationship would blossom primarily through text messages. She was a busy wife, mother, and businesswoman. I felt special when she made time to entertain my random thread of rambles. She was easy to talk to, so I shared pretty much everything with her.

During my free time, she permitted me to come to help out at the childcare center she owned. I would tidy the classroom, organize her office, run small errands, and lend a helping hand wherever else she instructed. If it meant being in her company, I'd do it.

For the sake of clarity, this was not a sexual attraction. But, I did wonder why I cared so intensely for this woman. Her welfare became my chief concern. I wanted to ensure her safety, and lessen her load in any way that I could. Not only did I offer my assistance during her business hours, but I began aiding her during weekly church services as well.

It was perhaps through prayer, or after realizing that I wasn't going anywhere when she informed me of the news. I had made being her shadow my hobby, but now, as her armor-bearer, my recreational pastime would become my official responsibility.

She encouraged me to begin researching what my new role entailed. She even suggested books for me to add to my personal library. I'd learn an armor-bearer was an honorable duty outlined several times throughout scripture. Jonathan, Abimelech, and Saul each had armor-bearers. As the title suggests, armor-bearers had the distinct privilege of carrying their commanders'

weapons into battle. They would also fight alongside their officers, ensuring their safety and victory.

Luckily, in the 21st century, the role of the armor-bearer has shifted. My job was to lighten the burden that came with full-time ministry, and to consistently cover her in prayer, through a regimen of intercession. The war was spiritual— to effectively serve in the armor-bearer capacity, and forget the spiritual nature of the role, was to do a major disservice.

I wore my armor-bearer badge with pride. I took pleasure in providing the absolute best care I could. I resolved the reason for my sudden obsession, had been due to a God-given desire to look after His faithful servants. I studied them. In time, I could anticipate their next words, moves, and consequently, their next needs. I adjusted my life around always being in place to extend my assistance. I created assessment tools to gauge my progress and identify any areas of improvement. Everything became second to my assignment.

I was the first one at church, and usually, the last one to leave. Brewing tea, prepping towels, and gathering mics were just a few of the tasks I'd complete before my pastor and his wife would arrive. I strived to serve in an excellent manner and was hard on myself when I didn't. I had to prove I was valuable. By executing my responsibilities flawlessly, I thought I proved I deserved to be in the room. Others took note of my exemplary charge, their affirmations often boosting my ego.

Performance became my idol.

I would replace personal prayer and devotion with research on how to be a great personal assistant. My priorities were misplaced, but it didn't matter to me. I was doing the thing I loved to do, for someone I loved deeply. It was only a matter of time before my faulty spiritual foundation would be exposed and fall from underneath me.

---

Don't miss her. She's been the recurring guest in every story.

The little girl. The little broken girl. The little wounded girl. The little rejected girl. The little abandoned girl. The little forgotten girl. The little helpless girl. The little hurt girl. The little angry girl. The little scared girl.

It could have taken root in the womb, this assault against her identity.

She didn't have to admit it. It was expressed in her behaviors. She was unsure of her worth, questioned her value, and wondered if she was good enough for anyone. She didn't know why she existed. Why she mattered. And what, if any, significance she brought to the world. It's why she clung desperately to the approval and pursuit of others. She needed to know that there was something special about her, and they saw it.

*It's why she sought validation in what she did, and how well she did it.*

*It's why she had to be perfect to make certain she gave no reason for them to leave.*

The spirit of an orphan had settled in her soul. She didn't even recognize it. Her fear drove her to distance herself from some, while codependently relying on others. Her pride, a subconscious ploy to avoid being hurt.

She was a 29-year-old, walking, talking, little girl.

I was probably in the fifth stage of grief when I realized the problem was me. My little girl tendencies had caused me to lose everything I treasured the most. It took a prophetic public service announcement to rein me in. Following a prayer service, my First Lady confronted me to share God's divine warning.

"WHATEVER YOU'RE DOING, AND WHOEVER YOU'RE DOING IT WITH, STOP!"

Just like that, I was forced to admit what I had been withholding in secrecy. For months, I had been intimately entangled in yet another same-sex relationship.

My deceit, lack of integrity, and dishonor were the final straws. I was rebuked, released from my role, and left to reassess the content of my heart. I was devastated.

*When I had nothing left to hide behind, I was forced to face my brokenness.*

In humility, I drew my white flag and raised it high in the air. I was tired of wrestling with God, and tired of wandering aimlessly along in search of the things I felt had been taken from me long ago. My healing became my mission. I refused to allow a self-sabotaging spirit to destroy my destiny. It was time to take the will of God for my life seriously. I wasn't a little girl, and I could no longer afford to show up as one.

By faith, I began to rehearse, meditate, and decree the Word over my mind. Unless I changed the way I saw myself, I would continue to remain the same.

I partnered with God to boldly confront my orphan's heart, an issue I had been made aware of through pastoral counseling. I leaned in and commanded myself to fully embrace God as my Heavenly Father, a concept I had previously struggled to comprehend.

*I wasn't a castaway. I wasn't a bastard. I wasn't an orphan.*

Over the course of a year, God began to show me how He'd always been with me. He reminded me that it was Him who had carefully orchestrated my steps. He revealed to me that it was His grace that carried me through my life's turbulence. He shared how His mercy interrupted the enemy's attack against me. He reassured me, that none of my hurt and pain would go unused. He urged me to consider His track record.

Who better to place my trust in but Him? He was the Mastermind behind my story from the very beginning, and He alone would get the glory through my transformation.

In gratitude, I rejoice at the journey—a beautiful juxtaposition. Being painfully stripped, I've found my true identity has always been in Him.

# Discover Your New Identity through the Gospel!

*I have no greater joy than to hear*
*that my children are walking in the truth.*

—3 John 4

When we walk in the truth, it brings our Father in Heaven great joy! However, walking in the truth can only happen if we first invite the One who calls Himself "the Way, the Truth, and the Life" into our hearts. Jesus is "the Truth" and when we ask Him to be our Lord and Savior, He not only forgives us of all sin and fills our beings with His Spirit of Truth, but He makes us new!

By His work on the Cross, and the truth of His Word, we receive a new identity; we become sons and daughters. In Christ, we are washed, freed, forgiven, and adopted into His family.

Have you received your new identity in Christ? Have you asked Jesus to come into your heart and to fill you with His Spirit—the Holy Spirit, who will continually lead and guide you into all truth? If not, we invite you to do so now, by praying the prayer below. Receive the free gift of salvation and your new identity today!

*Father, I believe that your Son, Jesus, lived on this earth to ultimately die for me. I know I've sinned; I've missed the mark many times and I cannot save myself. I know that no amount of good deeds can wash me clean – but Your blood can!*

*Today, I choose to place my trust in the price you paid for my sins on the Cross. I now turn from my own ways and toward You. I want to live for you and be the person you made me to be. Make me new. Make me like You.*

*I ask you fill me with your Holy Spirit today, and to lead and guide me into the truth about who You are and who I am, in You! Thank You for dying for me and giving me the gift of eternal life. Thank you for sending Your Holy Spirit to live in my heart and to guide me; today and always. Amen.*

# The Names of God

*Listed below are the self-revealing Names of God in the Bible:*

## ADON
To rule; sovereign; controller. In KJV printed as Lord (Capital "L" small case "ord"). Used about 31 times in the OT when referring to God.

## ADONAI
(Gen 15:2) Master; Lord; Owner. When printed as Lord (capital "L" small case "ord") in KJV to refer to Deity, the name usually refers to Jesus (Gen. 15:2)

## ADON-ADONAI
Jehovah our Ruler. A vigorous name of God expressing divine dominion; reveals God as the absolute Owner and Lord.

## ADONAI-JAH
Jehovah is Lord.

## EL
(Gen. 14:18) Root = to be strong. The Strong One. Indicates the great power of God. In the singular, it emphasizes the essence of the Godhead. It has been translated as "Mighty, Prominent, The First One."

## ELAH
(elahh) (Ez. 4:24) oak; an oak tree; like a tree. The denunciation of a curse. Root = an oak; tree symbolizes durability; the EVERLASTING God (Ez. 5:1 rebuilding the house of God). Indicates the living and true God who identifies with His people in captivity (used 43 times in Ezra; 46 times in Daniel).

## ELOAH

(elowahh) (Deut.32:15) Used 54 times in Scripture; 40 times in Job alone. Root = to fear; to worship; to adore. The adorable or worshipful One (Job 19:25-26). The name for *absolute Deity*. The only living and true God, in all His being. The object of all testimony and worship. It is the singular of Elohim. It speaks of the totality of His being; the finality of His decisions.

## ELOHIM

(el-lo-heem) (Gen. 1:1) Root = to swear; name indicates God, under the covenant of an oath with Himself to perform certain conditions (Heb. 6:13). Name implies: One in covenant; fullness of might. Refers to absolute, unqualified, unlimited energy. A plural name revealing God in the unity and trinity of *all* His divine personality and power.

## EL ELOHE-ISRAEL

(Gen. 33:18-20) God of Israel; God, the God of Israel.

## EL ELYON

(Gen. 2) Most high God; God most high; combined idea of might. (The Possessor or Framer of heaven and earth.)

## EL OLAM

(Gen. 20:13); God of eternity; KJV – the everlasting God. The God without a beginning; the God who never will cease to be; the God who will never grow old; the God to whom eternity is what present time is. Describes God as He who extends beyond our greatest vision of who we think God is. (No matter how great our concept of God is, He is always greater.)

## EL ROI

(Gen. 16:13,14 – only time used) The well of Him that lives and sees. Roi: root = that sees; of sight.

## EL SHADDAI

(el shad-di) Almighty God; all-sufficient God (first used in Gen. 17:1 and last used in Rev. 19:15). In Him all fullness dwells, and out of His constant fullness His own receive all things. "EL" sets forth God's Almightiness, and "SHADDAI" refers to His exhaustless bounty, i.e., the all-bountiful One. The psalmist reveals God's supremacy and sufficiency with His eternalness; He that dwelleth in the secret place of El Elyon, shall abide under the shadow of El Shaddai (Ps. 91:1). "...From everlasting to everlasting, Thou art God" (Ps.

90:2). "SHADDAI" = (Gen. 17:1) Almighty; used 48 times in OT, 31 times in Job, and about 10 times in NT where it speaks of the all-powerful One, the absolute Sovereign. In Scripture, the term Almighty (used about 58 times) is applied only to God. "SHADDAI" speaks of God Almighty; the mighty One of resource or sufficiency; the pourer forth of blessings (temporal and spiritual); the breasted One; the mighty One of resource of sufficiency (root = shad = a breast). Gen. 49:25 – the blessings of the breasts presents God as the One who nourishes, supplies, and satisfies. God, all bountiful; God, all sufficient.

## HELEYON or ELEYON
most high; highest; Jehovah most high (Ps. 7:17; 47:2; 83:18; 97:9). Reveals God as the high and lofty One who inhabits eternity (Is. 57:15). The title has to do with the Most High as the ascended One who is in the highest place, guarding and ruling over all things and making everything work to one given end (Dan. 4:25).

## JAH
(Ps. 68:4); Found 50 times in Exodus, Psalms, and Isaiah. A shortened, poetic form of Jehovah; the Independent One; the Lord most vehement. Root = to be; to breathe. The name signifies "He Is"; present tense of the verb "to be". (It foreshadows Jesus as the I AM in John). He will be; i.e., the Eternal who always is; the Eternal One; the name of the Lord everlasting. First used in Ex. 15:2, this song of salvation shows JAH to be a present and perpetual support and security (Is. 26:4). The name suggests Jehovah as the present Living God; the presence of God in daily life; His present activity and oversight on behalf of His own. JAH reveals God as the One intensely and personally interested in us, and who sits on the circuit of the earth observing our every action.

## JEHOVAH
(Gen. 2:4) Self-existent; the eternal, ever-loving One; He will be; i.e., the Eternal who always is; the eternal One; the I AM THAT I AM; (He) was, is, will be, the Lord God. Root = to be; to exist; being; to breathe. In Hebrew, this name is written as YHVH (called a Tetragrammaton or four-lettered name). This name reveals God as the One who is absolutely self-existent, and who, in Himself, possesses essential life and permanent existence. A name of covenant relationship; God's signature when He entered into a covenant with man. The name is first used as JEHOVAH-ELOHIM in Gen. 2:4, denoting that ELOHIM, the God of relationship, now requires order and obedience. The name is first used alone in God's revelation to Moses in Ex. 6:3. JEHOVAH is derived from the Hebrew verb "havah" = to be; to exist; being; to breathe. The name JEHOVAH

brings before us the idea of being or existence and life. JEHOVAH is the Being who is absolutely self-existent, the One who in Himself possesses essential life, the One who has permanent existence, He who is without beginning or end (Is. 43:10-11; Ps. 102:27). JEHOVAH is the ever-existent One – that is; the One continually revealing Himself, His ways and purposes. In the KJV, the Father, JEHOVAH, is printed as LORD or GOD (all caps); i.e., the Lord GOD, Ez. 16:8, 30 {ADONAI-JEHOVAH}. The only departure from this is found in Deut. 28:58 in the phrase "The Lord thy God" {JEHOVAH-ELOHIM}. Middle-Ages Jewish commentator, Moses Maimonides, stated that "All the names of God which occur in Scripture are derived from His works except one, and that is JEHOVAH, and this is called the plain name, because it teaches plainly and unequivocally of the substance of God. In the name JEHOVAH, the personality of the Supreme is distinctly expressed. It is everywhere a proper name denoting the person of God and Him only."

## JEHOVAH-ELOHAY
The Lord my God. Similar to Adhon or Adhonay; a personal name meaning My Lord; likewise emphasizing divine sovereignty (Jud. 6:15; 13:8). Elohay, however, points to the personal pronoun as being expressive of a personal faith in the God of Power (Zech. 14:5). Wherever the title is used, it is in the individual, personal sense, and not a general one as in The Lord our God.

## JEHOVAH-ELOHEENU
The Lord our God; suggesting the common wealth of God's people in Him.

## JEHOVAH-ELOHEKA
The Lord your God. This title is found 20 times in Deut. 16. Taking its use from Ex. 20 where it is often used, this divine name denotes Jehovah's relationship to His people, and their responsibility to Him. This name is more personal than His previous name, JEHOVAH-ELOHEENU, meaning "The Lord our God".

## JEHOVAH-ELOHIM
Reveals the majestic omnipotent God, combining the majesty and meaning of both names (Zech. 13:9; Ps. 118:27). Together they imply man's place of conscious intelligent relationship to his Creator. Reveals man's accountability to God. Name first used in Gen 2:4 (Lord God, 20 times in Gen. 2 and 3), reveals the nature of ELOHIM—the God of relationship, and JEHOVAH—the God of holiness and order who requires sacrifice (Gen. 8:20) and obedience (ex. 6:3) based on relationship.

## JEHOVAH-GMOLAH

(Jer. 51:7,8) The God of recompenses.

## JEHOVAH-HELEYON

(Ps. 97:9, 7:17; 47:2; 83:18) Reveals God as the high and lofty One who inhabits eternity (Is. 57:15).

## JEHOVAH-HOSEENU

(Ps. 95:6) The Lord our Maker. Refers to God's ability to fashion something out of what already exists (Heb. 11:10; Eph. 2:22), as opposed to His ability to speak and create out of nothing.

## JEHOVAH-JIREH

(Gen. 22:14) The Lord is provision; the Lord will see and provide.

## JEHOVAH-M'KADDESH

(m-kad-desh) (Lev. 20:8) The Lord is sanctification; the Lord who sanctifies; the Lord does sanctify (sanctify = to set apart). Root = sanctify; holy; hallow; consecrate; dedicate; sanctuary; Holy One. The term "holiness" from the Hebrew "kodesh" is allied to sanctify, which is translated by words such as dedicate, consecrate, hallow, and holy in the Scriptures. God wants us to know Him as JEHOVAH-M'KADDESH, JEHOVAH who sets us apart unto Himself. In connection with man, JEHOVAH-M'KADDESH (JEHOVAH who sanctifies), empowers us with His presence to set us apart for His service. The Lord wants us to be a holy nation (Ex. 19:5,6) that appreciates our high, holy, and heavenly calling (Ex. 31:13). We have no inherent holiness or righteousness apart from Him. God's command, "Sanctify yourselves", can be fulfilled only in the imparted and imputed righteousness of Christ, for "I am the Lord that sanctifies you."

## JEHOVAH-NISSI

(nis-see) (Ex. 17:8-15) The Lord is a Banner; The Lord my Banner; The Lord our Banner. Root = Banner; an ensign; a standard (Is. 5:26; 49:22; 62:10; compare Ps. 20:5; 60:4). A sign (Num. 26:10); and a pole in connection with the brazen serpent (Num. 21:9). Jesus is our victory over Amalek (the flesh) through the Cross; He is our banner leading us to victory. Dr. F.E. Marsh says: "The Lord in His death for us is our Banner in victory...our Standard in life...our Ensign in testimony...our Sign to all that He is the Triumphant Lord."

## JEHOVAH-ROHI
(ro-ee) (Ps. 23:1) The Lord is a Shepherd; the Lord my Shepherd. Root = shepherd; feed; to lead to pasture; tend a flock.)

## JEHOVAH-ROPHE
(ro-phay) (Ex. 15:22-26) The Lord is healing (physical and spiritual); the Lord who heals you; the Lord the Physician. Root = heals; healing; restore; repair; make whole. Ex. 15:26 can be "I Am Jehovah, thy Healer." Heals or healeth = to mend (as a garment is mended); to repair (as a building is constructed); and to cure (as a diseased or unhealthy person is restored to health: physically, mentally, emotionally). (Compare Ps. 103:3; 147:3; Jer. 3:22; Gen. 20:17; 2 Kings 20:5).

## JEHOVAH-SABAOTH
Hebrew: Tsebaoth; Greek: Sab-a-oth (Rom. 9:29; Jas. 5:4). Sabaoth = host or hosts, with special reference to warfare or service. The Lord of Hosts (1 Sam 1:3; Jer. 11:20. Used about 260 times in the OT). Lord of all power and might (material or spiritual). The Lord of Powers; the Lord all-controlling and all-possessing. Lord of heaven and earth; sole God and Ruler of the world; Lord of all angels, men and demons; the Absolute Monarch of this universe (Dan. 4:33). Hallelujah!!! Amen!!!

## JEHOVAH-SHALOM
(Jud. 6:24) The Lord is Peace; the Lord my Peace; the Lord our Peace; the Lord is or sends peace. Root = peace; welfare; good health; whole; favor; perfect; full; prosperity; rest; make good; pay or perform in the sense of fulfilling or completing an obligation.

## JEHOVAH-SHAMMAH
(Ez. 48:35) The Lord is there; the Lord is present. Root = presence.

## JEHOVAH-TSEBAOTH
Same as JEHOVAH-SABAOTH: Lord of Hosts. Hebrew: "Sabaoth" [Saw-Baw], 1 Sam. 1:3. Word literally means hosts; combines the ideas of divine maker and controller with special reference to warfare; implies divine revelation and authority; armies; a gathering together in His Name.

## JEHOVAH-TSIDKENU

(tsid-kay-noo) (Jer. 23:5; 6; 33:16) The Lord is Righteous; the Lord our Righteousness; the Lord my Righteousness. Root = straight; right; righteous; just; justify. This word represents God's dealing with men under the ideas of righteousness, justification, and acquittal.

*From: *The Exhaustive Dictionary of Bible Names*,
by Dr. Judson Cornwall and Dr. Stelman Smith.

Download and print this resource here:
thefewwomen.com/pdf/IDEffect.TheNamesofGodfor.pdf

# BECOME ONE OF THE
# FEW

In addition to monthly forums, women's leadership, coaching, and retreats, The Fellowship Of Extraordinary Women (FEW) is proud to stand by these impactful, engaging, and transformational books. Enjoy these titles from FEW International Publications. Most FEW books are sold on Amazon and almost all FEW authors are available to present to your church or organization. Refer to their websites listed in the biographies of this book OR reach out to FEW International Publications Founder and President, Kimberly Joy Krueger, at **www.kimberlyjoykrueger.com.**

Currently seeking women authors of all levels and experience who wish to have an extraordinary experiential writing journey in a book that glorifies God. Interested? You could be added to our list of dozens of #1 Bestselling Authors.
Contact us at **thefewwomen.com**.

Made in the USA
Lexington, KY
17 November 2019